The Art of Drawing
Fantasy Characters

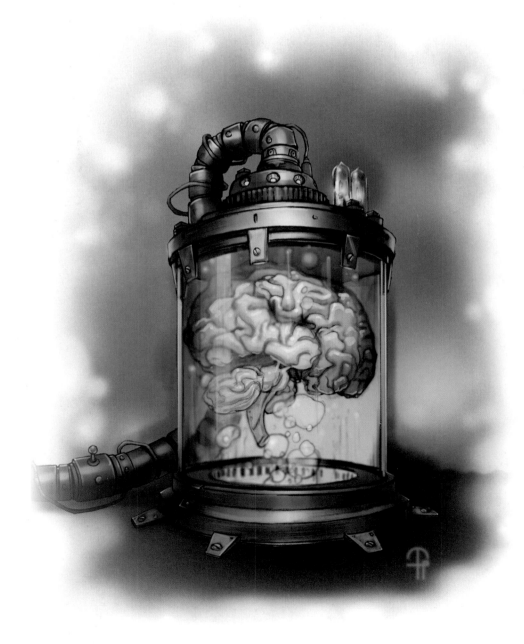

10 9 8 7 6 5 4 3 2 1

The Art of Drawing
Fantasy Characters

By Jacob Glaser
Designed by Shelley Baugh
Project Editor: Meghan O'Dell
Production Design: Debbie Aiken
Copyeditor: Merrie Destefano

www.walterfoster.com

Contents

Getting Started

In this book, I'll showcase my process of drawing characters and props from three speculative fictional traditions: science fiction, horror, and fantasy or adventure. Each genre has its own unique conventions and characters that populate movies, television shows, videogames, and literature. I have chosen various archetypes and icons from each genre and developed them to illuminate at least one way of approaching character illustration.

I prefer to do most of the basic work in the concept sketch or thumbnail stage, but for the purposes of this book, I work at full size so you can see the complete process. The best way to increase your ability to make convincing drawings is to continually study the world around you, especially human anatomy. I have also found great value in studying the processes of other artists, and I hope that seeing mine will be helpful to you.

Tools & Materials

One of the best things about drawing is that you can draw anywhere, anytime with just a piece of paper, an eraser, and a pencil. As your skills increase, you'll mostly likely want to expand your drawing tools, but it's best for beginners to just start with the basics. When you do start to purchase more supplies, remember that you get what you pay for, so purchase the best you can afford at the time and upgrade whenever possible. Although anything that will make a mark can be used for some type of drawing, you'll want to make certain your magnificent efforts will last and not fade over time. Also remember that everyone has his or her own preferences, and that experimentation is key. Here are some basic materials that will get you off to a good start.

Work Station You don't need a studio to draw, but it's a good idea to set up a work area with good lighting and enough room for you to work and lay out your tools. When drawing at night, you can use a soft white light bulb and a cool white fluorescent light so that you have both warm (yellow) and cool (blue) light. You'll also need a comfortable chair and a table (preferably near a window for natural light). You may also want to purchase a drawing board that can be adjusted to different heights and angles, as shown above.

Sketch Pads Conveniently bound drawing pads come in a wide variety of sizes, textures, weights, and bindings. They are particularly handy for making quick sketches and when drawing outdoors. You can use a large sketchbook in the studio for laying out a painting, or take a small one with you for recording quick impressions when you travel. Smooth- to medium-grain paper texture (called the "tooth") is an ideal choice.

Drawing Papers For finished works of art, using single sheets of drawing paper is best. They are available in a range of surface textures: smooth grain (plate and hot pressed), medium grain (cold pressed), and rough to very rough. The cold-pressed surface is the most versatile. It has a medium texture, but it's not totally smooth, so it makes a good surface for a variety of different drawing techniques.

Charcoal Papers Charcoal paper and tablets are also available in a variety of textures. Some of the surface finishes are quite pronounced, and you can use them to enhance the texture in your drawings. These papers also come in a variety of colors, which can add depth and visual interest to your drawings.

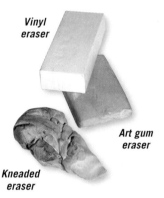

Vinyl eraser

Art gum eraser

Kneaded eraser

Artist's Erasers Different erasers serve different functions. I prefer a kneaded eraser, which can be formed into small wedges and points to remove marks in very tiny areas. I also use a hard plastic eraser, which is great for large areas. Art gum erasers are good for doing a lot of erasing, as they crumble easily and are less likely to damage the paper's surface.

Sharpeners You'll always want to keep a pencil sharpener handy, as you'll need a sharp point to make crisp, clean lines. An electric sharpener can be used but many artists prefer to use a regular hand-held sharpener, which affords more control over the shape of the pencil tip. You can also sharpen your pencil using a utility knife or by rubbing it against rough drawing paper or a sandpaper block.

Light Table Light tables vary in size and ease of use, from light lap- or table-top models to the 200-pound steel monster I have in my studio. They are very useful for tracing drawings onto clean sheets of paper and for composing multi-form illustrations. For those on a budget, I recommend using a large window (simply tape your sketch to the window with the clean sheet on top of it, and trace away). This can be uncomfortable, though, and requires daylight.

PENCILS

Drawing pencils are classified by the hardness of the lead (actually graphite), which is indicated by a letter. The soft leads (labeled "B" for "black") make dense, black marks, and the hard leads (labeled "H" for "hard") produce very fine, light gray lines. An HB is somewhere between the two, making it very versatile. A number accompanies the letter to indicate how hard or soft it is—the higher the number, the harder or softer the pencil. (For example, a 4B is softer than a 2B.) In this book, I switch between a 2H and a 2B pencil, but every artist as his or her own preferences. Any of the leads can be sharpened to the point you want (as shown at right), achieving a different effect. The result will also depend on the texture of your paper. Practice shaping different points and creating different effects with each pencil by varying the pressure you put on the pencil.

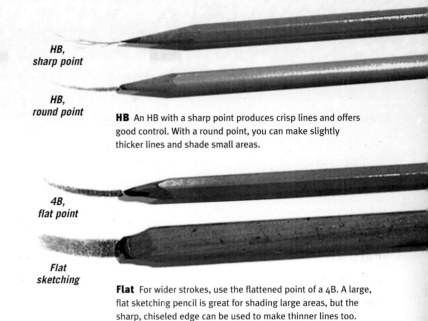

**HB,
sharp point**

**HB,
round point**

HB An HB with a sharp point produces crisp lines and offers good control. With a round point, you can make slightly thicker lines and shade small areas.

**4B,
flat point**

**Flat
sketching**

Flat For wider strokes, use the flattened point of a 4B. A large, flat sketching pencil is great for shading large areas, but the sharp, chiseled edge can be used to make thinner lines too.

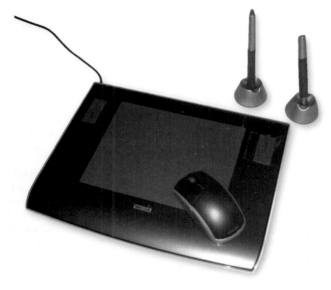

Pen Input Device When choosing a pen input device, base your decision on levels of sensitivity and personal comfort. I use a medium-sized Wacom® tablet and would not want anything larger, though I know several artists who use the smallest and largest tablets available. It's a choice of personal style and comfort.

DIGITAL PAINTING

You'll notice that I don't provide step-by-step instructions for the colored finals in this book; instead, I comment on my color choices. I chose not to include exact instructions because all software programs are different and all artists will use them differently, so it won't help to explain my process with my program. But to me, talking about color choice is always helpful. There are many complicated brushes, textures, and gadgets to experiment with, but I find that the most useful brush is a basic shape, like a circle or ellipse, that has the ability to easily control opacity, size, and the brush edge (the "hardness" and "softness" of the stroke). The fundamentals of painting with physical media such as watercolor and acrylic also apply to digital painting— especially in regard to color theory (see "Color Basics" at right)—so learning them will help you become a stronger digital artist as well.

PAINTING SOFTWARE AND PEN INPUT DEVICES

Many projects in this book include a painted final, which I create using painting software. Several products exist to simulate the experience of painting for digital artists; I can't imagine a more forgiving environment in which to learn and experiment with color, value, line, and composition. You'll need access to a computer with a monitor that can display good levels of values and colors, as well as painting software and a pen input device. There are many options for painting software, including Corel Painter® and Adobe Photoshop®. Both are great programs backed by teams that continue to improve their stability, creative options, and ease of use. While painting with a mouse is possible and the results can be impressive, you won't get the most out of your painting software without a pen input device, which allows you to use an electronic pen as you would a pencil or brush.

COLOR BASICS

Color theory is an extremely broad topic, so I'll just touch on the absolute basics. The primary colors are red, yellow, and blue; all other colors are derived from these. A combination of primary colors results in a secondary color, such as purple, green, or orange; and a combination of a primary and a secondary color results in a tertiary color (like red-orange or yellow-green). Pairing complements such as red and green results in a striking contrast that can add excitement to a painting. However, when mixed, complementary colors "gray" each other, resulting in a neutral color such as gray or brown. Colors are also considered either cool or warm, which helps express mood. Warm colors—reds, oranges, and yellows—are associated with passion, energy, and anger; whereas cool colors—blues, greens, and purples—evoke a sense of peacefulness and melancholy.

The Elements of Drawing

Drawing consists of three elements: line, shape, and form. The shape of an object can be described with simple one-dimensional line. The three-dimensional version of the shape is known as the object's "form." In pencil drawing, variations in *value* (the relative lightness or darkness of black or a color) describe form, giving an object the illusion of depth. In pencil drawing, values range from black (the darkest value) through different shades of gray to white (the lightest value). To make a two-dimensional object appear three-dimensional, you must pay attention to the values of the highlights and shadows. When shading a subject, you must always consider the light source, as this is what determines where your highlights and shadows will be.

MOVING FROM SHAPE TO FORM

The first step when creating an object is to establish a line drawing to delineate the flat area that the object takes up. This is known as the "shape" of the object. The four basic shapes—the rectangle, circle, triangle, and square—can appear to be three-dimensional by adding a few carefully placed lines that suggest additional planes. By adding ellipses to the rectangle, circle, and triangle, you've given the shapes dimension and have begun to produce a form within space. Now the shapes are a cylinder, sphere, and cone. Add a second square above and to the side of the first square, connect them with parallel lines, and you have a cube.

ADDING VALUE TO CREATE FORM

A shape can be further defined by showing how light hits the object to create highlights and shadows. First note from which direction the source of light is coming. (In these examples, the light source is beaming from the upper right.) Then add the shadows accordingly, as shown in the examples below. The *core shadow* is the darkest area on the object and is opposite the light source. The *cast shadow* is what is thrown onto a nearby surface by the object. The *highlight* is the lightest area on the object, where the reflection of light is strongest. *Reflected light*, often overlooked by beginners, is surrounding light that is reflected into the shadowed area of an object.

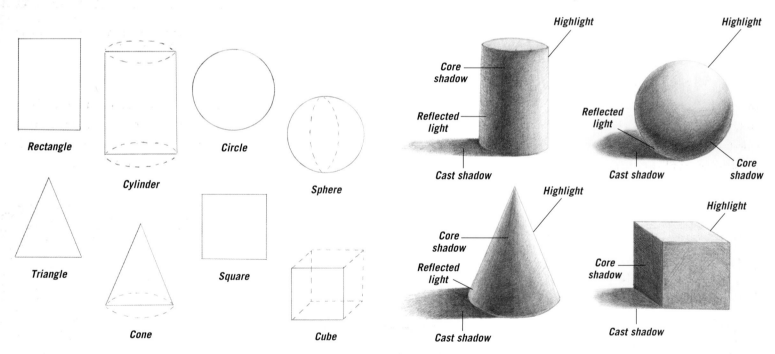

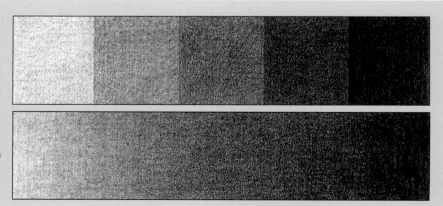

CREATING VALUE SCALES

Just as a musician uses a musical scale to measure a range of notes, an artist uses a value scale to measure changes in value. You can refer to a value scale so you'll always know how dark to make your dark values and how light to make your highlights. The scale also serves as a guide for transitioning from lighter to darker shades. Making your own value scale will help familiarize you with the different variations in value. Work from light to dark, adding more and more tone for successively darker values (as shown at upper right). Then create a blended value scale (shown at lower right). Use a blending tool to smudge and blend each value into its neighboring value from light to dark to create a gradation.

Basic Pencil Techniques

You can create an incredible variety of effects with a pencil. By using various hand positions and shading techniques, you can produce a world of different strok shapes, lengths, widths, and weights. If you vary the way you hold the pencil, the mark the pencil makes changes. It's just as important to notice your pencil point. The shape of the tip is every bit as essential as the type of lead in the pencil. Experiment with different hand positions and techniques to see what your pencil can do!

GRIPPING THE PENCIL

Many artists use two main hand positions for drawing. The writing position is good for very detailed work that requires fine hand control. The underhand position allows for a freer stroke with more arm movement—the motion is almost like painting. (See the captions below for more information on using both hand positions.)

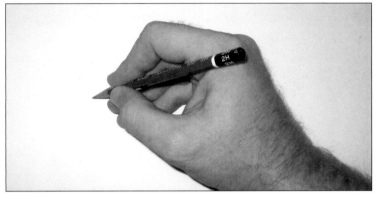

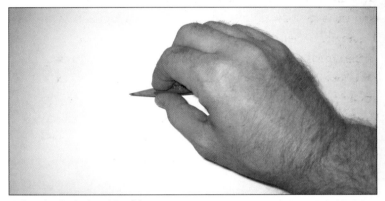

Using the Writing Position This familiar position provides the most control. The accurate, precise lines that result are perfect for rendering fine details and accents. When your hand is in this position, place a clean sheet of paper under your hand to prevent smudging.

Using the Underhand Position Pick up the pencil with your hand over it, holding the pencil between the thumb and index finger; the remaining fingers can rest alongside the pencil. You can create beautiful shading effects from this position.

PRACTICING BASIC TECHNIQUES

By studying the basic pencil techniques below, you can learn to render everything from the rough, wrinkled skin of a monster to the soft, smooth hair of a tower-bound maiden. Whatever techniques you use, though, remember to shade evenly. Shading in a mechanical, side-to-side direction, with each stroke ending below the last, can create unwanted bands of tone throughout the shaded area. Instead, try shading evenly in a back-and-forth motion over the same area, varying the spot where the pencil point changes direction.

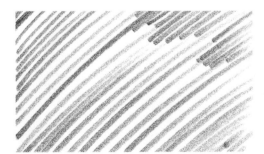

Hatching This basic method of shading involves filling an area with a series of parallel strokes. The closer the strokes, the darker the tone will be.

Crosshatching For darker shading, place layers of parallel strokes on top of one another at varying angles. Again, make darker values by placing the strokes closer together.

Gradating To create gradated values (from dark to light), apply heavy pressure with the side of your pencil, gradually lightening the pressure as you stroke.

Shading Darkly By applying heavy pressure to the pencil, you can create dark, linear areas of shading.

Shading with Texture For a mottled texture, use the side of the pencil tip to apply small, uneven strokes.

Blending To smooth out the transitions between strokes, gently rub the lines with a blending tool or tissue.

Creating Textures

Textures are not entities that exist on their own; they are attached to a form and are subject to the same basic rules as all other forms. A texture should be rendered by the way it is affected by the light source and should be used to build the form on which it lies. Texture shouldn't be confused with pattern, which is the tone or coloration of the material. Blindly filling an area with texture will not improve a drawing, but using the texture to build a shadow area will give the larger shape its proper weight and form in space. You should think of texture as a series of forms (or lack thereof) on a surface. Here are some examples to help you.

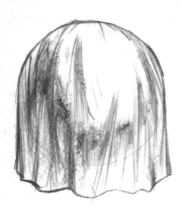

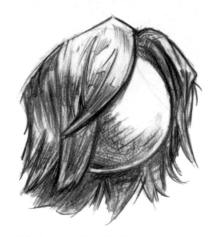

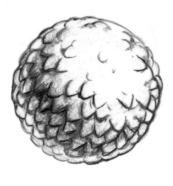

Cloth The texture of cloth will depend on the thickness and stiffness of the material. Thinner materials will have more wrinkles that bunch and conform to shapes more perfectly. As wrinkles move around a form and away from the picture plane, they compress and become more dense (which is an example of foreshortening; see page 11).

Long Hair Long hair, like cloth, has a direction and a flow to its texture. Its patterns depend on the weight of the strands and stress points. Long hair gathers into smaller forms—simply treat each form as it own sub-form that is part of the larger form. Remember that each form will be affected by the same global light source.

Scales Drawn as a series of interlocking stacked plates, scales will become more compressed as they follow forms that recede from the picture plane. I use a similar technique to create armor and chainmail.

Wood If left rough and not sanded down, wood is made up of swirling lines. There is a rhythm and direction to the pattern that you need to observe and then feel out in your drawings.

Short, Fine Hair Starting at the point closest to the viewer, the hairs point toward the picture plane and can be indicated as dots. Moving out and into shadowed areas, the marks become longer and more dense.

Metal Polished metal is a mirrored surface and reflects a distorted image of whatever is around it. Metal can range from slightly dull as shown here to incredibly sharp and mirror-like. The shapes reflected will be abstract with hard edges, and the reflected light will be very bright.

Feathers and Leaves As with short hair, stiff feathers or leaves are long and a bit thick. The forms closest to the viewer are compressed, and those farther away from the viewer are longer.

Curly Hair With curly hair, it's important to follow the pattern of highlights, core shadow, and reflected light (see page 8). Unruly and wild patterns will increase the impression of dreaded or tangled hair.

Rope The series of braided cords that make up rope create a pattern that compresses as it wraps around a surface and moves away from the picture plane.

Perspective Basics

Another important aspect in creating convincing drawings is the understanding of the basic principles of *perspective,* or the visual cues that help create the illusion of depth and distance in a drawing. Perspective can be broken down into two major types: linear and atmospheric. In linear perspective, objects appear smaller in scale as they recede from the picture plane. In atmospheric perspective, objects that are farther away have fewer details and appear bluer and cooler in color, whereas objects closer to the viewer are more detailed and warmer in color. With linear perspective, it's important to remember that the horizon line (an imaginary horizontal line where receding lines meet) can be the actual horizon or a line that falls at eye level. When working on any drawing, having an idea of the eye level of the viewer is important so you can apply perspective to the forms. When drawing figures, ellipses are especially useful in establishing and enforcing the direction and topography of forms.

FORESHORTENING

As with linear perspective, parts of the body that are closest to the viewer seem larger than those farthest away. To represent this in your drawings, you must use *foreshortening,* which pertains only to objects that are not parallel to the picture plane. Because of your viewing angle, you must shorten the lines on the sides of the nearest object to show that it recedes in the distance. For example: If you look at someone holding his arm straight down against the side of his body, the arm is vertical (and parallel to the picture plane), so it appears to be in proportion with the rest of the body. But if he raises his arm and points it directly at you, the arm is now angled (and no longer parallel to the picture plane) and appears disproportionate. (The hand looks bigger and the arm looks shorter.) Translate this shift in size relationship to your drawing, and you'll convey an accurate sense of foreshortening.

Incorrect

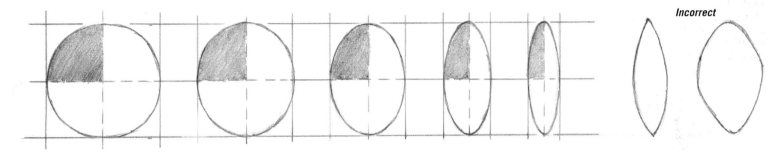

Drawing Ellipses An ellipse is merely a circle that has been foreshortened, as discussed above. It's important for artists to be able to correctly draw an ellipse, as it is one of the most basic shapes used in drawing. Try drawing a series of ellipses, as shown here. Start by drawing a perfect square; then bisect it with a horizontal line and a vertical line. Extend the horizontal lines created by the top and bottom of the square; also extend the center horizontal line to the far right. Create a series of rectangles that reduce in width along the horizontal line. Go back to the square and draw a curve from point to point in one of the quarters, as shown here. Repeat this same curve in the remaining quarters (turn the paper as you draw if it helps), and you will have created a perfect circle within the square. Repeat this process in each of the narrowing rectangles to produce a range of ellipses. Use this exercise whenever you have difficulty drawing a symmetrical ellipse or circle.

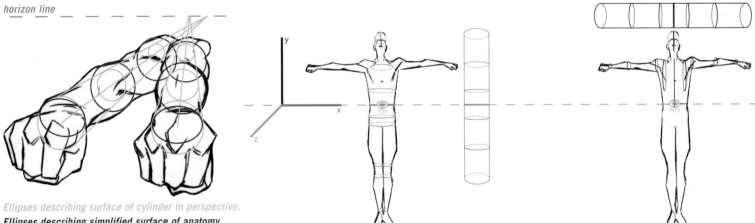

Ellipses describing surface of cylinder in perspective.
Ellipses describing simplified surface of anatomy.

Foreshortening As discussed above, when a limb or other extremity (like a finger) moves so that the center axis becomes perpendicular to the picture plane, the forms that make up the object appear to overlap and increase in size, meaning that they are foreshortened. Understanding the basic forms and the ellipses that describe the surface will help you understand and draw foreshortened forms.

Ellipses in Perspective The figure is basically a large cylinder. When the horizon line is at waist height, ellipses around the torso that are parallel to the ground appear as straight lines. Ellipses above this line appear as if we are looking up at them, and ellipses below the line appear as if we are looking down on them. The closer the viewer is to the object, the more dramatic this effect becomes. This is also true moving left and right of the point of view (labeled POV). The closer the ellipses move toward the center, the more they open up. Again, the closer the viewer is to the object, the more dramatic the effect.

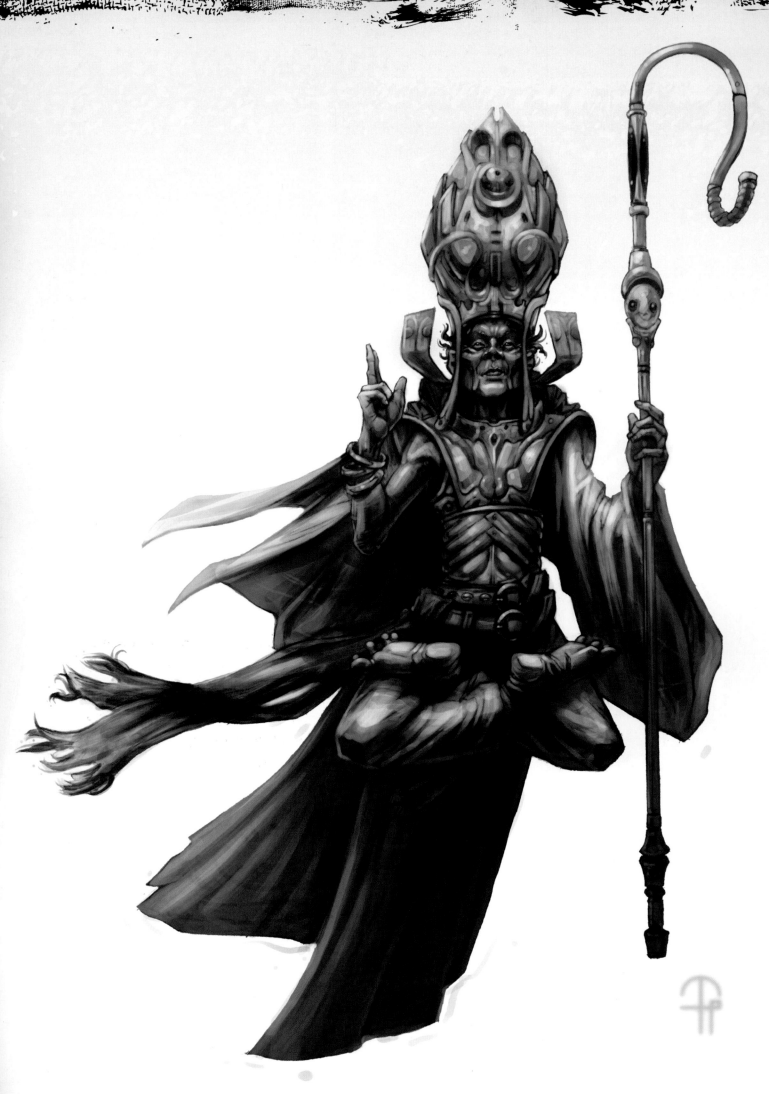

Science Fiction

Authors of the past have foreseen many of the inventions and social changes that are now a reality. We don't have flying cars yet, but space exploration, the atomic bomb, and robotics are all realities that were imagined in science fiction well before they were brought to us by engineers. Science fiction provides us with the ability to travel to possible futures so we can be inspired by the progress or learn from our mistakes before we make them. The rich tradition of these foreign worlds have created some iconic characters and props, which I will tackle in this chapter.

Gray Alien

This subject is a cultural icon; the challenge is to portray it in a way that isn't boring or cliché. Alien abductions have been actively chronicled since the 1960s, but accounts of interactions between humans and aliens go as far back as the 19th century. Some people believe we are part of a massive science project being conducted by these little gray men. The classic gray alien is often described with striking similarities by abductees and witnesses from all over the world. Whether this is due to mass hallucination or people conforming to popular images, the gray alien makes a great antagonist to any space hero.

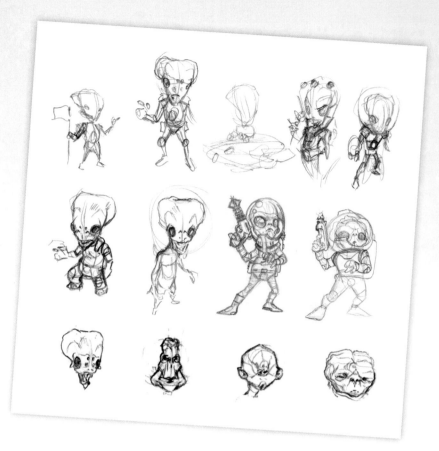

▶ **Concept Sketches** These small drawings help me warm up and keep me from falling into visual clichés. They also allow me to experiment with the character's attitude, costume, and props. Try fitting the heads into circles, squares, or even hearts and stars—the results will enhance your final drawing.

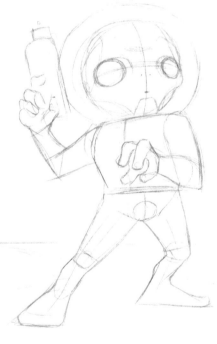

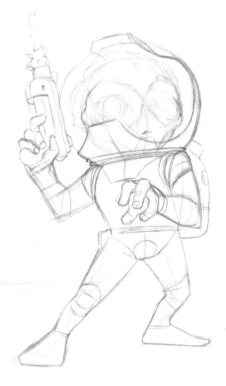

Step One When I start a drawing, I tend to hold my 2H pencil about 2.5" away from the tip to keep myself from getting too detailed and using dark lines too quickly. For the alien, I start with a few quick lines to establish the general shape and gesture of the figure. Then I refine the shapes, adding centerlines to the basic forms. I also place a horizon line, as it's important to know where the viewer's eye level is. I place this horizon line low on the page to make the diminutive character more imposing. Next I draw some ellipses around the brow line, waist, shoulders, and knees. To exaggerate the pose I make the alien's right shoulder a bit lower than his left. Next I add the fingers and the ray gun, being sure to "draw through" shapes to ensure that they make sense.

Step Two Now I start developing the alien's spacesuit. If I have strong ideas from my concept sketches I incorporate them, but in this case I mostly just draw shapes and make sure they follow the form of the alien's body. At this stage I'm still experimenting to see what I like.

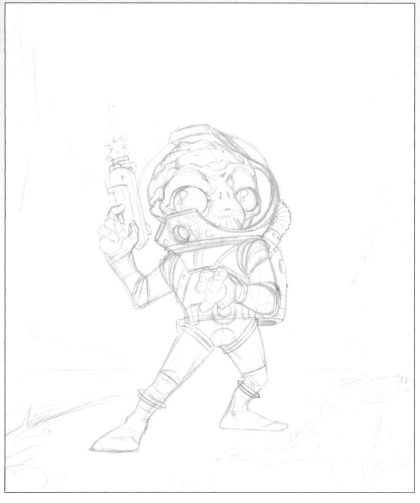

Step Three The alien's large head is a main feature of this drawing, so I start adding details and filling out the form. I create large, glassy eyes, developing the ocular cavities accordingly. I also experiment with some costume detail, such as rivets. Next I work on the alien's environment, as I want him to have some context. I imagine he's just landed at the edge of a forest in a lightly populated area, so I lightly sketch a tree stump, some grass, a tree line, and a large oval to represent the start of a flying saucer. The top of the stump is below the horizon line, so you can see a slightly open oval shape for the top plane. I make sure to draw the bark so that it wraps around the cylindrical shape of the stump.

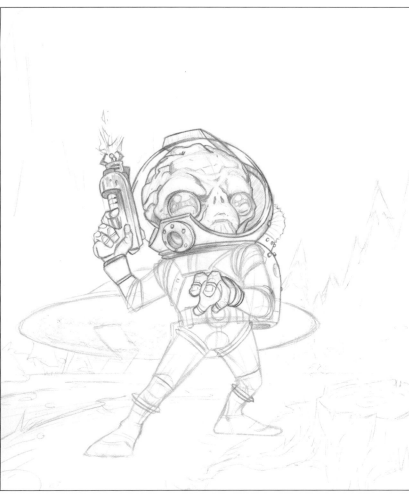

Step Four Now I switch to a 2B mechanical pencil to start filling in shadows and defining the rivets and folds in the cloth, erasing construction lines as I go. I decide to use the light from the ray gun and ambient moonlight as the two sources of light, with backlighting from the spaceship. I make sure to leave areas of white near the edges of some forms to suggest reflected light, which will help define forms in shadow and give a fuller feel to shapes. I also create lighter areas by lifting out graphite with a kneaded eraser.

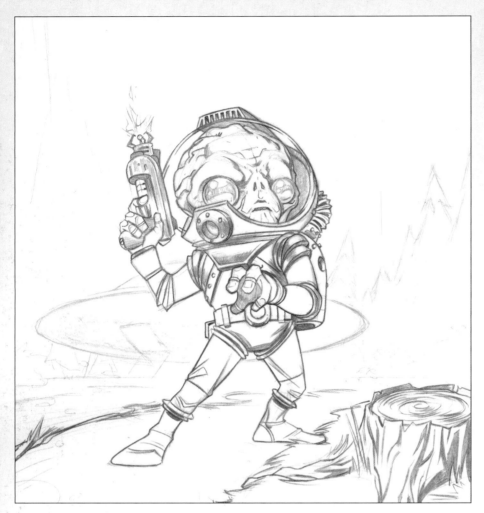

Step Five I continue to define the alien and his surroundings with the 2B pencil. When adding shadows to the background, I make sure to keep all light sources in mind. For instance, the ray gun is too far away from the background to cast any light on it. Instead, the light source in the background will come from the glowing open door.

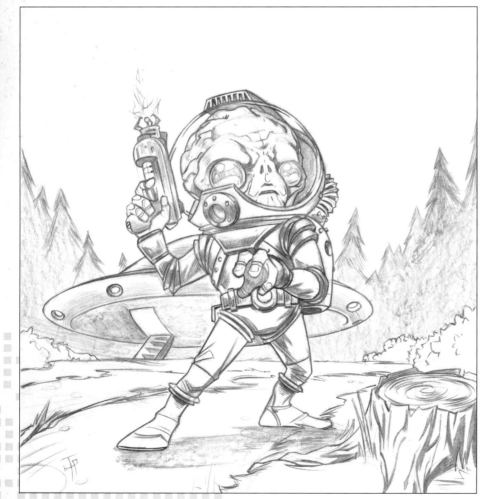

Step Six After darkening all of my lines with the 2B and developing the rest of the background (especially the spaceship and trees), I clean up my edges with a kneaded eraser. I also add details to the spaceship and create a cast shadow underneath the alien to ground him. I walk away from the drawing for a few minutes and come back to it with a fresh eye to see if I missed anything.

▶ **Colored Version** I use subdued colors to reflect a night scene. I start with a grayscale painting and add colors for the light sources and reflected light; in this case, the light sources are the moonlight (white), the ray gun (white), and the ship doors and lights (magenta). The alien's skin is gray (obviously), but I add tints of blue, purple, and green.

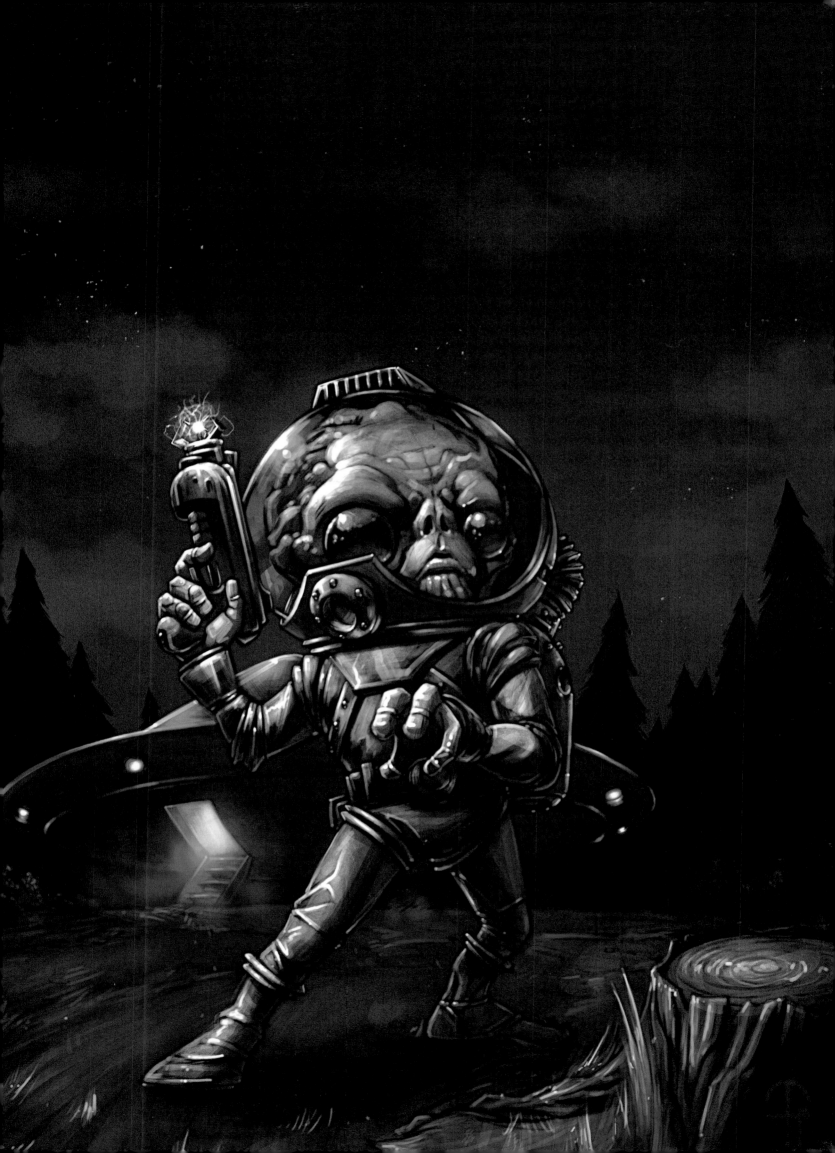

Ray Gun

Ray guns are descendents of today's firearms. The shape of the gun itself and the way it is used by a character can be very telling about his or her personality and the world he or she inhabits. Take a look at photos of real guns; you'll note that they all have some general characteristics in common, especially when it comes to the handle and trigger.

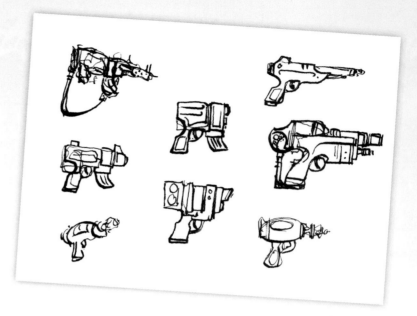

Concept Sketches It's easier to deal with guns in the design stage from a silhouette angle. Here I am just sketching out ideas and will probably end up taking bits and pieces from each as I draw the final. I've always felt the classic '50s-style gun looks too cartoonish and lacks an intimidating feel that a gun should have, so I'll probably steer away from that.

Step One With a 2H pencil, I lightly draw a grid to help me find the correct perspective (you may want to draw a grid and use a lightbox to place the grid over the drawing to check the perspective). For reproduction purposes, the lines are darker and a bit more exact here than the way I draw them. I lightly sketch the general shape of the gun, keeping in mind that it will need to fit in a human or humanlike hand.

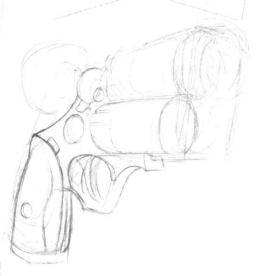

Step Two I refine the outline and pick out major forms to build upon as I figure out what this gun is going to look like. Developing the major forms will help me see how the silhouette will read.

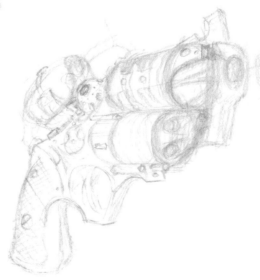

Step Three I darken my previous lines and use the flat edge of my pencil to lightly draw shapes and details that I think will look cool. At this point I'm experimenting and trying to figure out the functionality and character of the gun. I erase a few parts that I don't like and keep building shapes that feel right. I continue to reference the grid as I draw but keep everything loose. When I'm satisfied, I clean up the edges and forms with a hard plastic eraser.

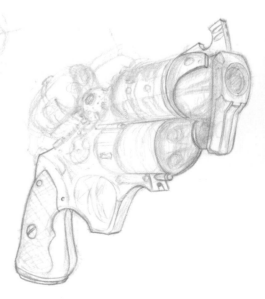

Step Four Now that I know what I want the final to look like, I use the 2H pencil to start darkening lines and developing the specific structures. I keep referring to the grid to ensure that my lines make sense. I also reference ellipses to make sure the perspective of circle is accurate.

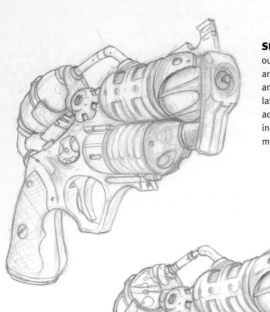

Step Five I finish the basic outlines and suggest some areas of shadow. I also erase anything that will get in the way later as I refine forms. Then I add a conducting-type form in the mouth of the muzzle to make the gun look more alien.

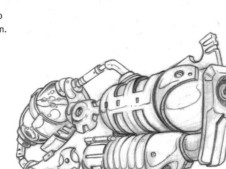

Step Six Now I switch to a darker 2B pencil and start laying in the final lines. Since I have the structure pretty well figured out, I can now concentrate on refining the forms and adding details.

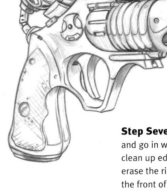

Step Seven I finish the drawing and go in with my plastic eraser to clean up edges and light planes. I erase the ribs I had added toward the front of the gun because the area was getting too busy and the ribs didn't seem to add anything to the look. I refine the edges of shadows but leave a lot of white space to reflect that the gun is metal.

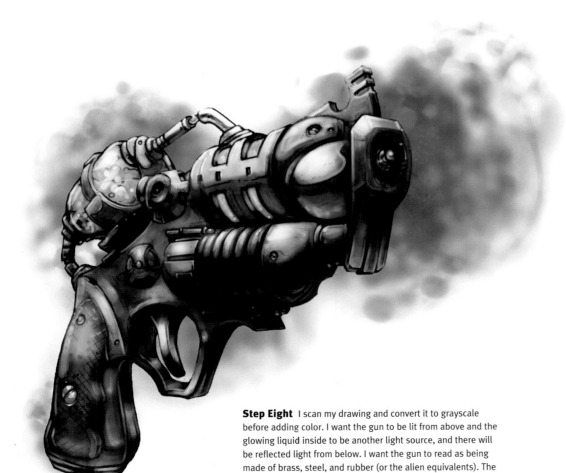

Step Eight I scan my drawing and convert it to grayscale before adding color. I want the gun to be lit from above and the glowing liquid inside to be another light source, and there will be reflected light from below. I want the gun to read as being made of brass, steel, and rubber (or the alien equivalents). The liquid plasma inside the gun is green and emits light, so I use that color throughout the gun and in the highlights.

Brain in a Jar

A brain in a jar is a standard evil/mad scientist prop. For some reason, brains stuck in jars eventually turn evil (more so if it's a Brain from Outer Space). But if you're a brain in a jar, do you really have anything better to do than to think evil thoughts? A brain that is detached from a body yet still able to think and perhaps (with mechanical or minion aid) act upon those thoughts is a danger to all.

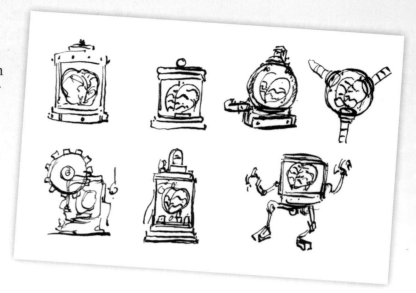

Concept Sketches This is a sci-fi subject so it needs to be dressed up with some technology. Be sure to reference photos or diagrams of brains so that the shape and texture will be recognizable.

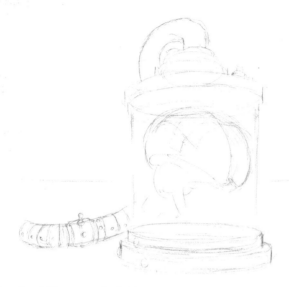

Step One With a 2H pencil, I lightly sketch the pose. I draw the horizon line and ellipses on the top of bottom of the jar; then I loosely sketch the general shape of the brain inside the jar. Next I tighten up the major structures of the jar. I could wait until later to do this, but I might find out that parts of the brain are sticking out or that the top and bottom of the jar don't line up, so I think it's better to refine the shape now. Then I add a tube coming out of the top of the jar for the technological element.

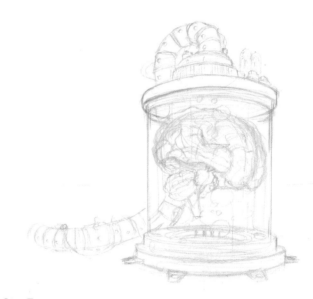

Step Two Now I use the side of my pencil to sketch some shapes and figure out what this is going to look like. I develop the brain further, making sure it looks like a brain.

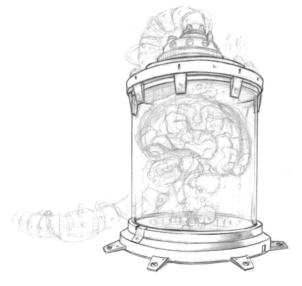

Step Three I continue adding details, mostly paying attention to the folds of the brain. Even if it looks like chaos, there's a rhythm to it. For the brain to look convincing, it's important to get the general idea of how the folds work. I also add details to the jar and draw some bubbles surrounding the brain. Because I'll be coloring this drawing, I leave the liquid and glass textures out of the drawing. There are also going to be several different light sources, so I leave a lot of white space. Next I switch to a 2B to finalize the lines, starting from the outside and working my way in.

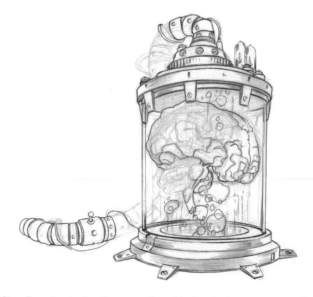

Step Four I go back to the 2H pencil to add a few shadows in the metal, and I switch to the 2B to darken the brain. I outline everything I can and start thinking about where to place shadows.

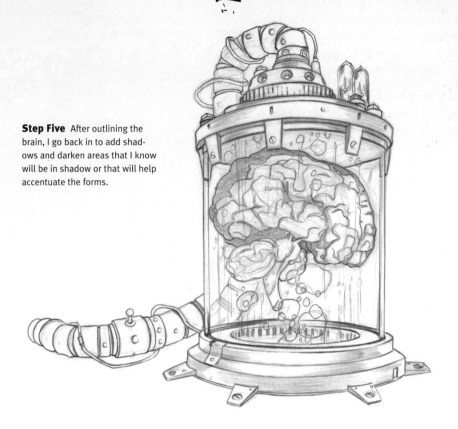

Step Five After outlining the brain, I go back in to add shadows and darken areas that I know will be in shadow or that will help accentuate the forms.

DID YOU KNOW?

The folds that make up the brain's surface are actually a sign of advanced intelligence. As a brain grows, its surface folds into itself, creating a wrinkled pattern. This expands the number of neurons in the brain without splitting the head open.

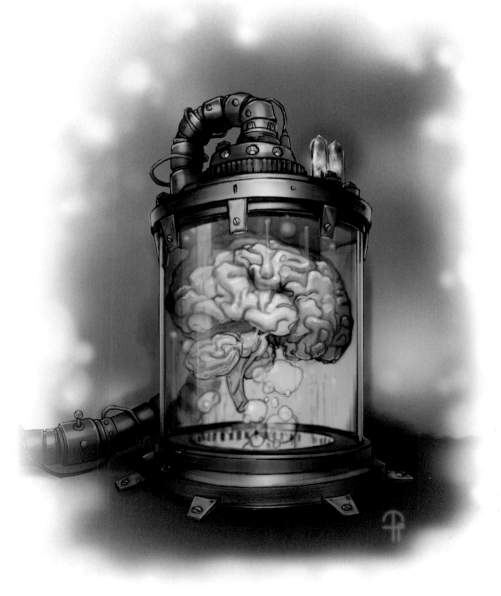

Step Six Starting off with a grayscale painting, I stay away from the traditional green glow and choose blue and salmon as my basic color palette. Outside the jar, the scene is lit from above; inside the jar, it's lit from below.

Android

The term "android" is broadly used to mean an artificial human created using silicon-based materials or bio-engineering. In fiction, an android often serves as a foil for the humanity of the other characters, explaining the human failings or emotions in the plot. The "human" look varies quite a bit among androids, but even the most robotic-looking ones are at least about the size of a human and have two legs, two arms, and a head.

Concept Sketches Generally robots are created to do work, and humanoid robots take the jobs that require a human face. I decide to put my android in the role of a food server. I think it's safe to assume that people will still be nostalgic for the '50s car culture, so I decide to go with a roller-skating drive-in diner waitress.

Step One I lightly sketch the pose with a 2H pencil, starting with the line of action. I aim for a skating pose even though I think I'll replace the skates with rocket shoes. I keep everything loose at this point.

Step Two I start developing the basic forms of a woman, since this android will be female. I move the arms and legs around a bit to see if I can find a better position. I also draw some loose lines under the legs for the smoke and flame trail, and I sketch the food tray.

Step Three I like the arm and leg positions so I further develop them. I also draw some shapes on the tray and start suggesting the hair and hands. I'm keeping most of my lines and erasing very little at this point.

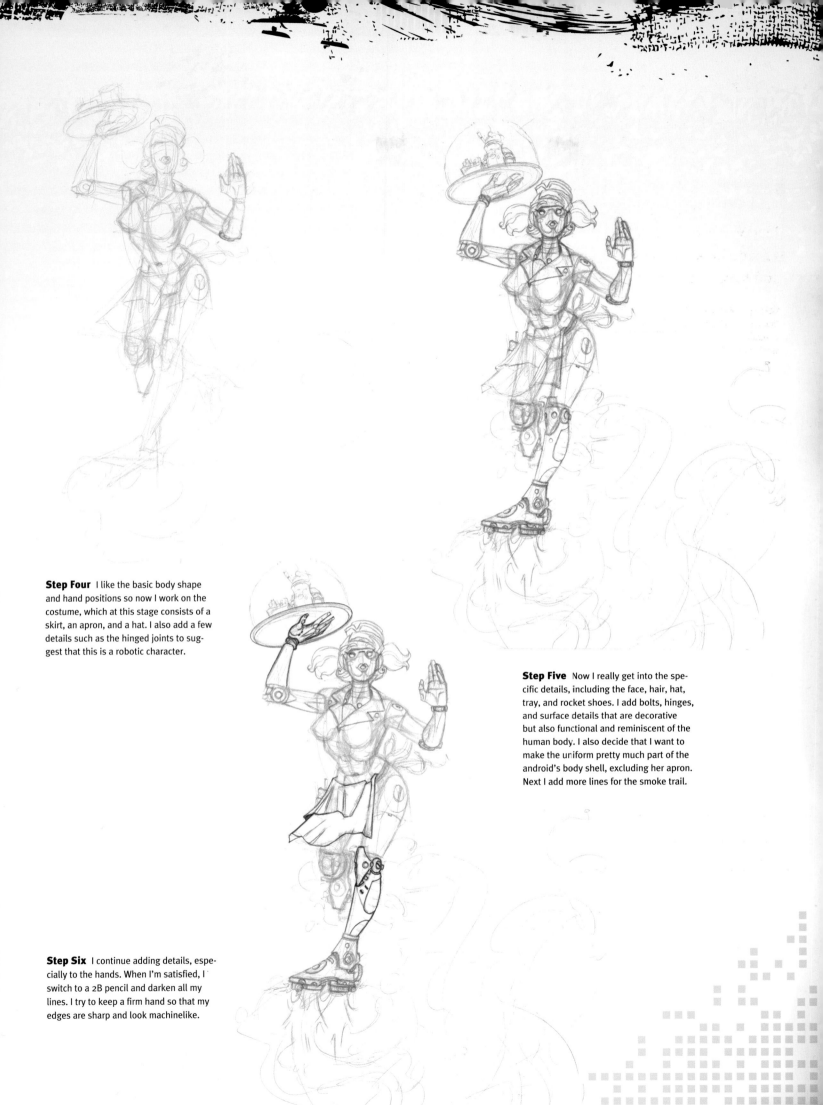

Step Four I like the basic body shape and hand positions so now I work on the costume, which at this stage consists of a skirt, an apron, and a hat. I also add a few details such as the hinged joints to suggest that this is a robotic character.

Step Five Now I really get into the specific details, including the face, hair, hat, tray, and rocket shoes. I add bolts, hinges, and surface details that are decorative but also functional and reminiscent of the human body. I also decide that I want to make the uniform pretty much part of the android's body shell, excluding her apron. Next I add more lines for the smoke trail.

Step Six I continue adding details, especially to the hands. When I'm satisfied, I switch to a 2B pencil and darken all my lines. I try to keep a firm hand so that my edges are sharp and look machinelike.

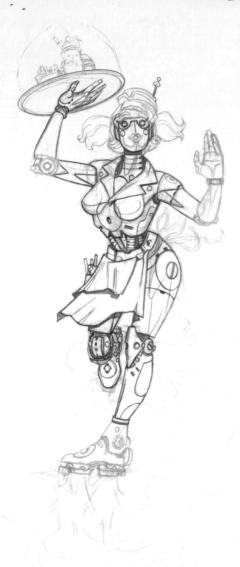

Step Seven As I continue creating the final lines and making the android look less and less human, I add contrast and define edges of forms. I also designate dark areas and shadows, but leave a lot of white space since the android is metal and I'll be adding a lot of reflections when I color the final drawing.

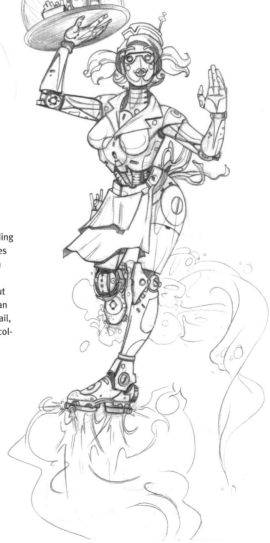

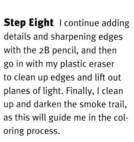

Step Eight I continue adding details and sharpening edges with the 2B pencil, and then go in with my plastic eraser to clean up edges and lift out planes of light. Finally, I clean up and darken the smoke trail, as this will guide me in the coloring process.

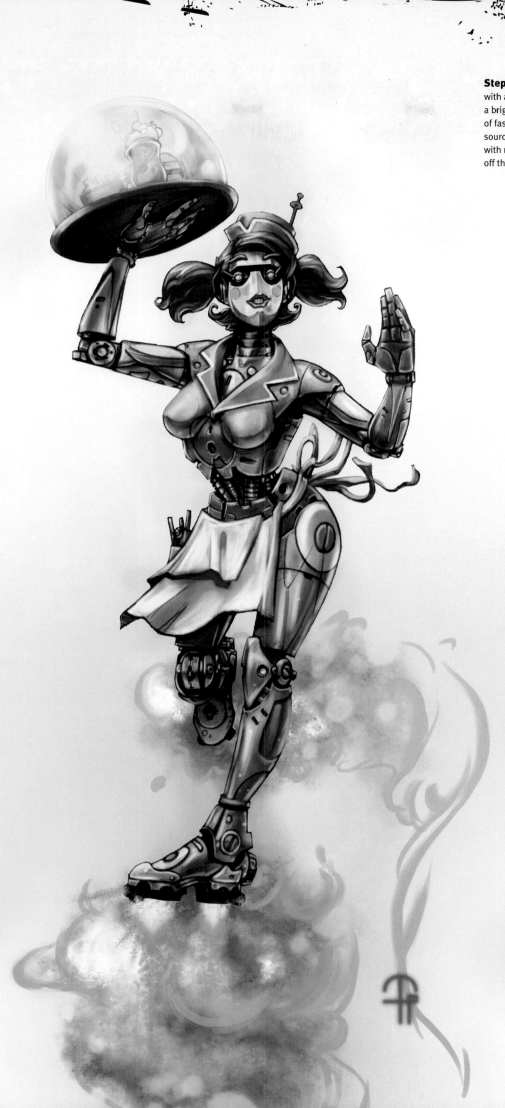

Alien Lord

No space odyssey is complete without some tyrannical alien lord to antagonize the hero. Just like political leaders here on earth, alien despots probably surround themselves with signs of royalty. Scepters, crowns, and official-looking robes help separate the alien leaders from the rest of the crowd, but an air of importance also helps.

Concept Sketches I look to pictures of leaders (past and present) to get ideas. I decide against perching the character on a throne, but I like several of the other ideas so I'll try to incorporate as many as possible into the final drawing.

Step One I use a 2H pencil to lightly sketch the pose. This leader needs to show strength and solidity, so I start with a very upright pose. I want the figure to read as a leader of men—or, rather, aliens.

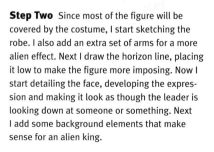

Step Two Since most of the figure will be covered by the costume, I start sketching the robe. I also add an extra set of arms for a more alien effect. Next I draw the horizon line, placing it low to make the figure more imposing. Now I start detailing the face, developing the expression and making it look as though the leader is looking down at someone or something. Next I add some background elements that make sense for an alien king.

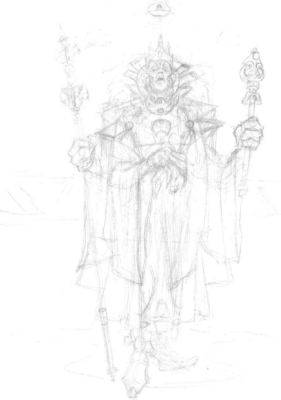

Step Three I continue developing the figure and costume, adding a scepter and a staff in the extra hands and some more detailed background elements. I also start developing the textures of the robes and props.

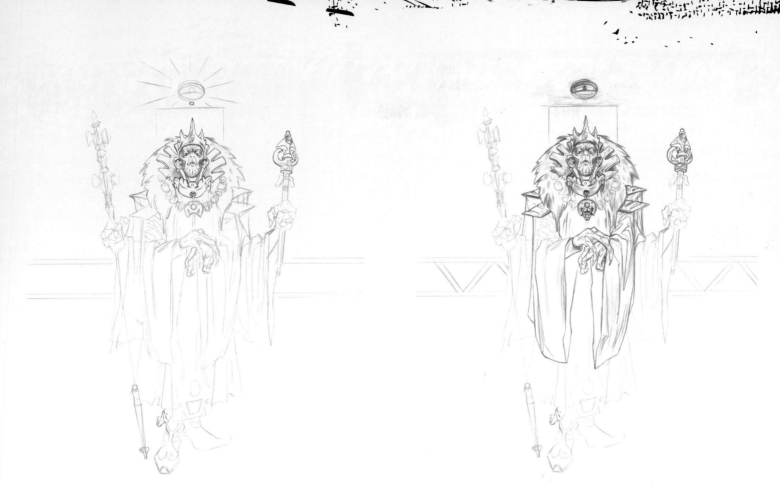

Step Four The page I'd been drawing on was getting messy, so I decide to transfer the main lines of my drawing to a clean piece of paper using a lightbox. On the new sheet of paper, I detail the face, adding wrinkles and making the cheeks look sunken in. Then I switch to a 2B pencil for the final lines and add shadows where they make sense.

Step Five I continue using the 2B to build up lines and add shadow to define forms, being careful to convey the correct textures, such as metal, fur, and cloth. I also continue to add details such as the ornate necklace, and I further develop the background elements.

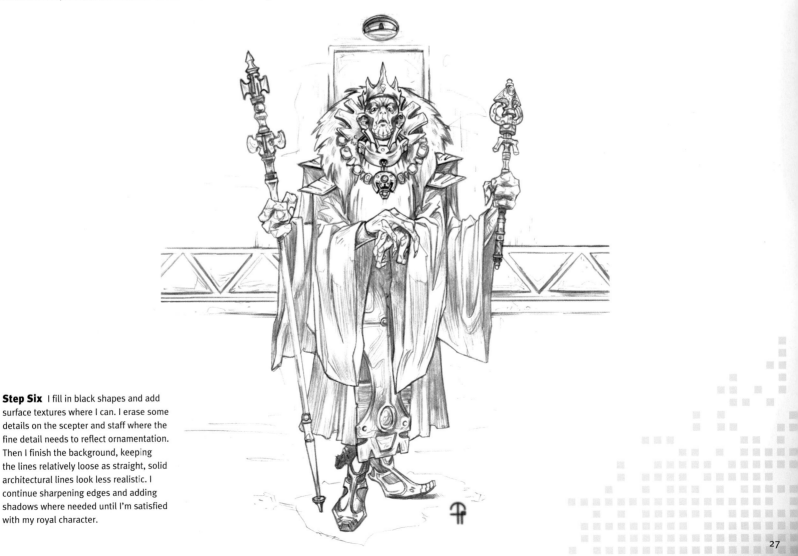

Step Six I fill in black shapes and add surface textures where I can. I erase some details on the scepter and staff where the fine detail needs to reflect ornamentation. Then I finish the background, keeping the lines relatively loose as straight, solid architectural lines look less realistic. I continue sharpening edges and adding shadows where needed until I'm satisfied with my royal character.

Space Hero

The word "hero" comes from the Greek word for demi god (*heros*, or half god). The term has come to apply to any character that commits to an action or thought that is beyond the average mortal, generally when facing obstacles that are supernatural or extraordinary. A space hero should depict these traits, sport some neat space gear to fit the role, and, of course, be in outer space. The space gear is broadly interpreted: from the classic bubble-headed space suit and cigar-shaped rocket to Arthur Dent's towel in *The Hitchhiker's Guide to the Galaxy*.

Step One I lightly gesture the pose with a 2H pencil, starting with the centerline and a few lines defining the silhouette of the figure, his gear, and some landscape.

Step Two Continuing to develop the figure with the 2H, I start noting major anatomical points and large parts of the costume such as the gun holster, helmet, and belt. The majority of my thinking here, however, is to see if the body makes sense in space before I start adding costume details.

Step Three I don't like the position of the arm on the left, so I move it down closer to his side and place the gun in the holster. I continue to develop ideas for the costume, note more anatomical points, and indicate the position of the facial features. I want a classic sci-fi feel, almost military, like old Buck Rogers comic strips. Next I lightly sketch a few background elements.

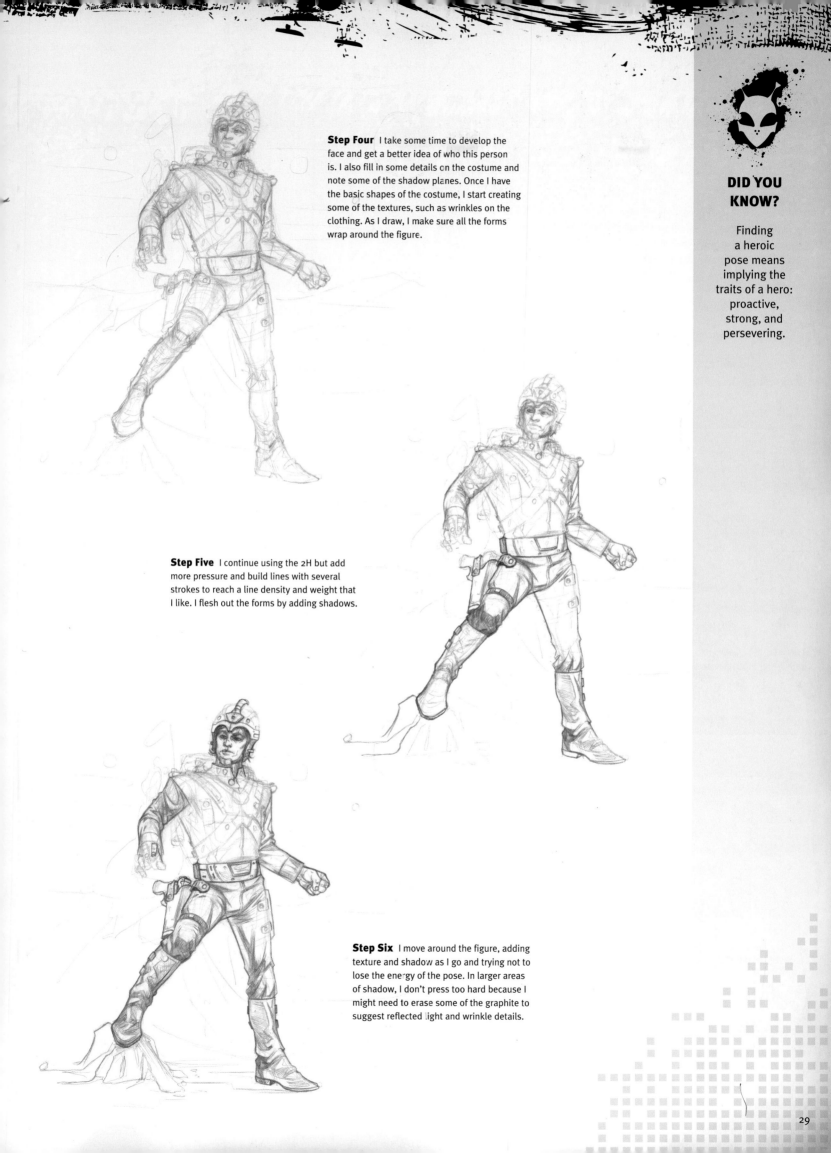

Step Four I take some time to develop the face and get a better idea of who this person is. I also fill in some details on the costume and note some of the shadow planes. Once I have the basic shapes of the costume, I start creating some of the textures, such as wrinkles on the clothing. As I draw, I make sure all the forms wrap around the figure.

Step Five I continue using the 2H but add more pressure and build lines with several strokes to reach a line density and weight that I like. I flesh out the forms by adding shadows.

Step Six I move around the figure, adding texture and shadow as I go and trying not to lose the energy of the pose. In larger areas of shadow, I don't press too hard because I might need to erase some of the graphite to suggest reflected light and wrinkle details.

DID YOU KNOW?

Finding a heroic pose means implying the traits of a hero: proactive, strong, and persevering.

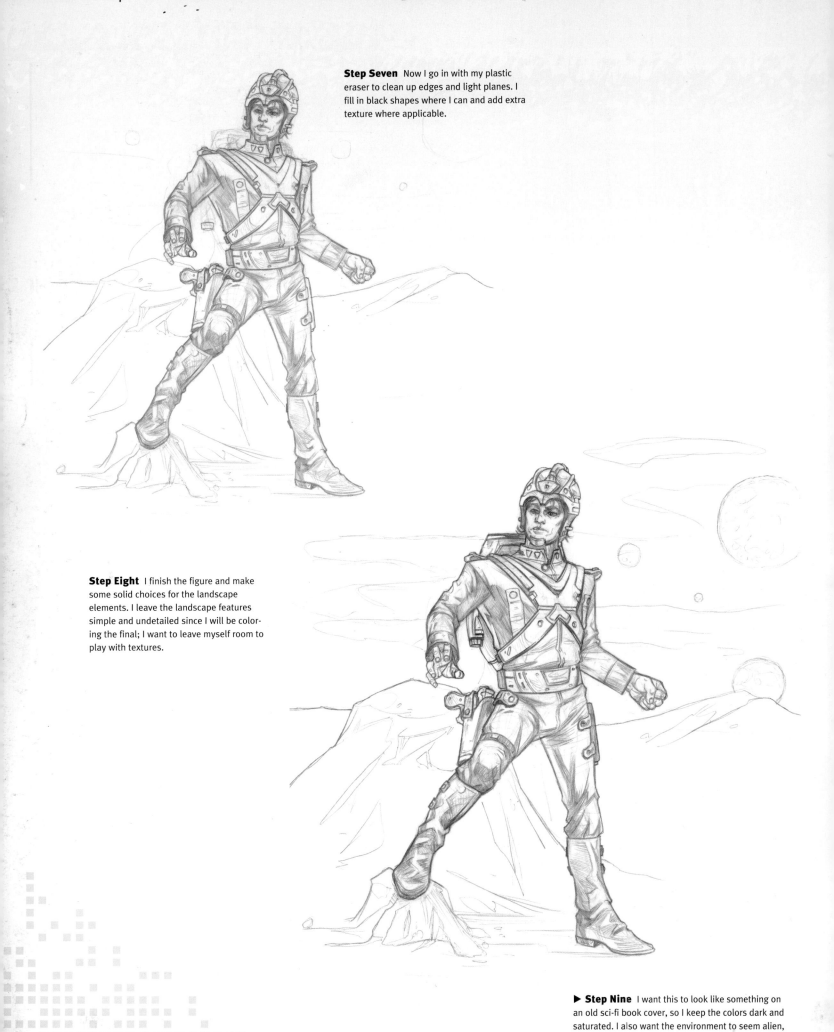

Step Seven Now I go in with my plastic eraser to clean up edges and light planes. I fill in black shapes where I can and add extra texture where applicable.

Step Eight I finish the figure and make some solid choices for the landscape elements. I leave the landscape features simple and undetailed since I will be coloring the final; I want to leave myself room to play with textures.

▶ **Step Nine** I want this to look like something on an old sci-fi book cover, so I keep the colors dark and saturated. I also want the environment to seem alien, so I use odd colors for the sky and shades of red reminiscent of Mars for the barren terrain.

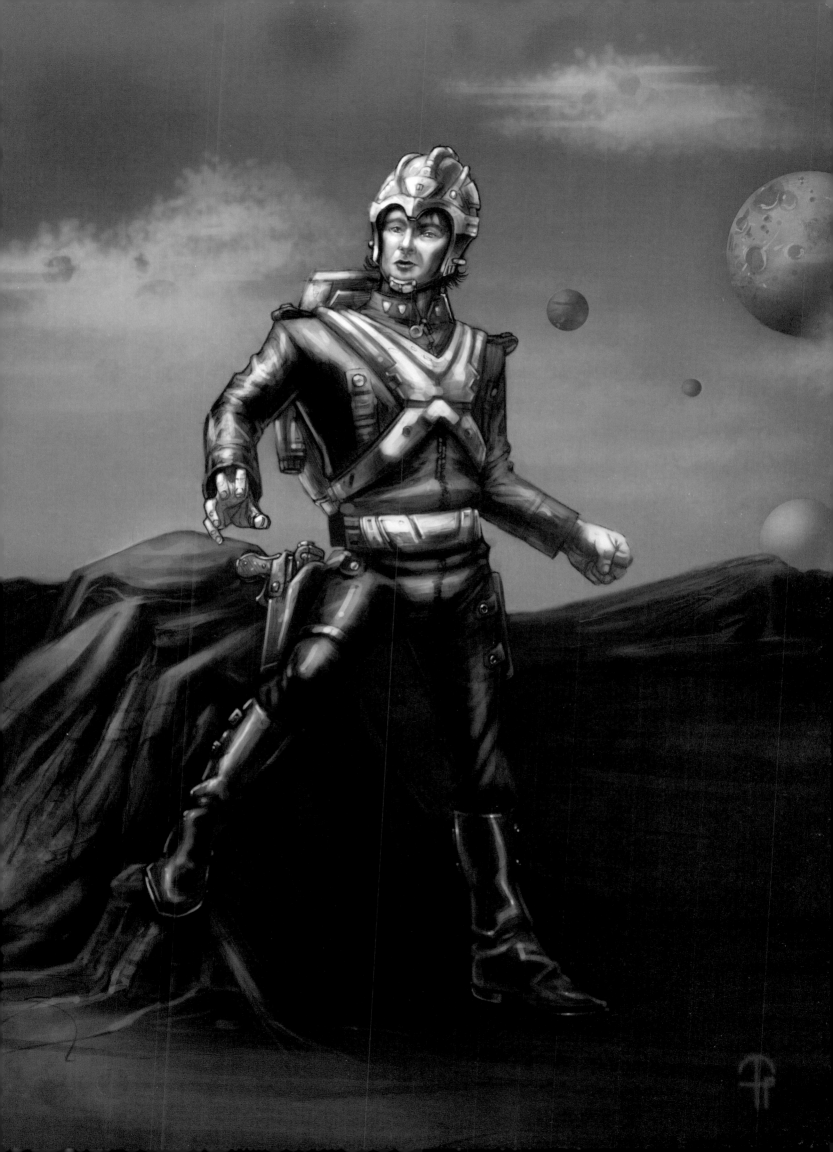

Alien Beast

Ride it, eat it, fight it: The alien beast can add a lot to an environment or to a character to help define his or her lifestyle or personality. Think of the TonTon in *The Empire Strikes Back* or the Tribbles from *Star Trek*. In this case, I am going for the kind of beast that one might encounter lurking about rather than a beast that is fought in the arena or ridden like a horse.

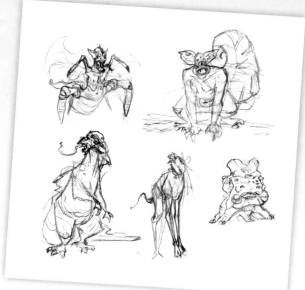

Concept Sketches Creature characters are especially fun—and since pretty much anything goes, I try a broad range of body shapes and appendage configurations. The key here is to make the creature structurally convincing but otherworldly.

Step One I lightly sketch the general pose of the beast. Here I'm getting an idea of the space on the page that the creature will eventually inhabit, as well as where its body and limbs are in relation to one another.

Step Two Still keeping my lines very light, I work out the large forms of the limbs, trunk, and tail. I also give some thought to features like the lashing tongue and fin along its back and head.

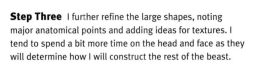

Step Three I further refine the large shapes, noting major anatomical points and adding ideas for textures. I tend to spend a bit more time on the head and face as they will determine how I will construct the rest of the beast.

Step Four Still using the 2H pencil, I sketch the muscles and bones that I think are going to show through the skin and fur. I also add lines to note the edges of forms.

Step Five Now I start laying in final lines by using more pressure, keeping in mind the forms and textures as I go. I decide that the traditional alien antennae are too normal so I change them into curling organic shapes. Then I begin adding form to the face by shading along the creases.

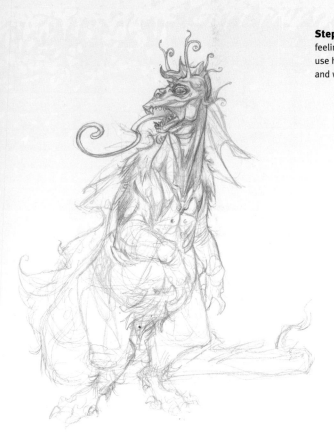

Step Seven Now that I have a good feeling for how this beast should look, I use heavier pressure to lay in the folds and wrinkles of the skin and shadows.

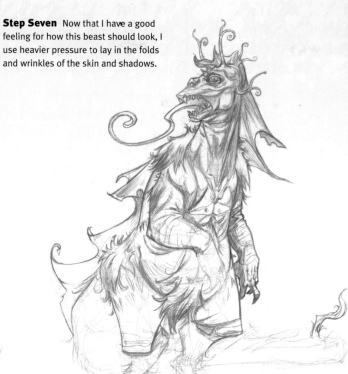

Step Six I like the way the fin and fur are looking so I lightly carry them through the rest of the creature. I also strengthen the forms in the head by erasing out some of the shadow I had built up around the eye and adding more specific details to the orbital socket.

Step Eight I finish the line work and go back through the drawing to add texture and shadows, and I erase as much as I can to clean up edges and light areas.

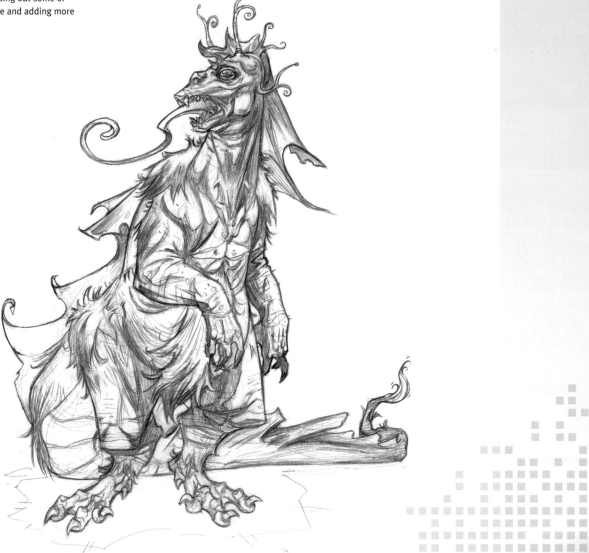

Cyborg

Half man, half machine: Cyborgs often serve to bring up the question of what physically makes us human. How much flesh can we replace with mechanical parts and still call the result human? Many times, cyborgs are depicted as physically superhuman but psychologically conflicted.

Concept Sketches I started out with a lot of the general buff, heroic poses and then stumbled on the idea of doing a older, less fit version of a cyborg. I like the contrast between perfect metal parts and the soft flesh of a retired military cyborg.

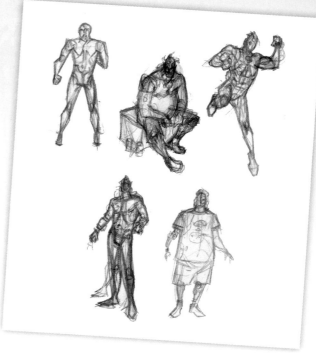

Step One I loosely sketch the figure in a seated pose and add the box he is sitting on. I'm getting the idea that he's on break from some job where his cybernetic parts are an advantage.

Step Two I flesh out the large forms, making sure his chest and stomach are round and full to show that he's out of shape. I also give his forward foot an unbalanced, relaxed tilt. Then I start noting major anatomical points and laying in some details that I might want to use later. I decide I want to give him a huge beard to contrast with the metal so I make the top of his head robotic looking but leave the jawline free to cover with hair.

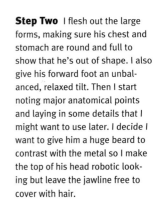

Step Three Now I really start getting into the details. I lightly describe the hair, costume, muscles, and mechanical parts while keeping in mind the personality I want to convey. The shadows start organically building up, so I erase out some light shapes if areas get too cluttered.

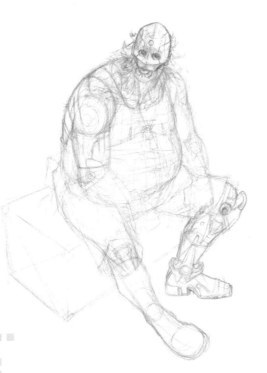

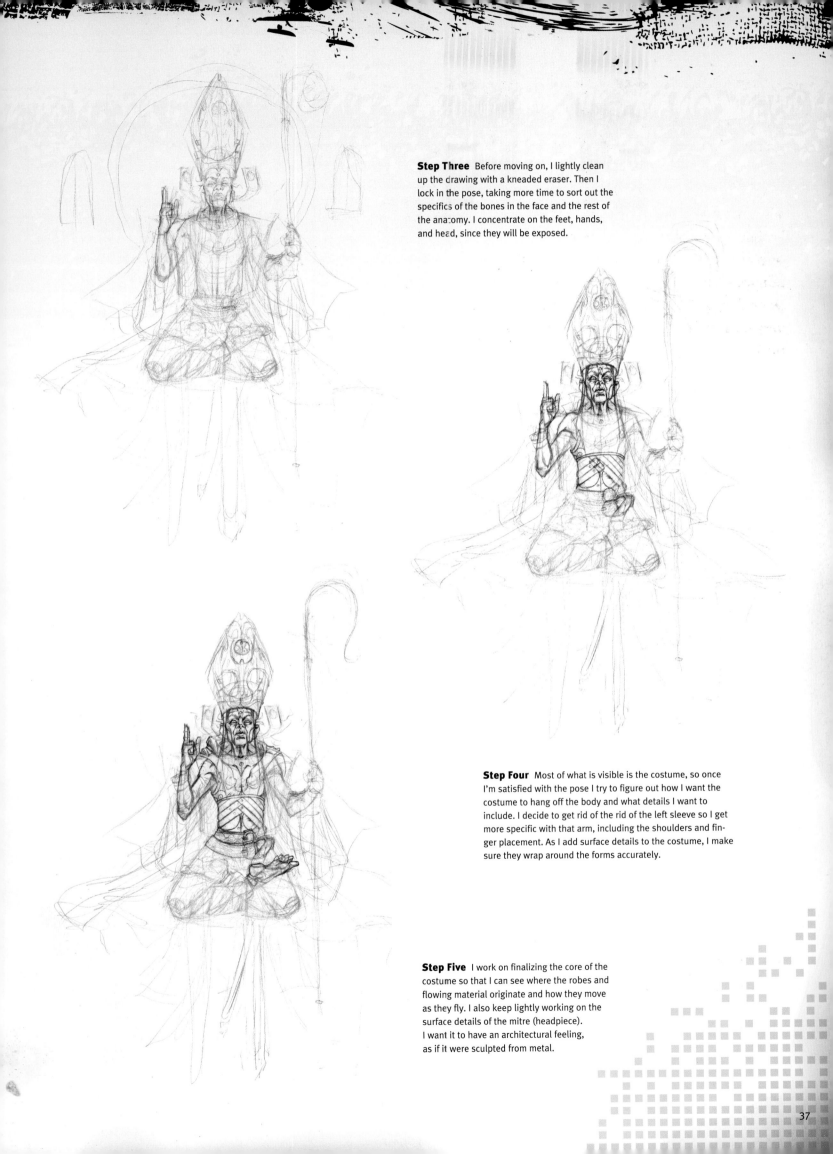

Step Three Before moving on, I lightly clean up the drawing with a kneaded eraser. Then I lock in the pose, taking more time to sort out the specifics of the bones in the face and the rest of the anatomy. I concentrate on the feet, hands, and head, since they will be exposed.

Step Four Most of what is visible is the costume, so once I'm satisfied with the pose I try to figure out how I want the costume to hang off the body and what details I want to include. I decide to get rid of the rid of the left sleeve so I get more specific with that arm, including the shoulders and finger placement. As I add surface details to the costume, I make sure they wrap around the forms accurately.

Step Five I work on finalizing the core of the costume so that I can see where the robes and flowing material originate and how they move as they fly. I also keep lightly working on the surface details of the mitre (headpiece). I want it to have an architectural feeling, as if it were sculpted from metal.

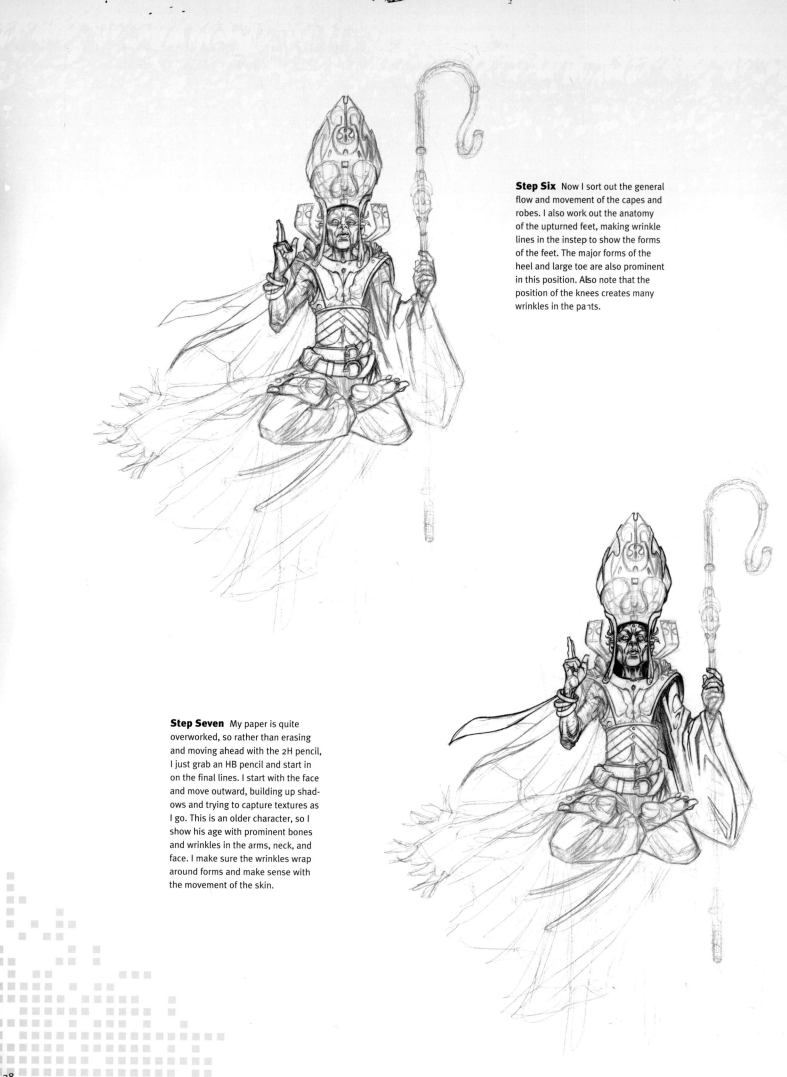

Step Six Now I sort out the general flow and movement of the capes and robes. I also work out the anatomy of the upturned feet, making wrinkle lines in the instep to show the forms of the feet. The major forms of the heel and large toe are also prominent in this position. Also note that the position of the knees creates many wrinkles in the pants.

Step Seven My paper is quite overworked, so rather than erasing and moving ahead with the 2H pencil, I just grab an HB pencil and start in on the final lines. I start with the face and move outward, building up shadows and trying to capture textures as I go. This is an older character, so I show his age with prominent bones and wrinkles in the arms, neck, and face. I make sure the wrinkles wrap around forms and make sense with the movement of the skin.

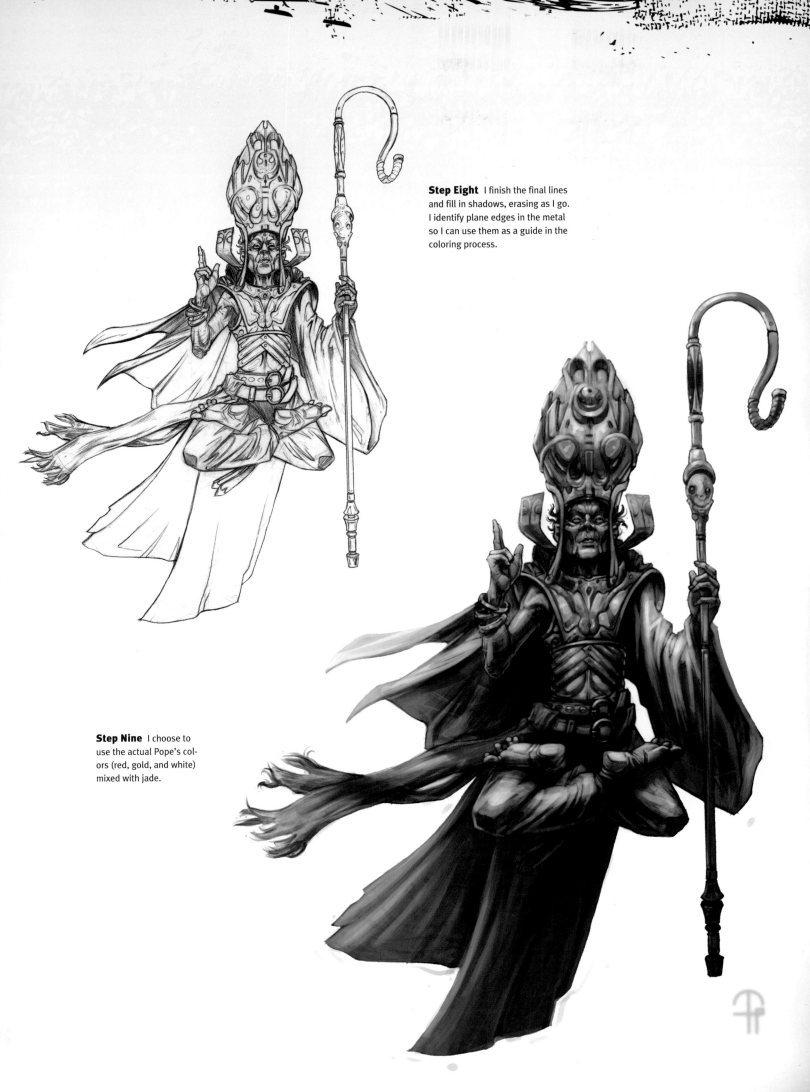

Step Eight I finish the final lines and fill in shadows, erasing as I go. I identify plane edges in the metal so I can use them as a guide in the coloring process.

Step Nine I choose to use the actual Pope's colors (red, gold, and white) mixed with jade.

Starfighter Pilot

Ever since the invention of the Flying Ace during World War I, people have been fascinated with these flying warriors. When extending this idea to future battles in space, we get the Starfighter Pilot. This character needs the ability to think quickly, to be tough in the face of extreme G-forces, and to have a bit of an addiction to adrenaline.

Concept Sketches I start out sketching males but create one female with a nice balance between looking tough and feminine, so I decide to go with her. I want to create a character who is mentally tough and a bit aggressive.

Step One I use a 2H pencil to lightly sketch the pose, using my concept sketch as a guide. I really like the way the body is positioned and the head is cocked. The line of action shows the hips pushing forward and the shoulders leaning back.

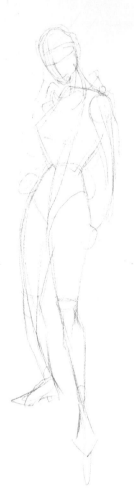

Step Two Now I use the basic cylinder, ellipse, and cube shapes for the forms of the body and the large costume elements. The placement of the arms and feet are very specific to the attitude I want to convey, and I make sure they are working here before I get too far along.

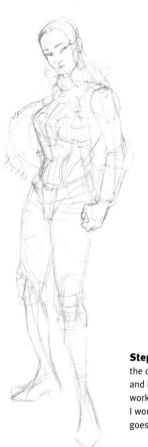

Step Three Still working lightly, I draw the costume around the core of the body and head, starting with larger shapes and working out to the arms and legs. Next I work up a facial expression that I think goes with the pose: tough and confident.

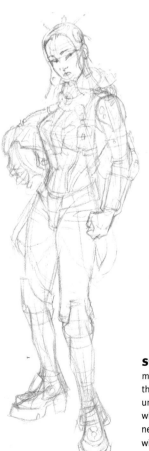

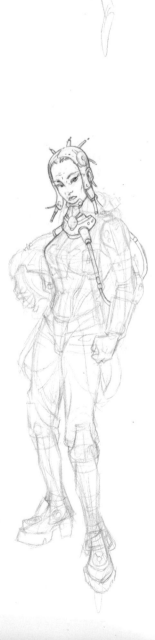

Step Four After I finish the core elements, I add details and the movement of the costume. Since the figure is wearing a uniform, I give the jacket more structure while retaining the female form underneath. I suggest a great deal of metal and wires and tubes that attach to the ship and monitor her vital signs.

Step Five Now I use the HB pencil to start laying in the final lines, beginning with the head. I mostly concentrate on outlining forms and defining planes and edges at this point. I will place shadows in later steps. A lot of the forms are overlapping so I need to "draw through" forms.

Step Six Switching to an HB pencil, I continue placing outlines and planes. The folds and wrinkles in the fabric are a great way to describe form. I make sure that the lines not only radiate from points of tension but also wrap around the form of the body.

Step Eight I use a cool, neutral palette to capture the look of a metal, utilitarian uniform. Notice, though, that the gray shifts from a tendency toward blue to a tendency toward violet where I want to create more depth and suggest reflected light from the environment.

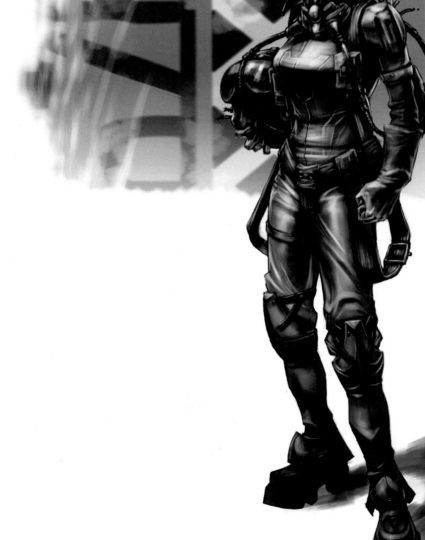

Step Seven At this point I start thickening lines and filling in black areas and shadow edges. I notice that the eyes look a bit too feminine (like she was wearing makeup), so I erase them out and create eyes with a harder look.

Robot Attack Pod

Small, agile, heavily armed, and expendable robotic sentries with full artificial intelligence are inevitable for future war and guard duty. As for design, functionality is key. The robot must be able to detect an enemy, so it needs some obvious detection devises like cameras and ocular-looking gear. It also must have some way of dispatching combatants and protecting itself, so it needs lots of armor and weapons. Finally, it needs to look intimidating. The best deterrent is to scare off the opposition before firing the first shot.

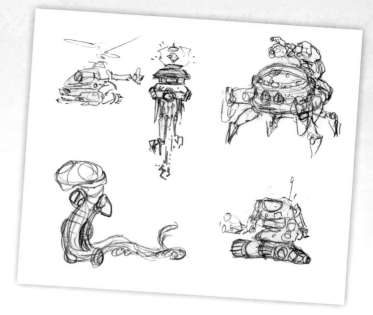

Concept Sketches The robot can take just about any shape, but at this stage the shape is mostly dictated by the method of locomotion. Flying, rolling, crawling, or slithering—all are valid depending on the terrain. As I don't have a particular terrain in mind, I choose the sketch I like best, which is the scorpion. It has the advantage of already looking scary.

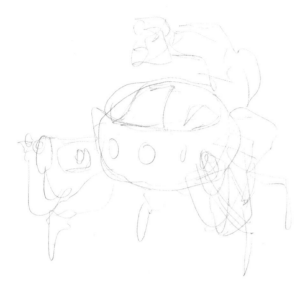

Step One Referring to my concept sketch, I use a 2H pencil to lightly gesture the shape and position of the main body and extremities.

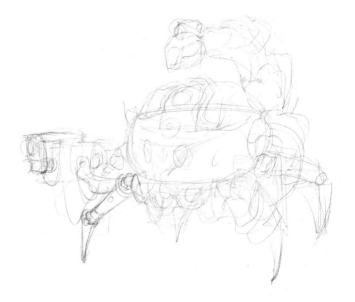

Step Two I start to draw the perspective of the fat cylinder that is the "body," as it will dictate the forms connected to it. I "draw through" the forms to be sure that the structures are sound and lay in other forms based on that "grid of structure."

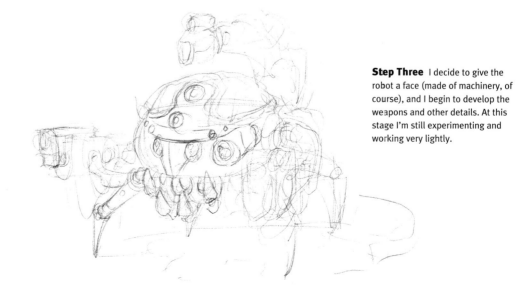

Step Three I decide to give the robot a face (made of machinery, of course), and I begin to develop the weapons and other details. At this stage I'm still experimenting and working very lightly.

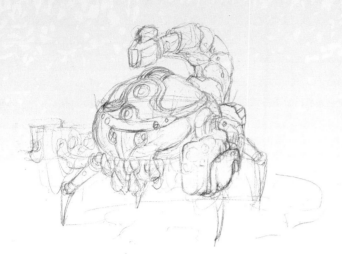

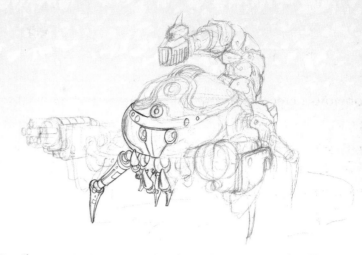

Step Four I erase a few ideas that aren't working and develop the rest a bit more. I like the idea of the thick, jointed tail but I don't like where I'm headed with the arms, so I take them out with the kneaded eraser.

Step Five I start developing the arm that's farthest from the viewer; I also add some shadow edges to the armor on the tail as well as some more structural detail to make it look more like a weapon. I'm still not sure about the arm closest to the viewer so I leave it alone for now and start to lay down final lines on the body.

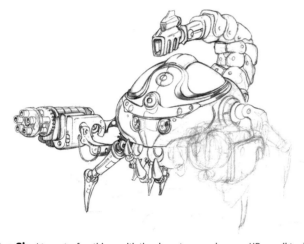

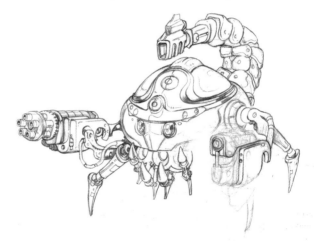

Step Six I try out a few things with the closest arm and use an HB pencil to develop the rest of the creature, making sure the forms have structure and adding blacks where I can to separate forms. The gun in the farthest arm has some strong cylindrical shapes, so I use ellipse templates to make sure the forms are precise. Once the major forms are in place, the rest of the shapes are simply drawn "on top" to reinforce the main form.

Step Seven I'm pretty much done so now I need to address the closest arm. I sketch a few ideas and finally settle on another gun. I also darken the rest of the lines and make the details a bit more heavy-duty.

Step Eight Now I use the HB to finish the details surrounding the closest arm, fill in dark areas, and add more thick and thin lines to solidify the forms.

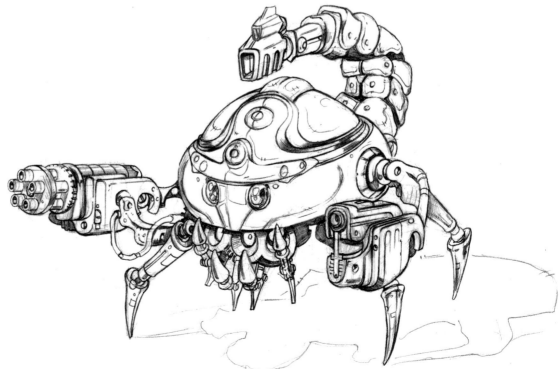

Alien Heroine

This is the female counterpart to the space hero. Generally it is preferred for a main character to be more humanoid and less monstrous, as he or she is supposed to be empathetic to audiences. What is called for is an attractive-looking human with some minor indication of alien origin like odd ridges on the face or green skin.

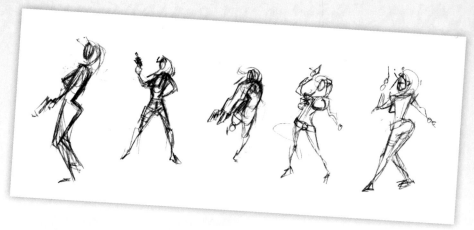

Concept Sketches I really want to get some action in this pose and I want to avoid the demure, pin-up look. I pick the profile angle because I like the tensed position.

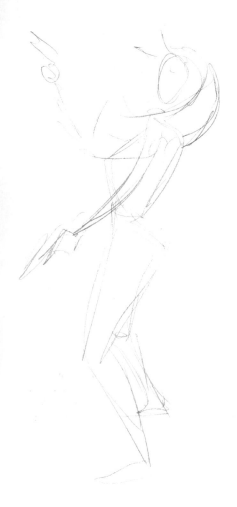

Step One I enlarge the concept sketch and trace it with the help of a lightbox, as I like the proportions and pose of my small sketch and don't want to lose it in translation. I think the back arm needs to come into play so I sketch it as being raised and holding another gun.

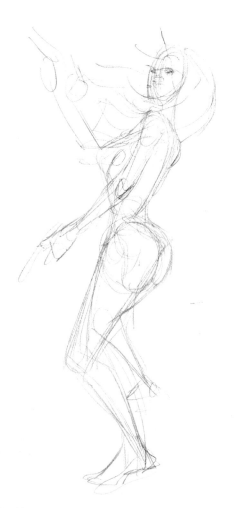

Step Two I'm going for a more extreme shot, at a low angle and tightly cropped. I need to add more space between the feet to really stress the action in the pose. I also place basic anatomical forms and sketch the hair.

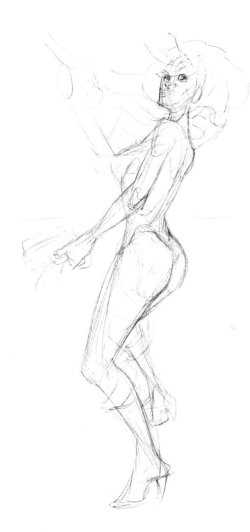

Step Three I know the suit is going to be form-fitting so I take a bit more time to get the forms working, and then I work on the facial expression. I want to get a better idea of the character before I move into the costume stage.

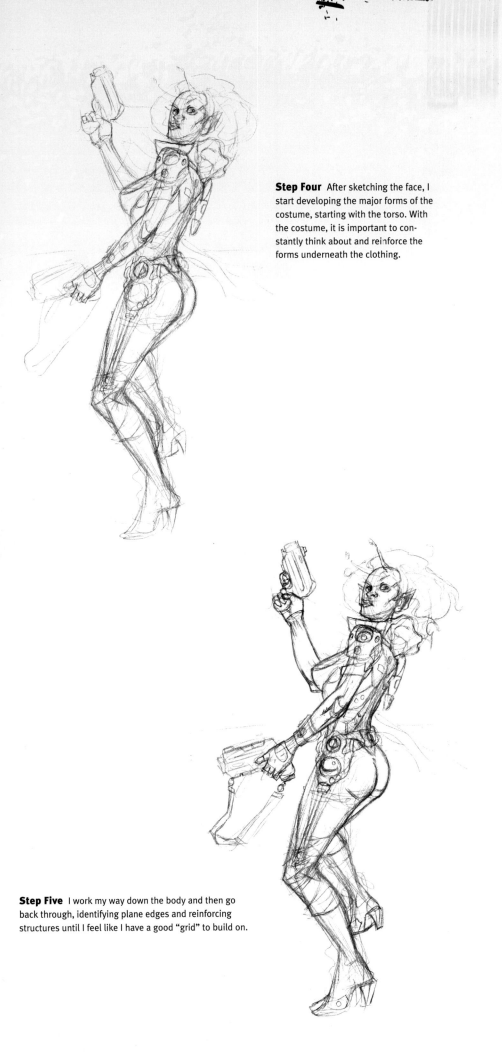

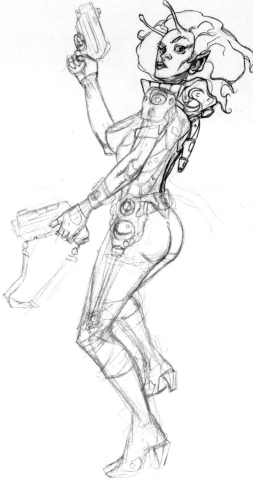

Step Four After sketching the face, I start developing the major forms of the costume, starting with the torso. With the costume, it is important to constantly think about and reinforce the forms underneath the clothing.

Step Six I like where the character is now, so I move forward with the final lines. Using 2H and HB pencils, I outline shapes, create texture, and fill in small areas of black. I erase as I go but don't get too rough in case I need to go back in and adjust.

Step Five I work my way down the body and then go back through, identifying plane edges and reinforcing structures until I feel like I have a good "grid" to build on.

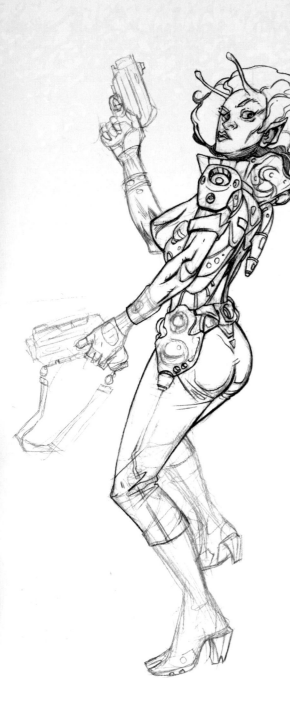

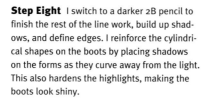

Step Seven Using the HB pencil, I move down the torso, developing the metal forms as they wrap around the shape of the rib cage. There is a nice deep shadow under her chin, so I fill it in to clarify the lighting and structure of the head. I place wrinkles in the pants where I want to stress weight or movement, and I make sure the wrinkles emphasize the shape underneath.

Step Eight I switch to a darker 2B pencil to finish the rest of the line work, build up shadows, and define edges. I reinforce the cylindrical shapes on the boots by placing shadows on the forms as they curve away from the light. This also hardens the highlights, making the boots look shiny.

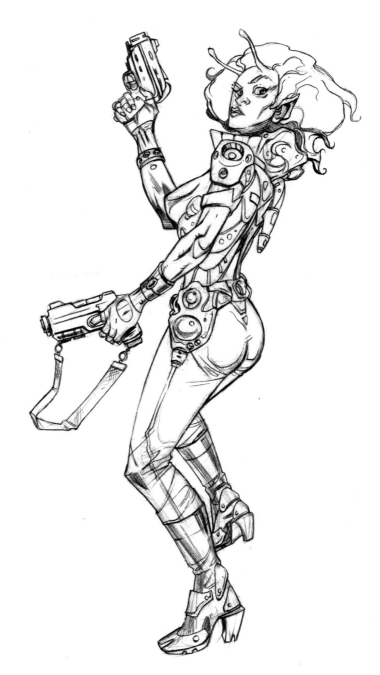

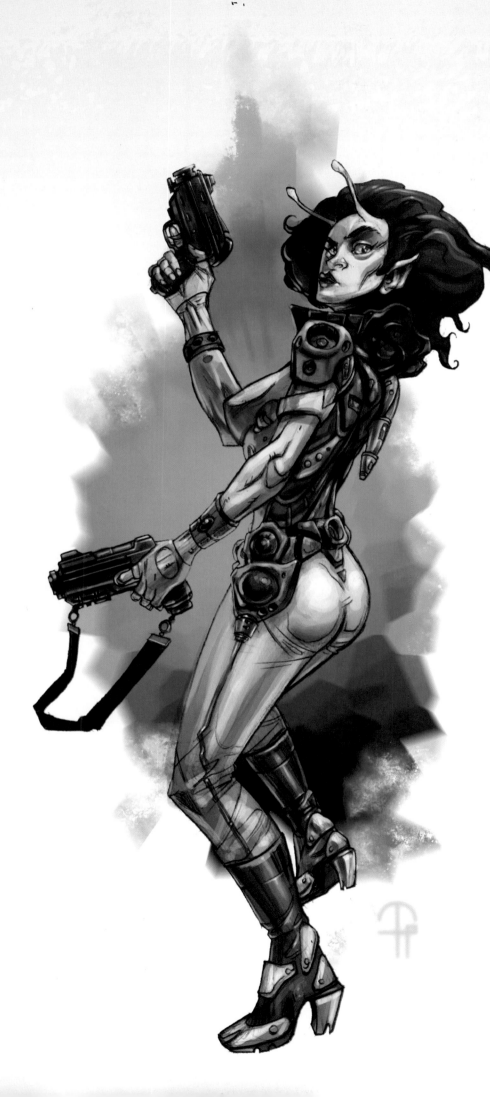

Step Nine I decide that the light source will be from above and to the right. I want to emphasize the alien and not the costume, so I keep her colors very saturated and full of contrast. The outfit stays pretty plain, except for a few bright details for interest.

Alien Trucker

In the mythology of road/space trips, the truck stop is seen as the equivalent of the watering hole in the Serengeti. All sorts of characters converge to refuel their ships and bodies. If you are on the run, you have to be careful because this little slice of civilization puts you back on the grid. Truckers are great sources of conflict and story movement. They travel extensively so they can bring information or have connections to just about anything in the universe. Beyond that, they make for great background characters to help develop the universe characters exist within.

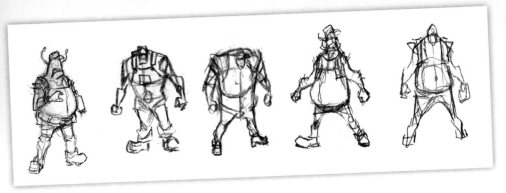

Concept Sketches I want a pose that indicates a bit of unwarranted bravado: intimidating verging on humorous.

Step One I use a 2H pencil to sketch the figure with a puffed-up chest. His enormous beer (or whatever equivalent they have on this planet) belly fights against gravity in this pose.

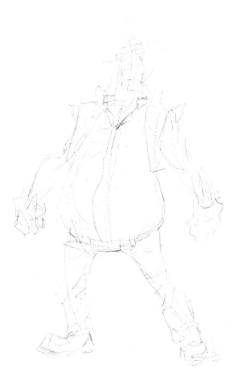

Step Two I define some of the major forms, using cylinders and cubes for his muscular but skinny arms and legs, and a large pear shape for the torso. I also place the hair, hat, eyes, and nose. I draw some of the costume, making sure the clothing wraps around the major forms. I use the centerline as a guide to lay in the edge where his jumpsuit comes together in the middle of his torso, but give it some personality to show the movement of stiff material.

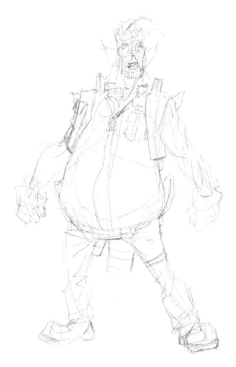

Step Three As I add details, I make sure they sit on the major forms and do not contradict the perspective or structure. I start with the torso and move out to the arms and down the legs.

Step Four I add more surface details and improve the shape and definition of the arm muscles. Then I add some extra details like the name patch and closures like buttons and zippers.

Step Five I switch off between the 2H and a 2B pencil to start my final lines, beginning with the head. I want the character to look dim and a bit scary; slack-jawed and moving with a bit of a swagger but not quite in fighting mode. I give the character a mullet haircut, as it seems fitting.

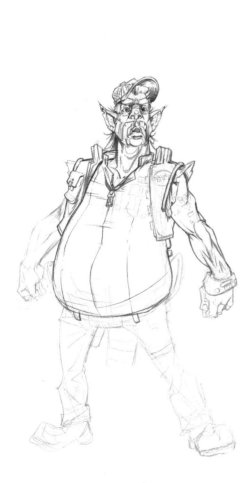

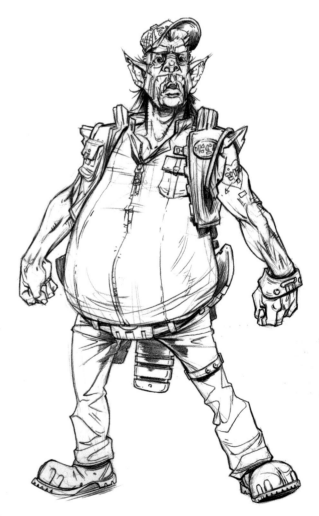

Step Six I use the 2B to build more lines and texture, filling in shadow areas as I go. I use the wrinkles in the fabric along the bottom of his belly to make the shirt seem really stretched out; I also make sure the belt and buckle disappear underneath the bulge of his stomach to heighten the effect.

Step Seven Still using the 2B pencil, I create my final lines and go back through the drawing, filling in black shapes and reinforcing lines to build form and texture.

Space Sword Mystic

In science fiction, secret societies or cults that draw on ancient traditions like the Bushido Code or Animist beliefs are common. Members of these groups usually perform supernatural feats, gain secret knowledge, or are just generally awesome with a sword. This are more possibilities in the realm of Sci-Fantasy since it is not strictly a science-based extrapolation but rather a fantasy story set in the future (and often in space). Calling upon some mystical device allows the character to credibly have superpowers. In this drawing, the character needs to exhibit some extreme supernatural power, an air of mystery, and some technology to indicate a futuristic setting.

▶ **Concept Sketches** Swords are fun compositionally since they are like great big pointing devices that move the eye around. I am drawn to the idea of having the sword in some inactive, downward-facing pose. A hood provides some built-in mystery by effectively masking his face.

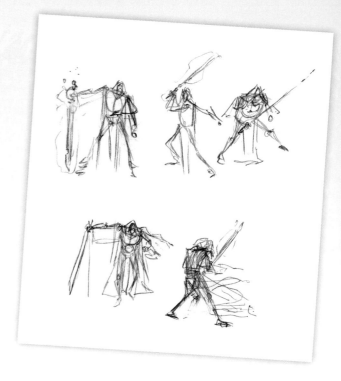

Step One I use a 2H to lightly sketch a pose based on the concept sketch. The robes are a major factor so I treat them as if they are a part of the body in this sketch. The forms are not exact and many of the lines are extraneous but may turn into something as I develop the costume.

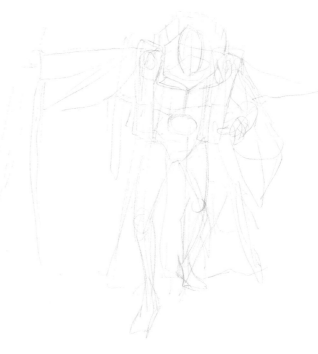

Step Two Most of the body will be covered by the robes but I still need to build up the underlying forms. I spend more time on the costume and how it fits over the body, though. To keep myself thinking about the body, I place a strong centerline down the chest and draw an ellipse indicating the abdomen and forward tilt of the torso.

Step Three I decide I don't like either of the leg positions, so I move them around and further develop the forms of the costume and anatomy that is showing. I scribble around a bit and experiment with some possible details for the costume, such as the feathers at the right shoulder.

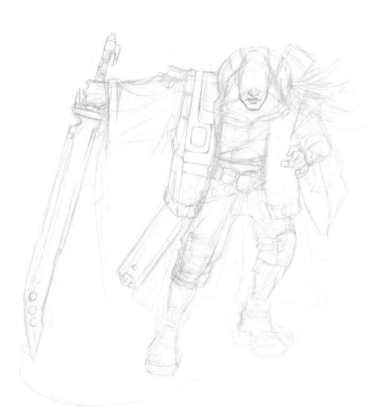

Step Four I feel more confident about the costume so I make some definitive lines with the 2H. I make sure to take some time to get a good expression on the visible part of the face and to define the shape of the head, as it will define the shape of the hood.

Step Five I'm not sure about some of the areas but I really like the vest, so while I wait for inspiration I start in on some final lines. I'm satisfied with the underlying structure so I use an HB pencil to lightly sketch ideas before I create the final lines. I feel my way through the folds in the shirt and the cord pattern, always thinking of the forms they are wrapping around.

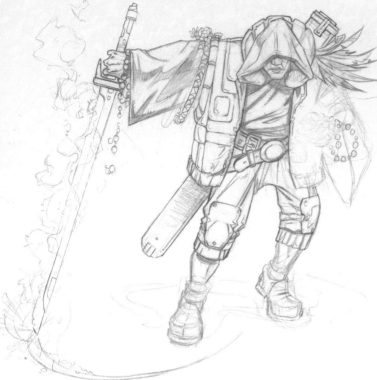

Step Six I feel that the sword is not elegant enough for the character, so I erase it and use an HB pencil to lightly draw a new one, complete with sparks and flames. Switching to the 2H, I create shadow planes on the outstretched sleeve and continue developing lines and shadows on the figure. I decide the hand on the right is not quite right, so I erase it for now.

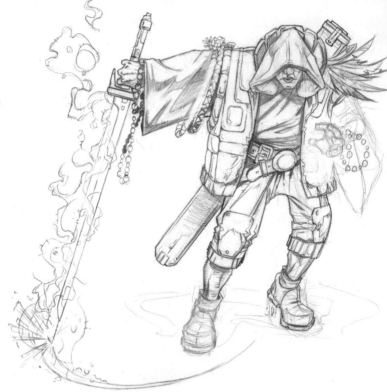

Step Seven While I wait to sort out the hand, I use a 2B to work on all the sections that seem right to me. I want some kind of energy coming off the sword as it scratches the ground, so I take time to draw cool effects that I can reference in the painting stage. As I darken lines and create shadows, I finally get a good feel for the hand and lightly sketch it in. I want some of the textures to be lighter to show that light is hitting them, so I erase some graphite (such as in the braided cords around his shoulder) and gradate the lines as they move into shadow.

Step Eight Still using the 2B, I finish the outlines and build up a few final shadows. Then I create the cast shadow on the ground to guide me in the coloring stage and show the direction of the main light source.

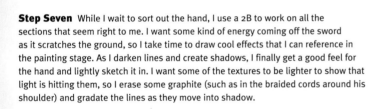

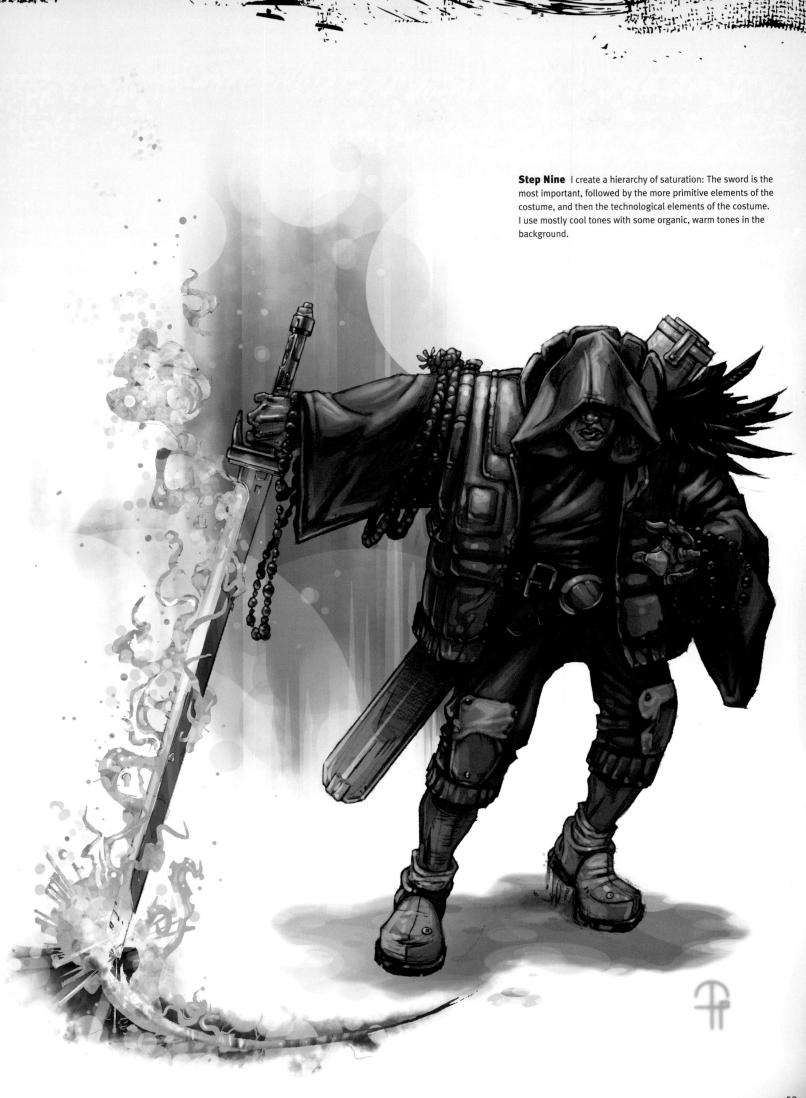

Step Nine I create a hierarchy of saturation: The sword is the most important, followed by the more primitive elements of the costume, and then the technological elements of the costume. I use mostly cool tones with some organic, warm tones in the background.

Sidekick

Every hero needs a sidekick, especially in space where you can travel for years without encountering civilization. The sidekick serves as a sounding board to reveal the inner workings of the hero's brain. I like drawing sidekicks because they can be just about anything, from a small robot dog to a huge reptilian humanoid. Since there is little chance we are going to need to be interested in the sidekick's love life, you can make the sidekick as ugly as you want.

Concept Sketches The shapes for this character are limitless, but I think I want to do something like the Hair Monster from Bugs Bunny but more thuggish.

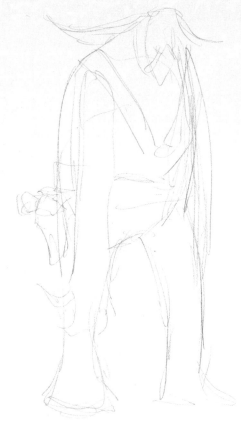

Step One I enlarge and trace the concept sketch I am most drawn to, since I like the proportions and pose.

Step Two With a 2H pencil, I translate the rough forms into actual shapes, indicating some of the anatomy and costume. The ellipses of the bandoleer indicate the perspective and further define the form of the torso.

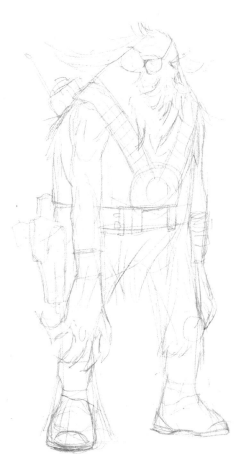

Step Three I have a good idea of where I am going with this character, so I jump right into the facial expression and add a few more costume details.

Step Four I add a few more details with the 2H and then switch to the HB for the final lines, feeling my way through the texture and around the forms.

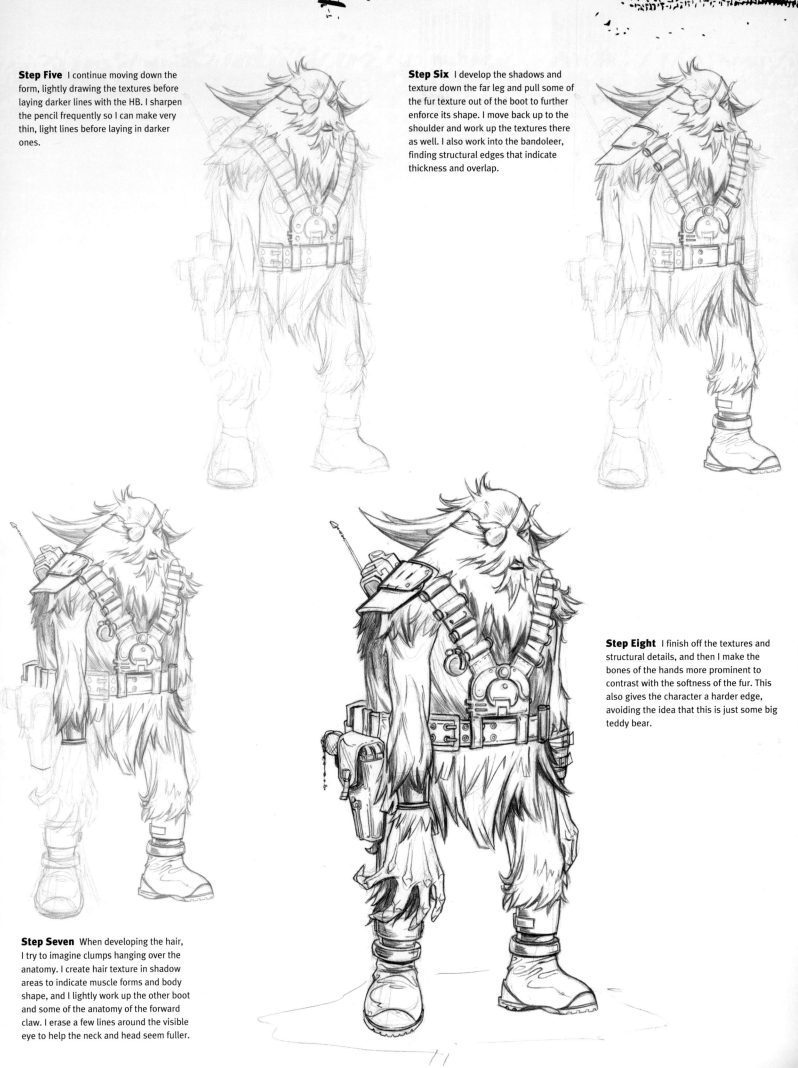

Step Five I continue moving down the form, lightly drawing the textures before laying darker lines with the HB. I sharpen the pencil frequently so I can make very thin, light lines before laying in darker ones.

Step Six I develop the shadows and texture down the far leg and pull some of the fur texture out of the boot to further enforce its shape. I move back up to the shoulder and work up the textures there as well. I also work into the bandoleer, finding structural edges that indicate thickness and overlap.

Step Eight I finish off the textures and structural details, and then I make the bones of the hands more prominent to contrast with the softness of the fur. This also gives the character a harder edge, avoiding the idea that this is just some big teddy bear.

Step Seven When developing the hair, I try to imagine clumps hanging over the anatomy. I create hair texture in shadow areas to indicate muscle forms and body shape, and I lightly work up the other boot and some of the anatomy of the forward claw. I erase a few lines around the visible eye to help the neck and head seem fuller.

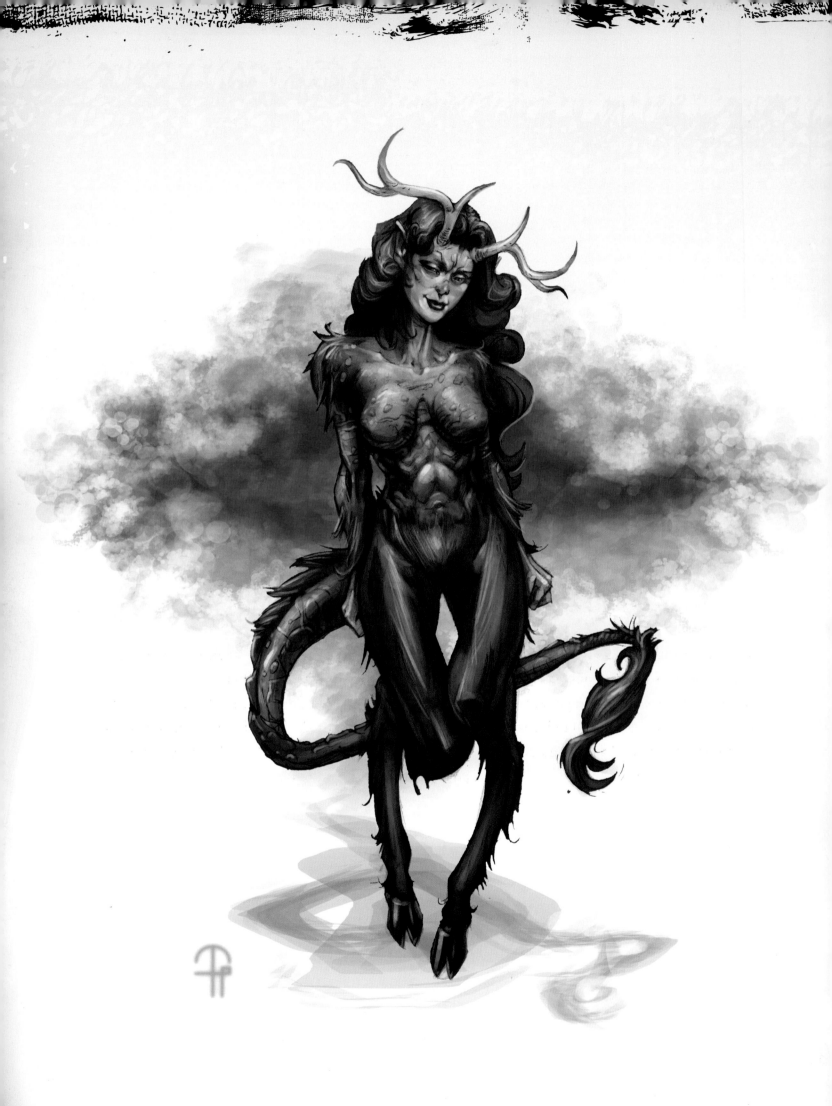

Horror Characters

The horror tradition is longstanding: The frightening myths and legends created in ancient times still influence us as we continue to create all sorts of new and vibrant ways to make each other scream and fear the dark. The fear of death and the undead is a common theme. When drawing horror characters, it's a good idea to study skeletal structures. It's also important to study objects commonly thought of as fear-inducing, such as pointed, dangerous-looking tools, insects, and decaying things, as you will likely be incorporating these into your compositions.

Frankenstein's Monster

Written at the beginning of the Industrial Revolution—when science seemed to hold the keys to man's progress—Mary Shelley's story of Dr. Frankenstein's attempt to defy the laws of nature spawned the allegorical tale of science run amuck. Frankenstein's monster is unable to find his place in the world other than as a horrible, monstrous mistake. Giving a creature the mind of a child but the body of a huge, powerfully built man made for unfortunate mistakes.

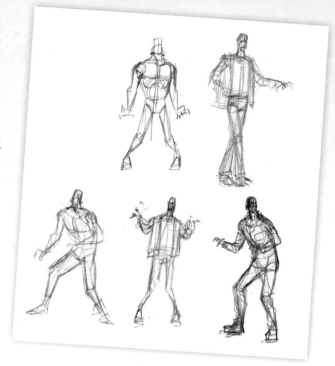

Concept Sketches I'm looking for a pose that shows the lurching, unsteady walk of someone learning to walk or just unfamiliar with his body.

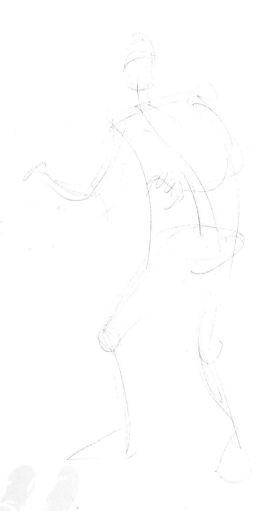

Step One I decide on a pose reminiscent of a baby learning to walk. I feel it's a good contrast and less contrived than the standard arms-extended stiff walk of the Boris Karloff reprisal. With a 2H pencil, I lightly trace the pose using a light-box, focusing on capturing the pose with hand, feet, and head placement.

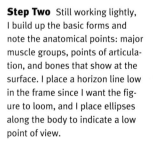

Step Two Still working lightly, I build up the basic forms and note the anatomical points: major muscle groups, points of articulation, and bones that show at the surface. I place a horizon line low in the frame since I want the figure to loom, and I place ellipses along the body to indicate a low point of view.

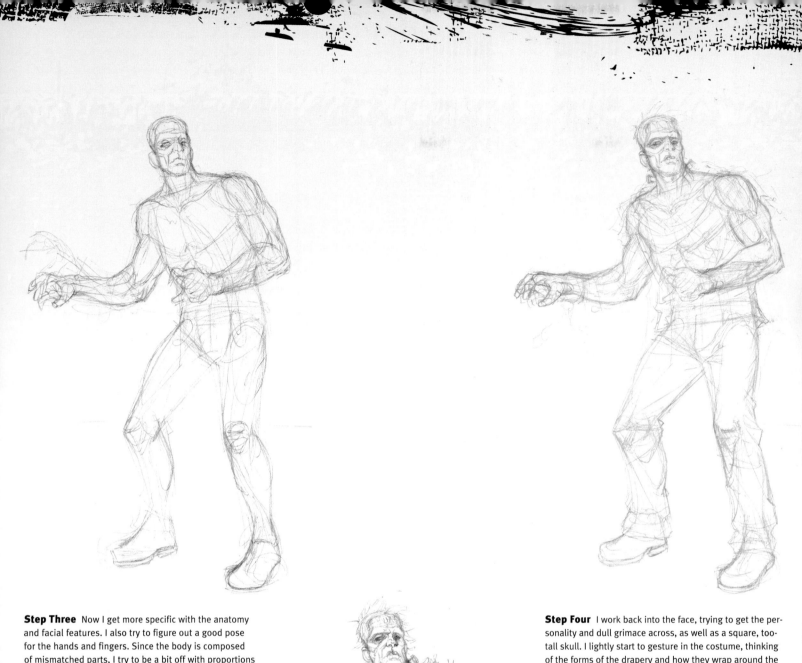

Step Three Now I get more specific with the anatomy and facial features. I also try to figure out a good pose for the hands and fingers. Since the body is composed of mismatched parts, I try to be a bit off with proportions and symmetry. I also note which forms are overlapping and create hard edges to define form, direction, and shadow edges.

Step Four I work back into the face, trying to get the personality and dull grimace across, as well as a square, too-tall skull. I lightly start to gesture in the costume, thinking of the forms of the drapery and how they wrap around the body. I want something different from the standard over-sized suit á la Boris—maybe a bit more modern.

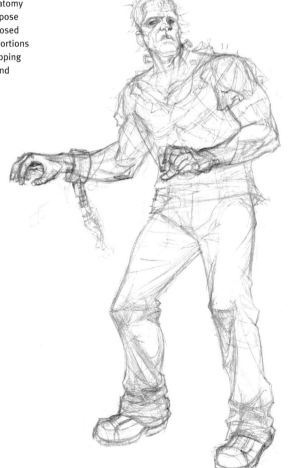

Step Five I develop more details of the surface anatomy and clothing. I want the clothing to resemble well-worn hand-me-downs, so I indicate holes and frayed edges. I add the wrist cuff and chain to indicate an intent to hold him in captivity. I draw along the forms of the shoes and add some structure to build the idea of heavy boots. I also stat to indicate some of the shadow pattern in the legs and torso.

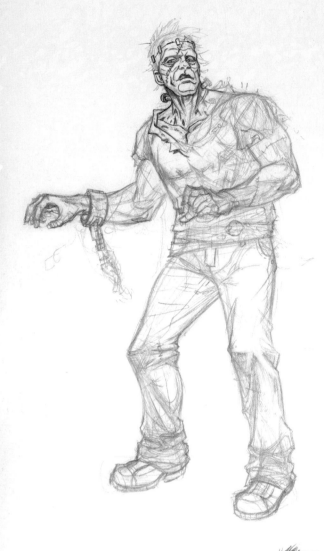

Step Six Now that I have a strong idea of where I want to go, I begin to lay in final lines, starting with the face. I am mostly outlining, concentrating on line edges and forms and placing shadows where they make sense.

Step Seven I work my way through the torso, outlining and then building shadow. The shirt is loose fitting, but I make sure to indicate that there is a powerful chest underneath. At the waist, I dissolve the form into a pattern of wrinkles and compression folds. As I build forms, I also indicate the lines of incision and stitches for the different bits that have been pieced together.

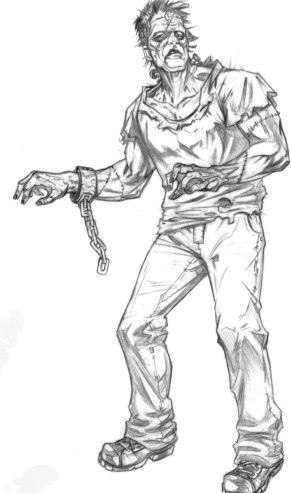

Step Eight First I erase as much of the construction lines as I can. Then, after I outline all the forms, I go back through to add texture or extra lines to show form or stress on fabric. I develop the head a bit more to build up its bulk and make it more square. I also deepen the shadows around the eyes to give a more sunken look to his face.

▶ **Step Nine** I want to indicate many different types of skin patched together and to keep the colors saturated but dark. I choose dark colors and avoid using too much green, which seems to be the standard color for Frank these days. I add stripes to the shirt to give a stronger indication of a childish mind trapped in a brute's body.

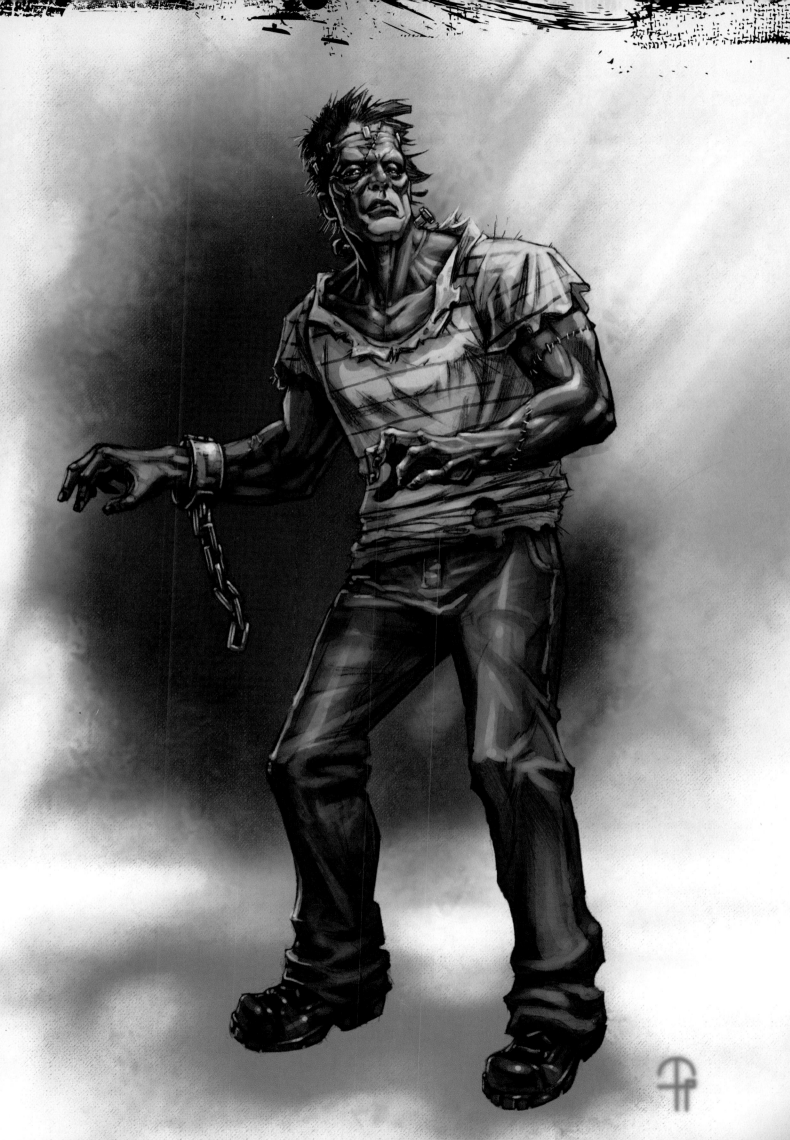

Vampire

Vampires are the risen dead who have been cursed by the bite of another vampire (or other means) and can only derive sustenance from the blood of the living. Modern Western folklore holds that most vampires are charming and elegant with an air of decrepit age and ancient evil. At their best, vampires are able to attract and repulse victims at the same time. Depictions of vampires greatly vary in popular culture, and the bloodsucking undead are used as analogies for all sorts of human behavior. As story elements, they possess a seemingly endless well of melodrama built into the conflict between their once human existence and their true vampire nature.

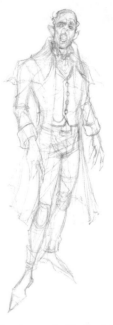

Step One I lightly sketch the pose with a 2H pencil, starting with the centerline (or line of action) and a few lines to define the torso, legs, and arms. I'm aiming for a general idea of the proportions and position of the figure. I'm not worried about being too exact because I will most likely move everything around a bit as I develop the character.

Step Two I change the angle of the head a bit and start defining major areas of the figure, including the coat. I want the character to have a sinuous body with signs of age and atrophy, so I exaggerate joints and bone structure, especially in the hands, feet, and face. I study the proportions of elderly men for reference.

Step Three Vampires are depicted in all kinds of costumes and clothing; I prefer those from the Edwardian/Victorian era, so I develop a coat with some details reminiscent of armor. I want the clothing to have a kind of dapper and aged look. I also start to experiment with the vampire's hair and facial expression.

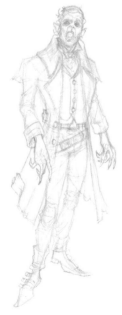

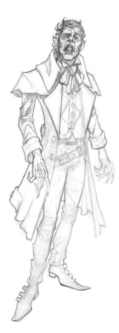

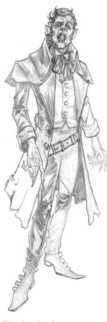

Step Four Still using a 2H, I continue developing the costume and figure. I want to fully capture the facial expression and textures before I start placing final lines, as they'll be harder to erase. I want his hands to look aged and powerful; more lizard or rat than human. I make the knuckles large, the veins prominent, and the fingers sharp. Then I begin adding details to the coat, pants, and shoes.

Step Five Now I switch to a 2B to start darkening lines and adding shadows, erasing construction lines as I go. I also add curving lines to the hair to show motion. Then I add a checker pattern to the vest and change the shape and size of the bow at the neck.

Step Six I didn't like the checker pattern so I removed it with a kneaded eraser. I continue working up shadows and filling in dark areas of the clothing, leaving white areas for highlights. I also add frayed edges to the coat to show age.

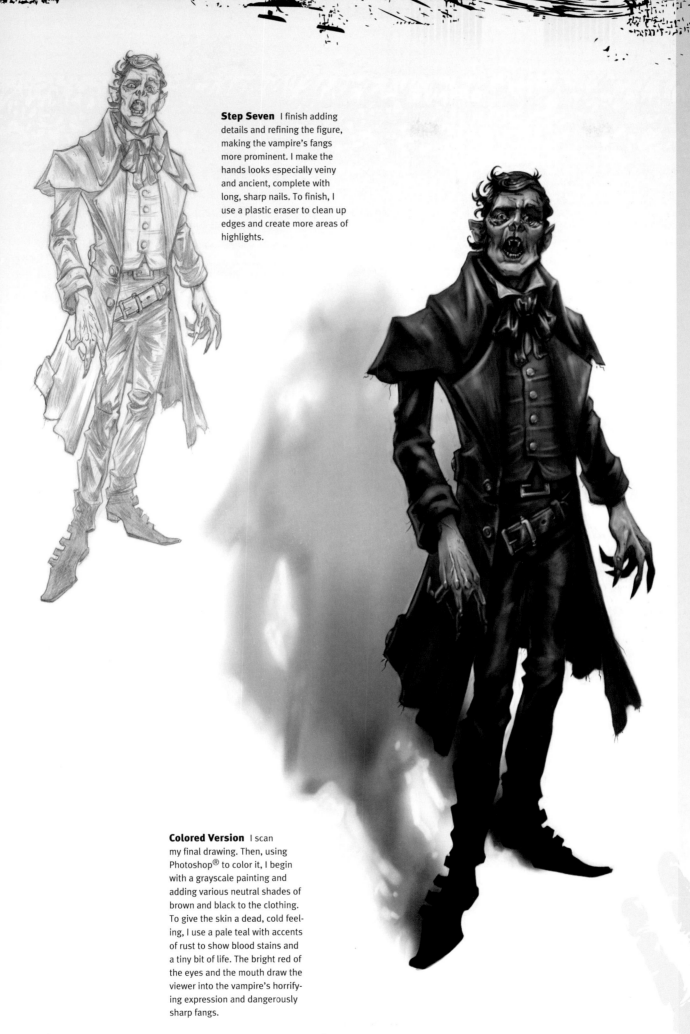

Step Seven I finish adding details and refining the figure, making the vampire's fangs more prominent. I make the hands looks especially veiny and ancient, complete with long, sharp nails. To finish, I use a plastic eraser to clean up edges and create more areas of highlights.

Colored Version I scan my final drawing. Then, using Photoshop® to color it, I begin with a grayscale painting and adding various neutral shades of brown and black to the clothing. To give the skin a dead, cold feeling, I use a pale teal with accents of rust to show blood stains and a tiny bit of life. The bright red of the eyes and the mouth draw the viewer into the vampire's horrifying expression and dangerously sharp fangs.

DID YOU KNOW?

Vampire myths exist all over the world and vary quite a bit in regards to the monsters' attributes and weaknesses. For instance, Chinese vampires suck Chi (life energy) instead of blood, and older Western myths say that vampires cannot cross running water and lack a reflection and/or shadow.

Zombie

Originally, the myth of the zombie was derived from tales of Voodoo worshipers who believed that powerful magic could reanimate the dead and transform them into servants of the sorcerer. These days, "zombie" can refer to any corpse brought back to life through many means, the most popular being by viral infection, which appeals to our highly skeptical modern minds. Zombies are in essence broken humans: rotting human bodies lacking the mental capacity beyond that of a feral animal, consuming with no thought to consequence or morality, moving en mass like cattle from one feeding ground to the next.

Concept Sketches I want a pose that is broken and staggering but still threatening.

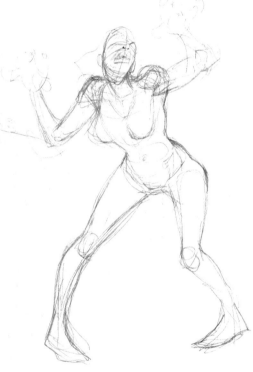

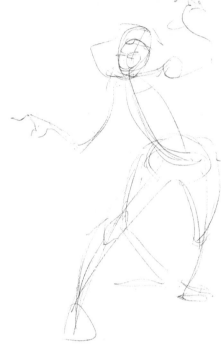

Step One I really like one of the concept sketches so I enlarge and trace it using a lightbox and a 2H pencil, focusing mainly on the motion and shape of the pose. I want to get the energy of the pose now so that it will carry through as I work up the details.

Step Two I start by lightly placing the block and cylinder forms, trying to get a good silhouette for the pose, and I try out a position for the head.

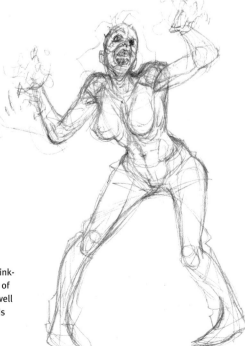

Step Three Still using the 2H pencil, I work up more specific details and try to create an undead snarl for the facial expression. I'm still not too worried about the decaying flesh; I want to have a solid form to build on first. I draw a centerline down the torso and note which forms are overlapping other forms to enforce the direction of the shapes. I try a few different poses for the hands as well.

Step Four I work up more of the facial details and lightly gesture in the pants, thinking of the silhouette and the stress points of the hips, knees, buttocks, and thighs, as well as the drape along the lower legs and folds around the ankles.

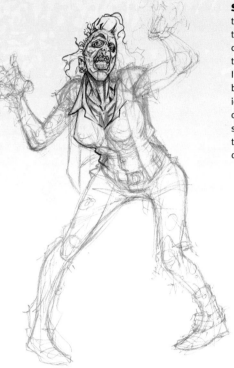

Step Five I feel good about the face, so I switch to a 2B and start on the final lines. Once I lay in the face, neck, and hair, I go back to the 2H and draw the shirt, vest, and belt. I also start noting tears in fabric and decay on the flesh. Many times I'll start working on the final lines in certain areas before I've locked in other areas. If I have good ideas I want to get them in before I lose them. I only do this, however, when I feel that the overall structure has been decided. Laying in final lines too early can lead to a lot of wasted work and overworked drawings.

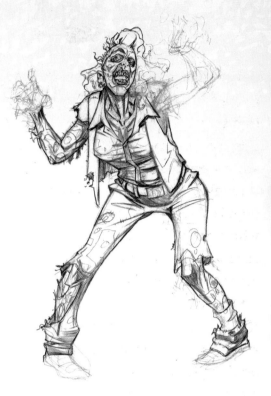

Step Six I keep working with the 2B, moving down into the torso and legs. Thinking mostly of lines and form edges, I also create deep shadows where appropriate. I'm always thinking about the form in 3D when I place lines and textures.

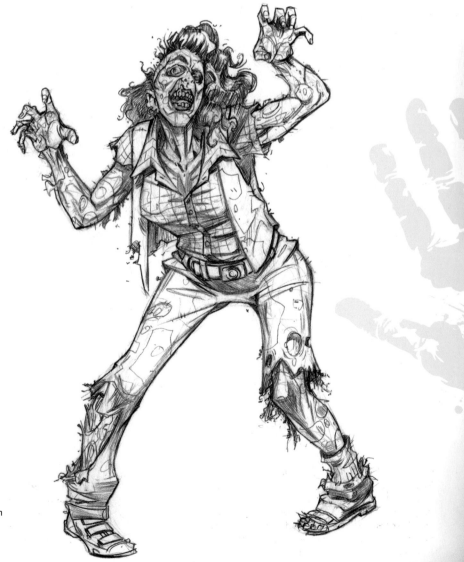

Step Seven I hold off on the hands and move back up the body to add surface texture and shadows. I also add a checkered pattern to the shirt and darken the frayed edges of cloth and skin.

Step Eight I finish off the arms, hands, and feet with the 2B and then go back in to add extra texture and darken the deep shadows of the hair and back shoulder. I also go back through the whole figure to develop any extra textures, erase construction lines, and clean up edges.

Witch

Witches have a better reputation these days than they did in Cotton Mather's time, but the idea of supernatural power used for evil by a loveless old crone still has the power to instill fear. Twisted by the evil forces to which they have aligned themselves, witches use their powers to stay beautiful or just go with it and look the part of a scary old hag. In the past, a fear of old women with an affinity for herbal medicine transformed into a hysteria that left us with a ghastly mythology of witches eating babies, souring milk, turning people into animals, and consorting with devils.

Concept Sketches I try out a few of the common pointy hat and broom witch designs but decide to go a different route. I like the idea of incorporating some sort of ritualistic knife and having the wind blow her hair around.

Step One None of the concept sketches are exactly what I want but I use a few of the ideas to sketch a pose with a 2H pencil. I like the arm and leg being thrown back and a bulky body type so I indicate all of that. I gesture in a bit of costume and the knife as well.

Step Three I don't like the way the head was positioned and I want to exaggerate the thrust of the right arm, so I remove portions with a kneaded eraser. Then I place a new oval for the head with a centerline that indicates she is looking down. I work out some surface details and have fun drawing all the folds of fat. Most of this will be covered by the costume but it helps me understand the forms better and get into the character a bit more.

Step Two Now I start placing more specific forms, spending a bit more time on the face to get an idea of how it will affect the body position. When placing the forms, surface anatomy is less important than body proportions and the direction of major forms.

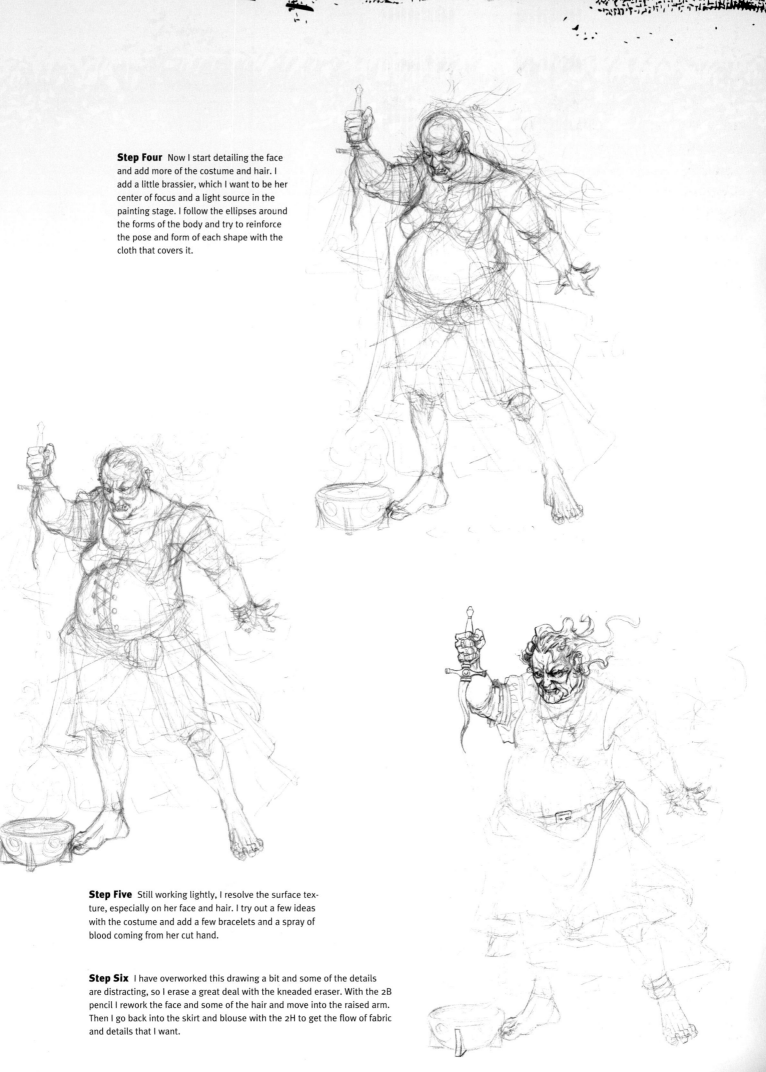

Step Four Now I start detailing the face
and add more of the costume and hair. I
add a little brassier, which I want to be her
center of focus and a light source in the
painting stage. I follow the ellipses around
the forms of the body and try to reinforce
the pose and form of each shape with the
cloth that covers it.

Step Five Still working lightly, I resolve the surface tex-
ture, especially on her face and hair. I try out a few ideas
with the costume and add a few bracelets and a spray of
blood coming from her cut hand.

Step Six I have overworked this drawing a bit and some of the details
are distracting, so I erase a great deal with the kneaded eraser. With the 2B
pencil I rework the face and some of the hair and move into the raised arm.
Then I go back into the skirt and blouse with the 2H to get the flow of fabric
and details that I want.

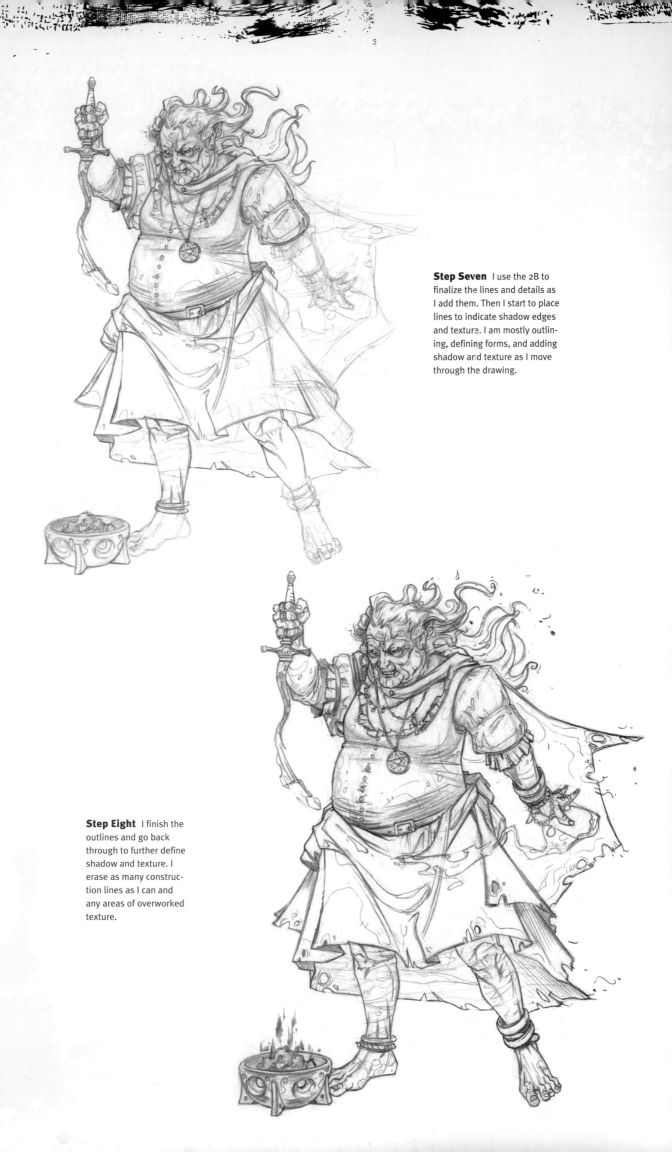

Step Seven I use the 2B to finalize the lines and details as I add them. Then I start to place lines to indicate shadow edges and texture. I am mostly outlining, defining forms, and adding shadow and texture as I move through the drawing.

Step Eight I finish the outlines and go back through to further define shadow and texture. I erase as many construction lines as I can and any areas of overworked texture.

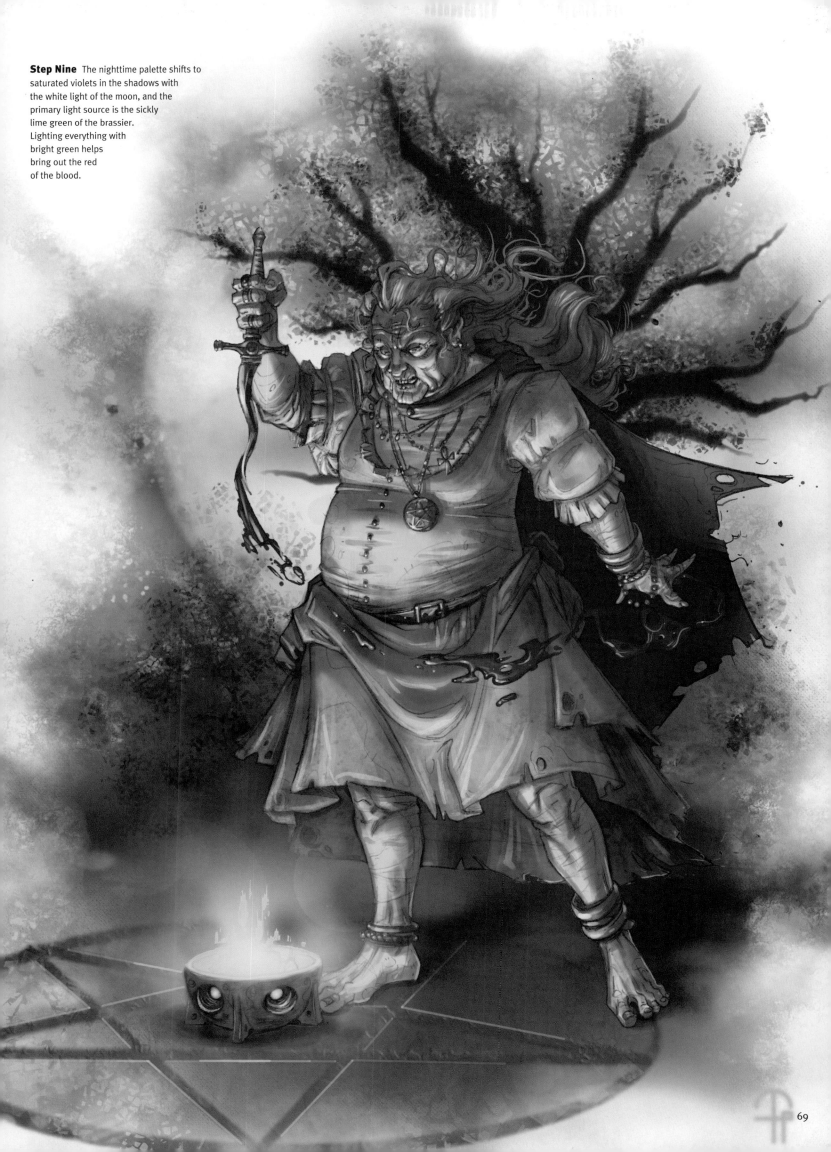

Step Nine The nighttime palette shifts to saturated violets in the shadows with the white light of the moon, and the primary light source is the sickly lime green of the brassier. Lighting everything with bright green helps bring out the red of the blood.

Mummy

Preservation, either by natural conditions or by human intervention, leaves behind eerie, fresh-looking dead people that are thousands of years old. Mummies, although real and on display in many museums, have given rise to a familiar curse: the mummy who is seeking revenge on those who despoiled its tomb. Mummies exist in many cultures and areas in the world; they are not exclusive to Egypt. I am partial to the mummified remains of the Bog People left from ritual killings of the Celts, but I'll see what speaks to me as I build the character.

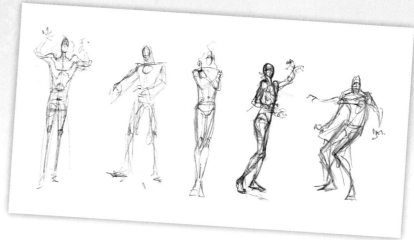

Concept Sketches Horror fiction today usually takes lurching creatures like zombies and mummies and speeds them up, making them superhumanly fast. I personally chalk this up to lazy writing and prefer a nice slow, decrepit mummy.

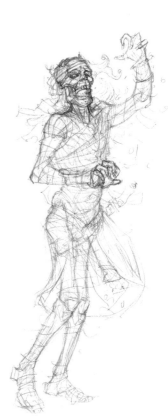

Step One I'm really partial to one of my concept sketches so I enlarge it and trace it onto Bristol board with a 2H pencil. The pose is a bit off-balance and in mid-lurch forward. Note that the chest is more turned away from the viewer than the pelvis. The basic forms here will be the skeletal structure, which will show through prominently. I start noting the major forms, making sure they are more detailed than they usually are at this stage because I'm trying to figure out what is left of the muscle to give the figure form.

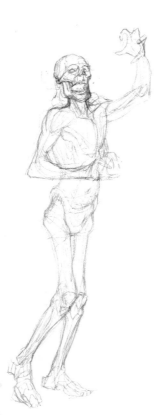

Step Two Now that I have the skeletal structure down, I go through and start adding three-dimensional forms. The face is a skull, so I just draw the entire skull, planning to add the details of what remains of the face later. I build up the pose of the hands as well, making sure they look as if they are grasping for something.

Step Three Still using the 2H, I add the surface details and facial features, including teeth, hair, eyelids, and tongue. I draw lines as guides for the gauzy material, making sure they wrap around the forms. I decide this mummy is from a mythical land (Atlantis, maybe), so I give him costume elements that are non-specific but appear ancient.

Step Four I have all my guides in place, so now I switch to a 2B and start placing final lines, beginning with the face. I am careful to outline the bandages and then erase portions that will show the form beneath. Generally shadows will occur on the shadow planes and also where the fabric stretches across gaps (such as on the bridge of the nose). I place shadows where I can and add some tattered, frayed edges to the bandages and costume as they occur to me.

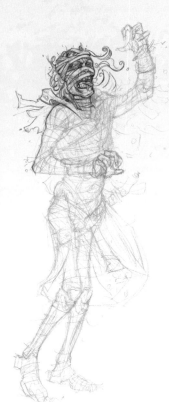

Step Five I continue to move down the body with the 2B, outlining some of the costume elements and the bandages. I also build up shadows to show form. I darken a few places in the face to heighten the sunken, decomposed look.

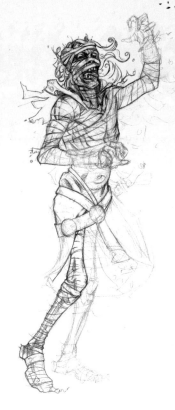

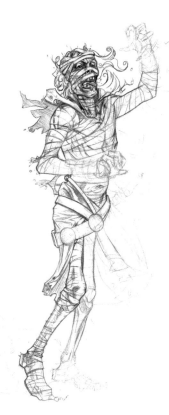

Step Six I work back into the fabric and loose bits of cloth in the background to add interesting shapes. Then I accentuate the forms of the pelvis.

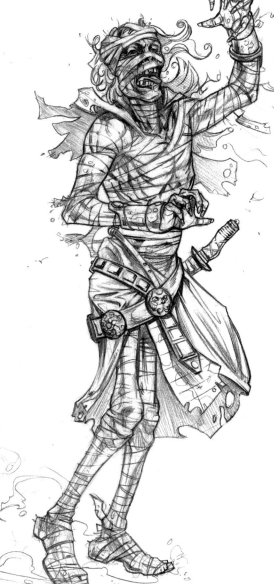

Step Seven Switching between a 2B and a 2H, I finish the forms and go back through the figure to build up more shadows and add texture. I add scrolling to the belt buckles to make them more convincing. I also build up cast shadows (such as on the cloth and under the neck). Then I erase areas to make them lighter and thin out the bandages where the lighting is strong to give the forms more dimension.

71

Evil Scientist

Dr. Jekyll, Dr. Frankenstein, Dr. Moreau: Where would we be without our mad scientists? Mix a man (or woman) with a vision and a slight God complex, add a lack of foresight into the potentially horrific consequences, or a tragic science lab accident, and you get horror gold. In an age when witchcraft seems less credulous, these are the new purveyors of the bizarre and terrible curses on humanity: Science gone awry. The challenge here is to show both madness and discovery.

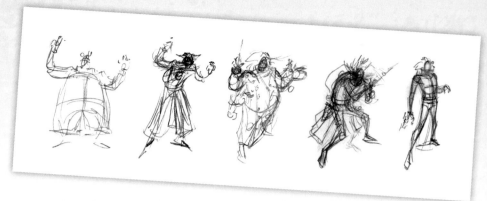

Concept Sketches I plan on covering madness in the look of the character, but as for discovery and science, I want a pose that captures the "Ah-ha!" or, rather, the "It's alive!" moment.

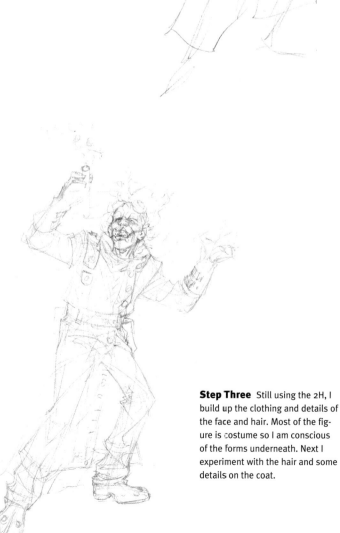

Step One None of the thumbnail sketches is exactly what I want, but I go ahead with one of the poses, sketching it with a 2H pencil. Here the character crouches with a test tube held up in a moment of evil celebration.

Step Two I lightly block in the basic forms, trying to get an idea of the placement of the hands, feet, and head. I draw centerlines down forms to show direction and volume. I also block in some of the costume, since he will mostly be covered by his lab coat.

Step Three Still using the 2H, I build up the clothing and details of the face and hair. Most of the figure is costume so I am conscious of the forms underneath. Next I experiment with the hair and some details on the coat.

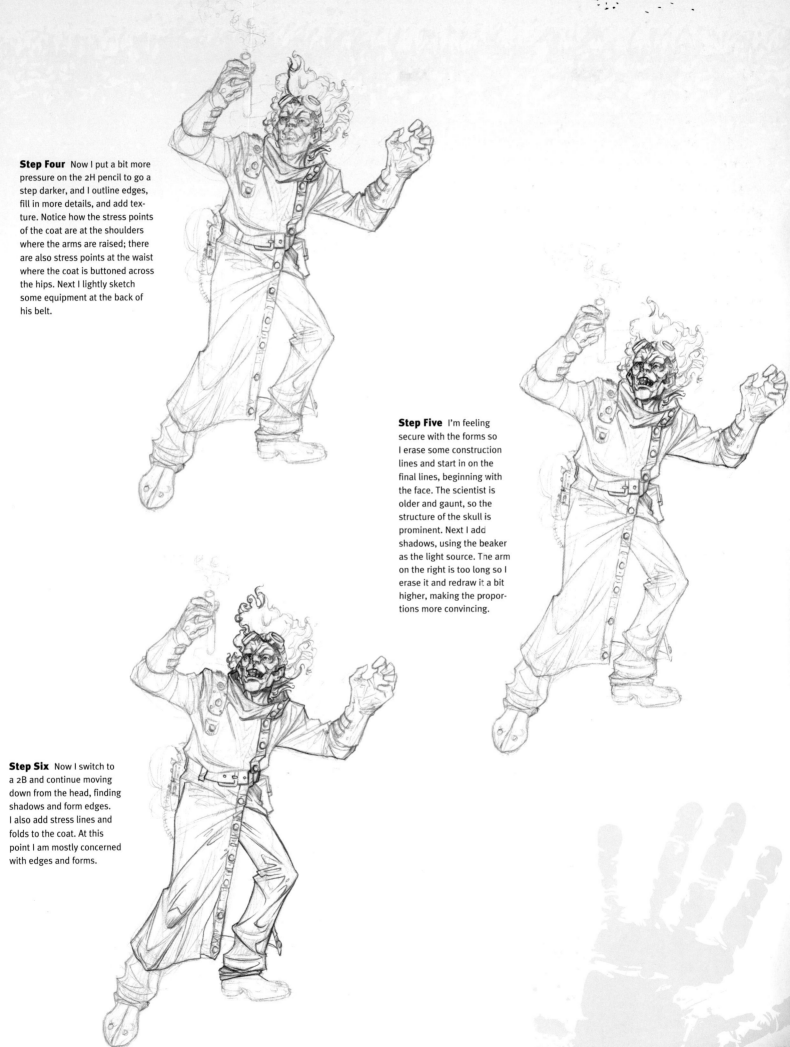

Step Four Now I put a bit more pressure on the 2H pencil to go a step darker, and I outline edges, fill in more details, and add texture. Notice how the stress points of the coat are at the shoulders where the arms are raised; there are also stress points at the waist where the coat is buttoned across the hips. Next I lightly sketch some equipment at the back of his belt.

Step Five I'm feeling secure with the forms so I erase some construction lines and start in on the final lines, beginning with the face. The scientist is older and gaunt, so the structure of the skull is prominent. Next I add shadows, using the beaker as the light source. The arm on the right is too long so I erase it and redraw it a bit higher, making the proportions more convincing.

Step Six Now I switch to a 2B and continue moving down from the head, finding shadows and form edges. I also add stress lines and folds to the coat. At this point I am mostly concerned with edges and forms.

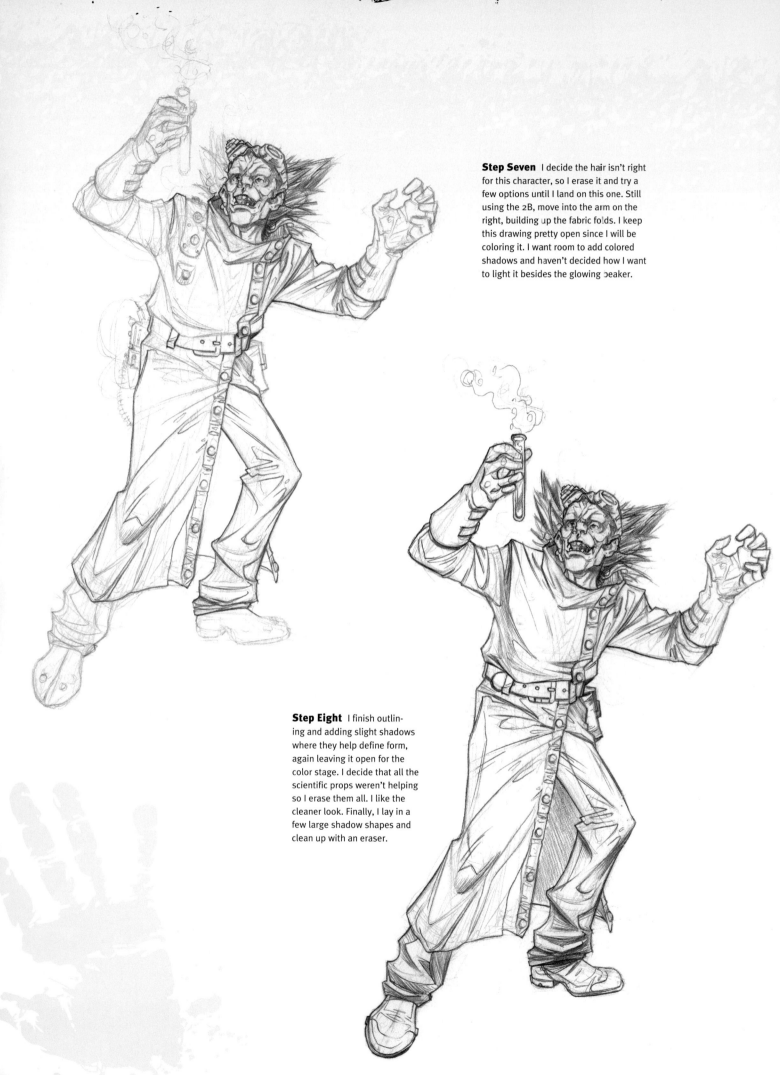

Step Seven I decide the hair isn't right for this character, so I erase it and try a few options until I land on this one. Still using the 2B, move into the arm on the right, building up the fabric folds. I keep this drawing pretty open since I will be coloring it. I want room to add colored shadows and haven't decided how I want to light it besides the glowing beaker.

Step Eight I finish outlining and adding slight shadows where they help define form, again leaving it open for the color stage. I decide that all the scientific props weren't helping so I erase them all. I like the cleaner look. Finally, I lay in a few large shadow shapes and clean up with an eraser.

Step Nine The palette is basically chartreuse and turquoise. I like the sickly look of the chartreuse in the vapor, and the bright blue has the cool, intellectual feel of a science lab with weird glowing stuff. I add some background elements, making it look like a dark lab or warehouse.

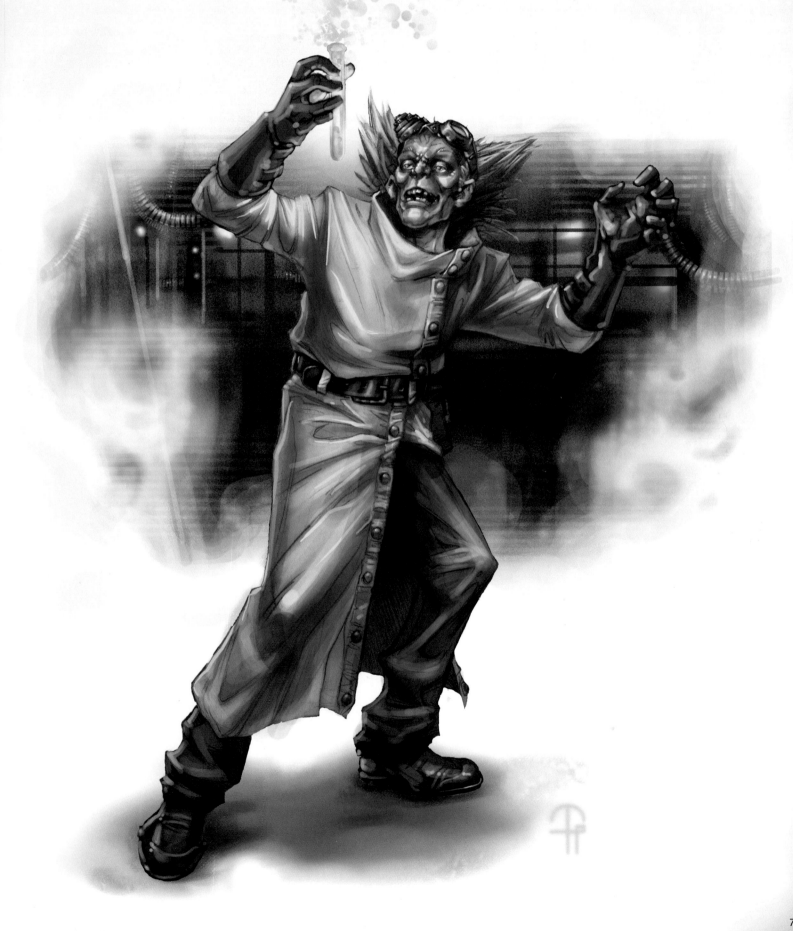

Werewolf

The lycanthrope, or werewolf, is a human with the ability (under his control or not) to turn into a wolf-like killing machine, complete with sharp claws and teeth, superior hearing and smell, and a lack of remorse about killing humans. The full moon is often associated with this change and is featured in many werewolf stories, but it is not a part of all werewolf mythologies. The challenge in this project is to do more than just draw a man with a wolf head; we must portray the feral nature of a beast like this.

Concept Sketches I want the figure to be engaged in a nice, loping run—a bestial jog. This pose is deceptively casual yet threatening.

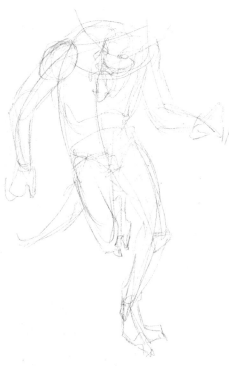

Step One I enlarge and trace the thumbnail that I like best, noting the movement of the spine, the relation of the hips to the shoulders, the placement of the limbs, and the distribution of the weight. With the 2H, I lightly start drawing the major forms. The hands are positioned so that the figure is running with his hands clawing through the air. The major forms of the head indicate the direction and expression.

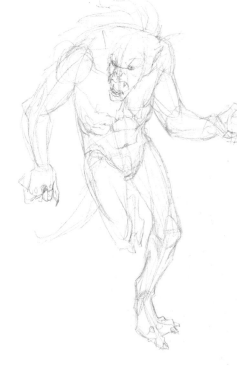

Step Two Now I focus on the specific details, noting major muscles and anatomy and begin to draw some of the surface anatomy. This character will be covered in fur, but I want to make sure the underlying anatomy is solid before I start laying in fur patterns.

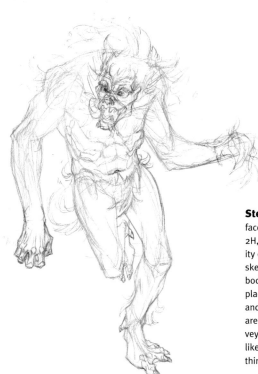

Step Three Starting with the face, I go a step darker with the 2H, figuring out the personality of the beast. I also begin to sketch the hair on the head and body. I get a bit detailed here, placing the forms of the ribcage and surface muscles. The hands are important, as I need to convey the movement of his body. I like the lower hand, but am still thinking about the raised one.

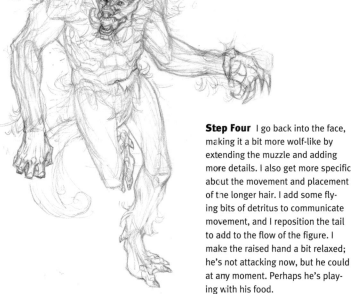

Step Four I go back into the face, making it a bit more wolf-like by extending the muzzle and adding more details. I also get more specific about the movement and placement of the longer hair. I add some flying bits of detritus to communicate movement, and I reposition the tail to add to the flow of the figure. I make the raised hand a bit relaxed; he's not attacking now, but he could at any moment. Perhaps he's playing with his food.

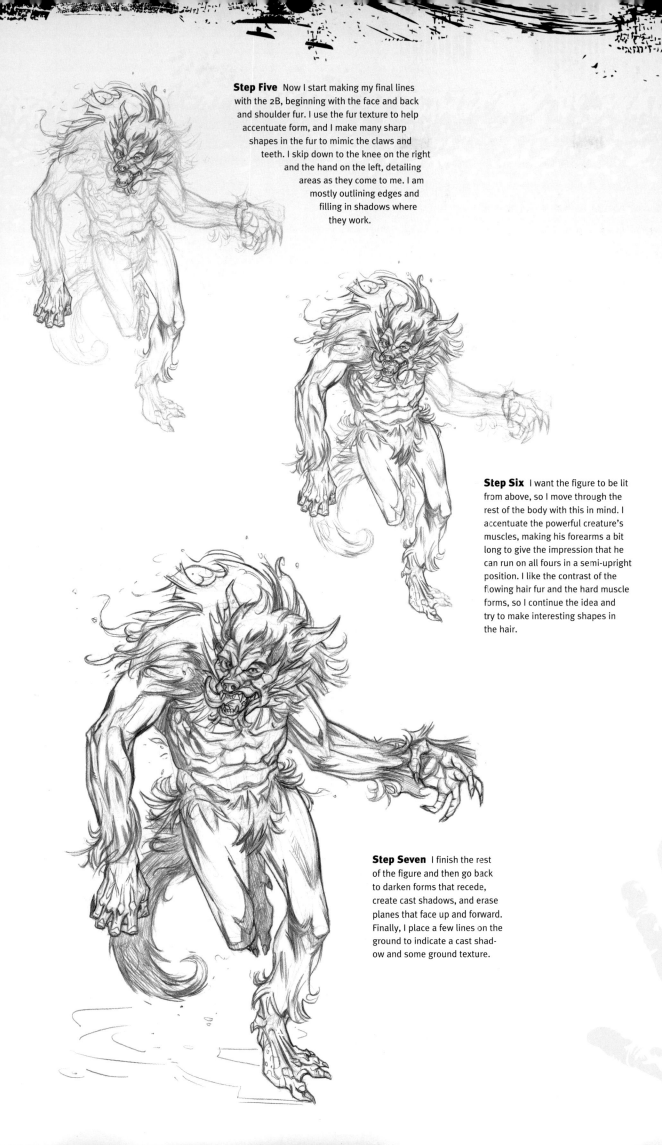

Step Five Now I start making my final lines with the 2B, beginning with the face and back and shoulder fur. I use the fur texture to help accentuate form, and I make many sharp shapes in the fur to mimic the claws and teeth. I skip down to the knee on the right and the hand on the left, detailing areas as they come to me. I am mostly outlining edges and filling in shadows where they work.

Step Six I want the figure to be lit from above, so I move through the rest of the body with this in mind. I accentuate the powerful creature's muscles, making his forearms a bit long to give the impression that he can run on all fours in a semi-upright position. I like the contrast of the flowing hair fur and the hard muscle forms, so I continue the idea and try to make interesting shapes in the hair.

Step Seven I finish the rest of the figure and then go back to darken forms that recede, create cast shadows, and erase planes that face up and forward. Finally, I place a few lines on the ground to indicate a cast shadow and some ground texture.

Grim Reaper

Death, or rather the personification of death, takes on many guises in world mythology, but for this project I want to focus on the traditional Western version. The skeleton who wears a black robe and carries a scythe comes to us from a 15th-century European interpretation of the four horsemen of the Apocalypse (Pestilence, War, and Famine are the others). In a mostly agrarian society, the scythe symbolized the end of the life cycle and came to represent a deadly weapon with which to collect souls. The black cloak, while mysterious and foreboding, most likely mimicked of the mythological Greek character Charon, who takes souls across the river Styx. I want to create a character that is frightening but also has aspects of ethereal beauty.

Concept Sketches I'm looking for a pose that is hunched, looming, and mysterious. I try several, some more active than others, but I want something less confrontational.

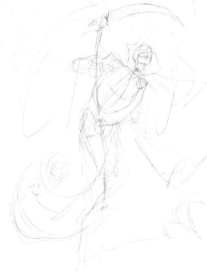

Step One I use a 2H pencil to lightly sketch the hunched, floating pose. The movement of the spine, placement of the head and hands, and relation of the shoulders to the pelvis are all in these few lines, but I keep it loose so I can adjust as I develop the character. I start with major forms and then go to more specific placement of limbs and costume elements. This character is basically an S-shaped tube of swirling fabric, so I think of that form as I draw. I note the major anatomical points to check proportion and placement of forms.

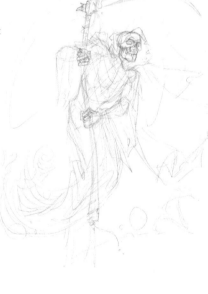

Step Two Now I use a bit more pressure on the pencil and try out some details. I want the draped robe to have a thin, flowing quality, so I make lines to indicate large shapes and changes in direction, but leave room to indicate the texture later. The main attraction in any Death portrait is the skull, so I check some reference materials and draw the general features.

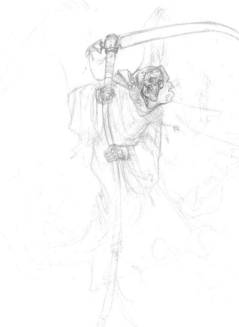

Step Three Now I direct my attention to the rest of the costume; I throw in a windswept, tattered cloak and add forms that I will be able to elaborate on in the next step. I sketch the wings a bit darker, trying to get a feel for how they should frame the figure.

Step Four Now I begin laying in final lines with the 2B. I take extra time to get the skull accurate, as I want it to read as a fully formed human skull. The scythe looks a bit wimpy so I wipe out much of it with the kneaded eraser and beef it up a bit with the 2H, thickening the shaft and extending the crooked blade. With the 2H, I add more details to the costume and get more specific with the hands. I also finally get a good shape for the wings.

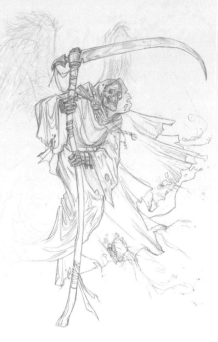

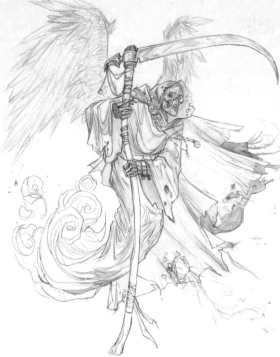

Step Five I go through the figure with the 2B, feeling out the forms and finding edges. I want the drawing to have a bit of an etched feeling, so instead of just filling in large black shapes, I fill in the shadows with fluid lines to indicate fabric with a lot of folds. I also detail the tattered edges and add shadows where I can. I use the 2H to develop the wings, using a reference as a guide. There are three levels of a wing in terms of mass and feather shape, so I try to indicate those here.

Step Six I continue outlining forms with the 2B, and add detailed curls of smoke that surround the figure. Then I switch to the 2H and use the side to lay in shadows and unify forms. I also add more shadows to the cowl to make the skull advance forward. I don't shade the smoke curls to make them look white.

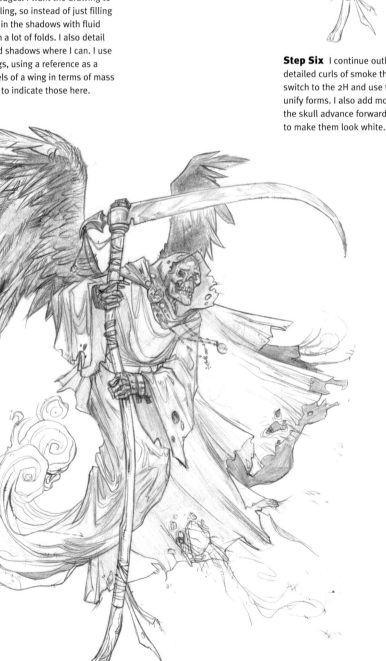

Step Seven I add final textures to the shaft of the scythe and detail the wings. I do not fill every part of the wings with feather shapes, as the wings could easily become very busy and detract from the rest of the figure. Lastly, I use the 2B to add more shadows and finish detailing the smoke tendrils.

Succubus

Succubi are demons that take the form of women to seduce their prey and then feed off their life energy, which results in weakness, permanent injury, rapid aging, and even death of the victim. The resulting emission of energy is then used by the male counterpart to seduce and impregnate a human woman. I want to create a demonic character that is both seductive and repulsive, a figure that expresses a sinister playfulness.

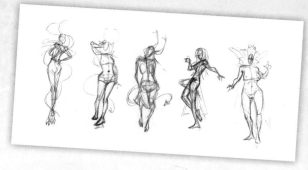

Concept Sketches There are many pin-up poses that can work here, but I want a playful come-hither look, rather than overtly sexual.

Step One I enlarge the thumbnail I like best and trace it onto Bristol paper using a 2H. I want the pose to be appealing and a bit vulnerable. As I draw, I make sure that she doesn't look as if she'll topple over by making her head turn counter to the direction of her body.

Step Two I start to lightly place the basic shapes (cylinders, boxes, and spheres) to show how the large shapes of the body sit in space. I draw the centerline quickly so I can establish the relation of the torso to pelvis and find the waist so I can draw the oval form of the ribcage.

Step Three Now I make my lines a bit darker and note the major anatomical points, as well as details of the anatomy that are affected by the body position. I'll be giving her the legs of a deer, so I use a reference to get the forms right.

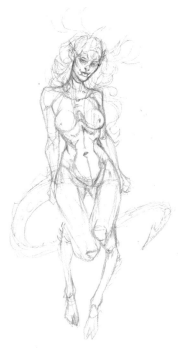

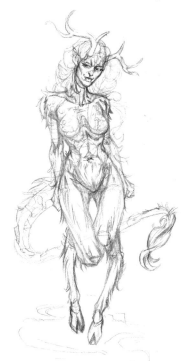

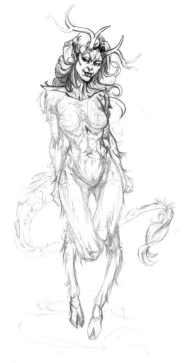

Step Four Since the anatomy is going to be mostly exposed, I take extra time to get the details and forms down. I take a stab at the facial expression and experiment with the hair and horns.

Step Five I continue adding surface details and fur patterns. I want her to have cloven hooves and horns like a demon, but I also want her to be attractive, so I soften the fur and make the horns more elegant.

Step Six Now I use a 2B pencil to develop the face and head. I change the facial expression a bit since I didn't feel confident enough with it. As I draw, I erase out shadows and areas to accentuate form.

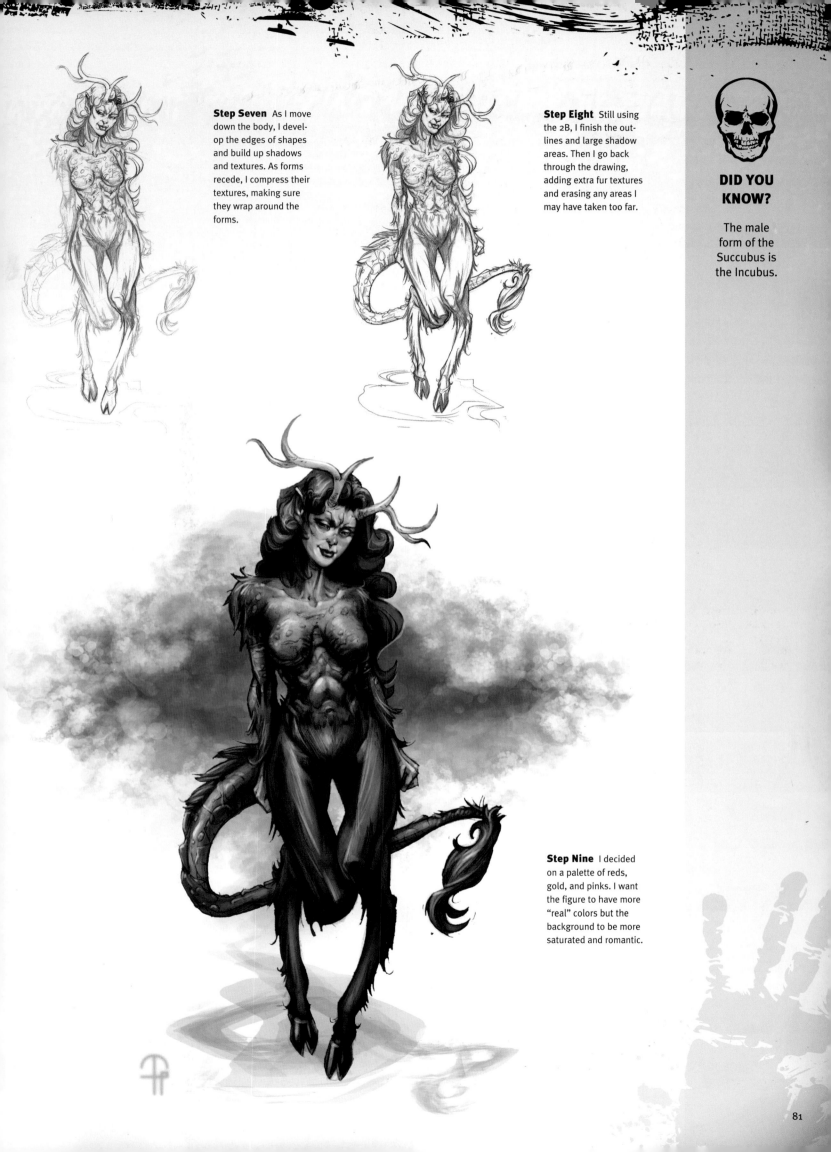

Step Seven As I move down the body, I develop the edges of shapes and build up shadows and textures. As forms recede, I compress their textures, making sure they wrap around the forms.

Step Eight Still using the 2B, I finish the outlines and large shadow areas. Then I go back through the drawing, adding extra fur textures and erasing any areas I may have taken too far.

DID YOU KNOW?

The male form of the Succubus is the Incubus.

Step Nine I decided on a palette of reds, gold, and pinks. I want the figure to have more "real" colors but the background to be more saturated and romantic.

Hell Hound

These fierce, undead protectors of hidden relics, treasure, and often their undead masters are ever-watchful sentinels. Usually the daytime protectors of vampires, these demon dogs appear to the casual observer to be nothing more than very large and bestial canines. However, when provoked, they may reveal a more demonic appearance and call on hell fire while discharging their duties. Supernaturally fast, strong, and aware, these demonic companions are no living man's best friend.

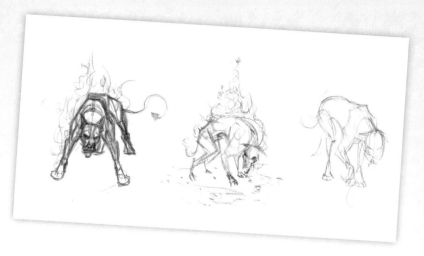

Concept Sketches Animals are a bit more challenging for me because I don't draw them as often as other subjects. I always use reference materials but tend to spend more time looking at pictures of animals to get the rhythms and postures in my head before starting the concept sketches. I want to convey the largeness and ferocity of this dog in a pose that is more extreme than your average mutt.

Step One I lightly sketch the pose with a 2H pencil, starting with the line of action and a few lines to define the silhouettes of the torso, legs, and flames. I aim for a general idea of the proportions and position of the dog, and am not worried about being too exact because I will most likely move everything around as I develop the drawing.

Step Two As I continue to develop the hound with the 2H, I start noting major anatomical points (ribcage, pelvis, head, feet, ears, and tail) and the start of the flame pattern. The horizon line is off the page so I don't sketch it in, but I keep the idea of it in my head as I move forward.

Step Three I continue developing the anatomy, using what I know about dogs and the goals I have for the character. I want a powerful yet gruesome figure, so I exaggerate bones and muscle structure, leaving some bones exposed and leaving holes in the skin and some muscles. I also start to work on the face and enraged expression, complete with drool. Then I continue developing the flame pattern.

Step Four A dog's ears say a lot about its character and mood, so I make this dog's ears tattered and bat-like. I continue working on the flame, playing with the rhythm of the curls. I also add some markings on the ground. Hellhounds are essentially servants so I add a powerful-looking collar and chain. Then I further develop the dog's anatomy, including the long tongue and intimidating claws.

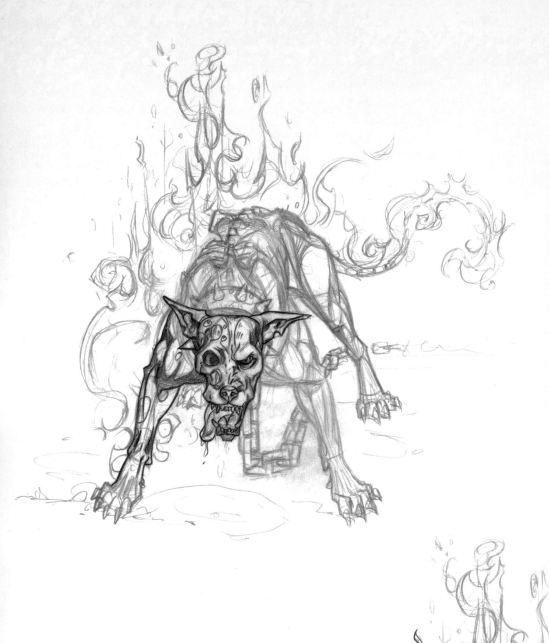

Step Five I decide that the ambient light source is coming from above and that the flames will cast light from the left. Switching to a darker 2B pencil, I start creating the final lines, outlining shapes and adding shadows. I move all over the figure, erasing construction lines as I go. Rather than working systematically, I follow the lead of whatever occurs to me while drawing. The brow on the right side of the dog's face was looking too human so I erase and change it. Then I work on the back area of the dog, making sure the lines along the ribcage are shortened for perspective (this is called fore-shortening).

Step Six I go in with my plastic eraser to clean up the edges and create planes of light. Then I add a few more shadows and add the final details. Note that the flames look somewhat unfinished because I'll be recreating them in color.

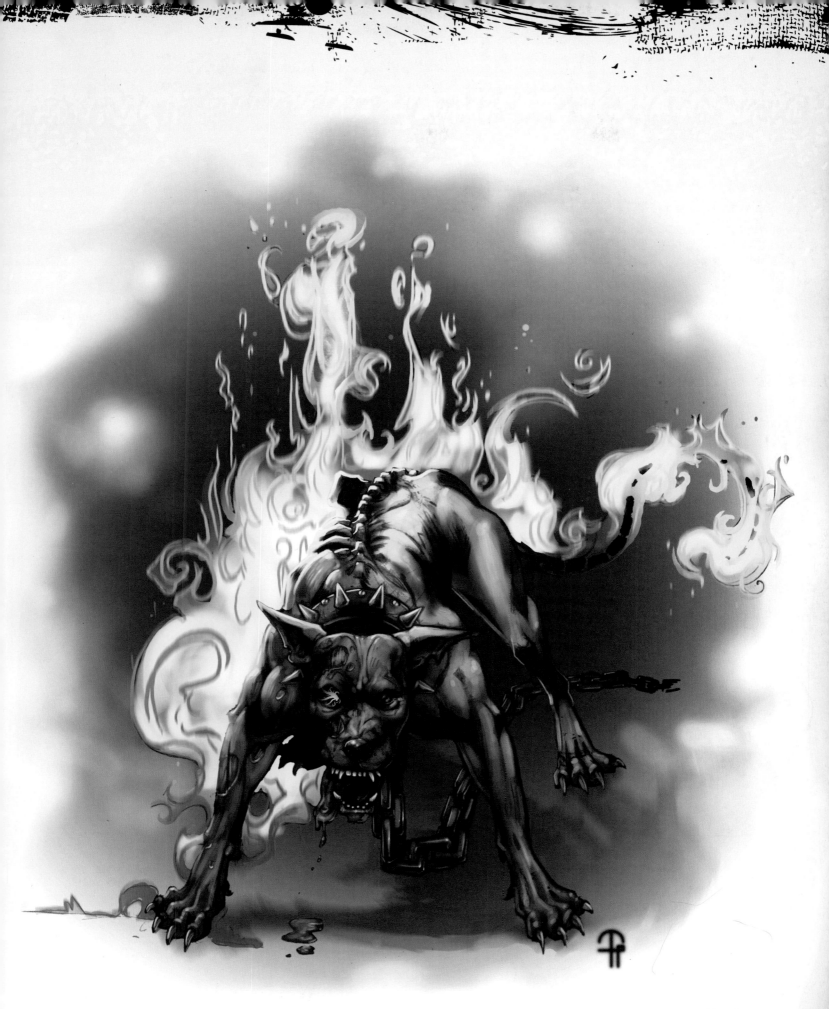

Step Seven I want the side lit by the flames to look raw, so I use fleshy red tones. I use cooler tones on the right side of the dog's body to contrast the bright, saturated fire colors. I like the graphic shape of the flames so I leave in the lines and hard edges.

Boogeyman

As soon as the lights go out, a pile of laundry and toys transforms into a looming specter: Boogeymen are polymorphic spirits that change shape to suit your worst fears. In this project, the Boogeyman will look like a misshapen mass with all sorts of different patchwork clothing, made up of whatever can be scavenged from a messy room.

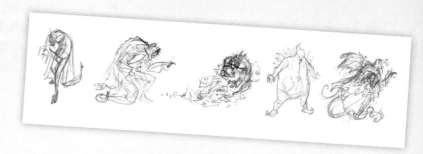

Concept Sketches A monster like this lends itself to all sorts of shapes and poses, but I am thinking about a hulking mass of vapor and cloth.

Step One The basic shape is like a giant bell tipped forward with the head and shoulders sticking out of the top. I use a 2H pencil to lightly sketch the basic shapes, and I indicate tentacles and wings as well. Since the figure is mostly vapor, I'm drawing mostly costume and whatever other appendages I decide to add. I draw the centerline to indicate the directions of the body and head, and I place a large egg shape where the torso would be.

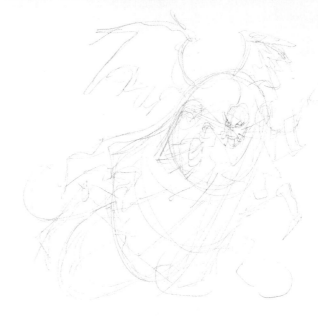

Step Two I start placing some details and trying out hand positions and face structure, adding basic shapes to indicate what I might want. I sketch lines to indicate the tattered cloth and add some shape to the wings. I want to combine a rat, an insect, and a pile of dirty laundry, but I'm open to happy accidents.

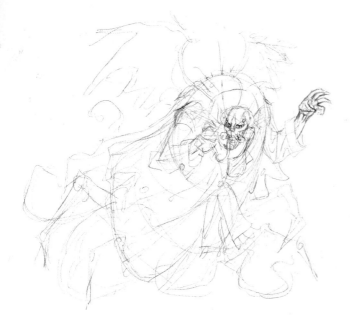

Step Three I refine the head and the hands, and I indicate forms for the jacket, scarf, and insect-like legs. I'm still drawing very lightly to prevent overworking the paper. I make sure the clothing wraps around the bell shape, with the top of the hump and the button closure being the stress points.

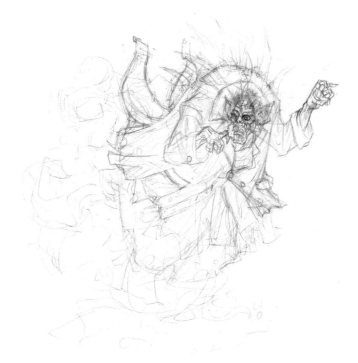

Step Four Now that I'm getting a feel for this monster, I discard the wing idea for some spikes and replace the insect legs with vapor. I think the Boogeyman is less substantial than the legs would indicate and is more of a floater than a flyer. I develop the skull structure of the face and create deep-set eyes and ratlike ears. I add details to the jacket, making it look distressed. Then I add cuffed sleeves and bulky pockets and tails to give the jacket an older look.

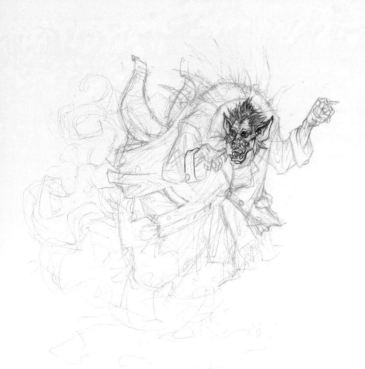

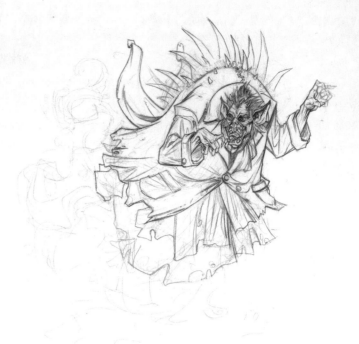

Step Five Next I use the 2B to develop the face and nail down the character so I can extend the characterization to the rest of the figure. Spiky shapes in the hair and flared-out teeth help give the figure a threatening look, and the grimace and mismatched eyes indicate that this character is a mischievous menace.

Step Six As I go through the figure, I outline all the forms and make sure to continue wrapping elements around the bell shape. I also add areas of shadow and treat edges. I twist his hands into awkward claws that are more creepy than threatening. I draw several layers of clothing to give the idea of mounds of fabric underneath the coat. These are chunky, tattered shapes that create nice patterns and reinforce the bell shape.

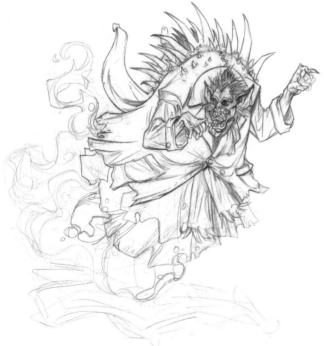

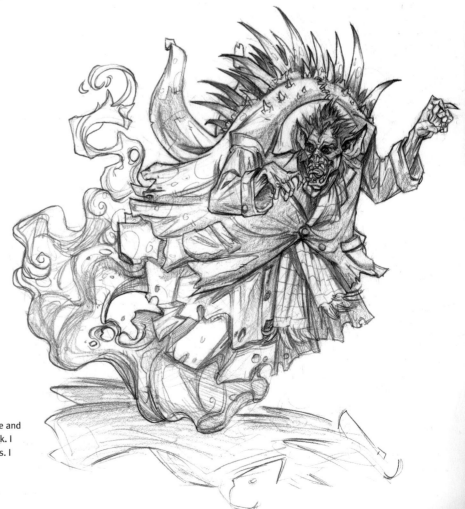

Step Seven Still using the 2B, I add more spikes, shadows, and textures to the main form. I also get more specific with the vapor trail. I silhouette some of the spikes to unify the forms, and I sketch a cast shadow on the ground to accentuate the figure.

Step Eight Using the side of the 2B drafting, I add shadows all over the figure and beneath each layer of clothing, thus separating them and creating a billowy look. I use the point of the pencil to build up darker shapes and more specific shadows. I also add more texture and erase out light shapes where I can.

Man-Eating Plant

"The Little Shop of Horrors," the stories of Edward Gory, and tales from deep jungle explorations give accounts of man-eating plants: giant, carnivorous plants that prey on indigenous animals and will consume a man whole if one is within reach. The origins of the myth may come from the many species of flowering plants that exude the powerful smell of rotting flesh, or the many actual carnivorous plants that actively feed on insects and small animals.

Concept Sketches With these thumbnails, I'm trying to get a general idea of the shapes I can use in the final and of the mechanics of the plant. None of them are exactly what I want but they help get ideas flowing before I start sketching.

Step One Using the side of a 2H pencil, I sketch the placement of major forms and the general shape of the plants. I don't want to just draw one plant since these large carnivorous plants generally live in lush forests. I want to indicate the complete surrounding ecosystem.

Step Two Unlike drawing humans or animals, there are no set structures to build upon, so I just start sketching random forms and shapes to see what works. Starting with the main flower, I lightly build up shapes and ideas for what this monster plant will look like. I keep in mind special forms like cylinders and domes for the central area; for other parts I think about texture and silhouette shape.

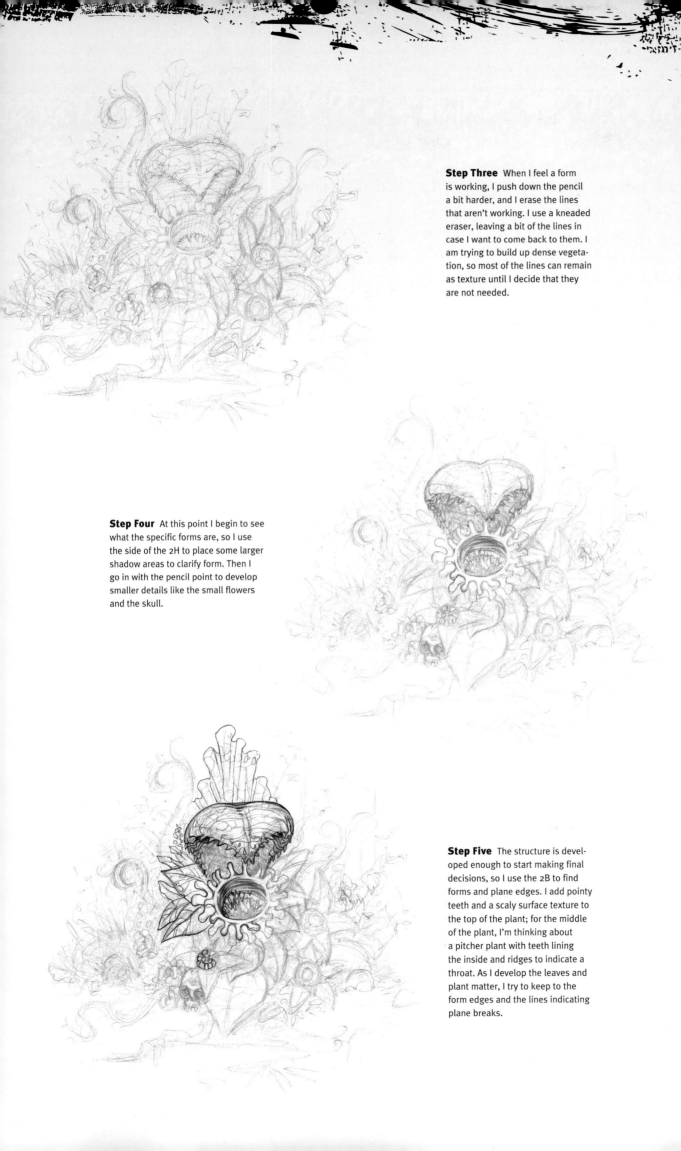

Step Three When I feel a form is working, I push down the pencil a bit harder, and I erase the lines that aren't working. I use a kneaded eraser, leaving a bit of the lines in case I want to come back to them. I am trying to build up dense vegetation, so most of the lines can remain as texture until I decide that they are not needed.

DID YOU KNOW?

The smell of rotting meat that some plants emit is analogous to the sweet smell of other plants; it attracts flies and beetles that assist in the pollination process.

Step Four At this point I begin to see what the specific forms are, so I use the side of the 2H to place some larger shadow areas to clarify form. Then I go in with the pencil point to develop smaller details like the small flowers and the skull.

Step Five The structure is developed enough to start making final decisions, so I use the 2B to find forms and plane edges. I add pointy teeth and a scaly surface texture to the top of the plant; for the middle of the plant, I'm thinking about a pitcher plant with teeth lining the inside and ridges to indicate a throat. As I develop the leaves and plant matter, I try to keep to the form edges and the lines indicating plane breaks.

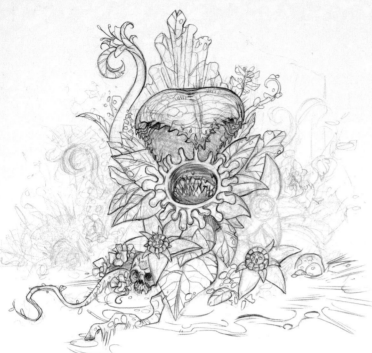

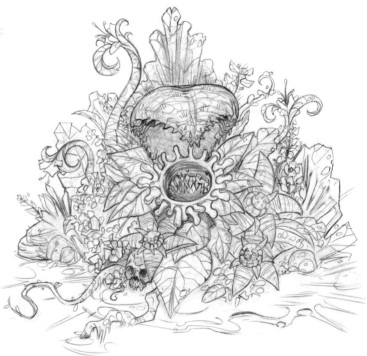

Step Six When working with masses of textures made from many smaller forms, it is helpful to think of it like finding shapes in clouds. Each final line is a decision between the many shapes created during the first steps. So I choose forms that work and erase areas to accentuate my decisions. As I make these forms, I try to add details like small leaves and veins.

Step Seven I continue moving outward to develop the rest of the plant. Placing texture on the plants is like adding wrinkles to cloth. The texture should follow the form underneath: In this case, most of the forms are either dome (leaves) or cylinder (vine/stem) forms. Next I erase areas that face the light source and clean up edges.

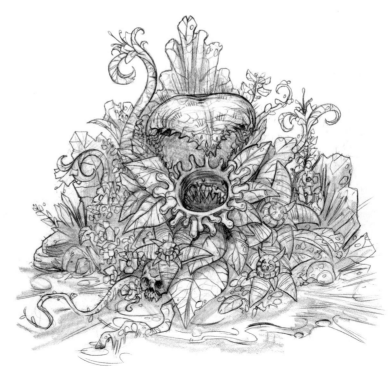

Step Eight I use the side of the 2H to place shadows and to make areas either recede or advance. I also place cast shadows from one level of leaves to the next to help give them form and placement in space.

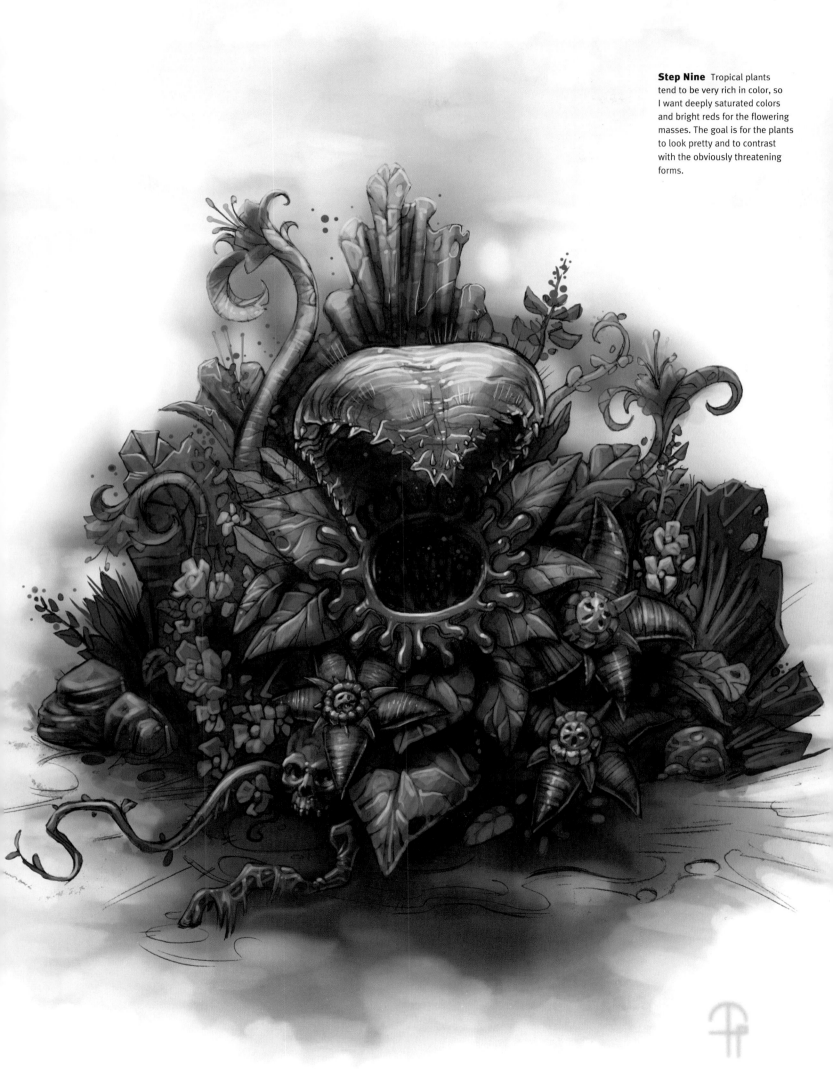

Step Nine Tropical plants tend to be very rich in color, so I want deeply saturated colors and bright reds for the flowering masses. The goal is for the plants to look pretty and to contrast with the obviously threatening forms.

Banshee

Irish legends and folklore have given us many great creatures and characters. Along with leprechauns, fairy mounds, and moor hounds, we have the banshee (or bean shìth). Her wailing song is a warning of imminent death in the family. She may appear in one of three forms representing the three phases of life: young maiden, mother, or old crone. Some traditions hold that the banshee also appears around certain trees, rocks, and caves to sing their song. Males who come across them and do not show courtesy or challenge them in some way are doomed.

Concept Sketches I want a haunting character that is reaching out. I decide on the maiden figure with flowers in her hair and a flowing gown.

Step One I use a 2H pencil to lightly sketch the pose, including the hair since I want it to mask her face a bit. I want to get a nice floating pose here and am not concerned with details.

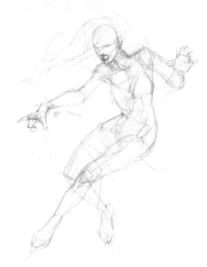

Step Two I start noting the anatomy and placement of forms, using circles, cylinders, and boxes for the basic shapes. I want the pointing hand to be expressive and a bit claw-like. It's helpful to think of fingers in groups at this stage in a drawing, lumping them together as a mass when you can. The pointing finger and thumb are separated but the rest are just part of the mass.

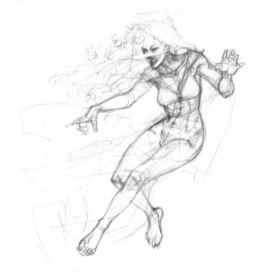

Step Three I keep developing the anatomy to be sure I understand how all the parts fit together and that they make sense. The costume is going to be flowing robes, so I lay in a few darker lines to get an idea of how the cloth will drape. I start working on the face, which I want to have a haunted expression.

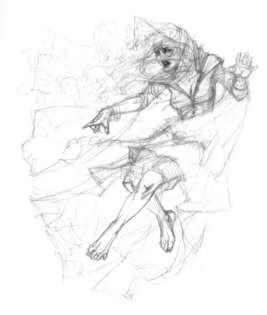

Step Four Where the forms are covered by costume, I think about the anatomy underneath. I build up the visible anatomy and start placing some shadows to help plan the larger masses. The hair whipping around gives me a great opportunity to have fun with patterns, so I try to find some rhythms as I sketch the lines.

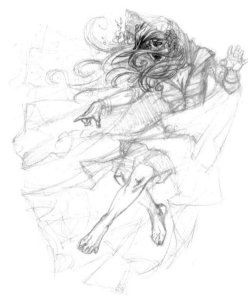

Step Five Beginning with the face, I use the 2B to develop the eyes and mouth, trying to give an impression of sorrowful singing. I lightly add shadows to some of the hair to give it a nice flow, making sure I'm still revealing parts of the face. When I feel a line is right, I use more pressure to lock in the shape.

Step Six I keep developing forms and placing shadows where I can. With very textured surfaces like hair, I use the lines of the hair to develop the shadows and form. I also start detailing the blouse and hood, complete with tattered sleeves and edges.

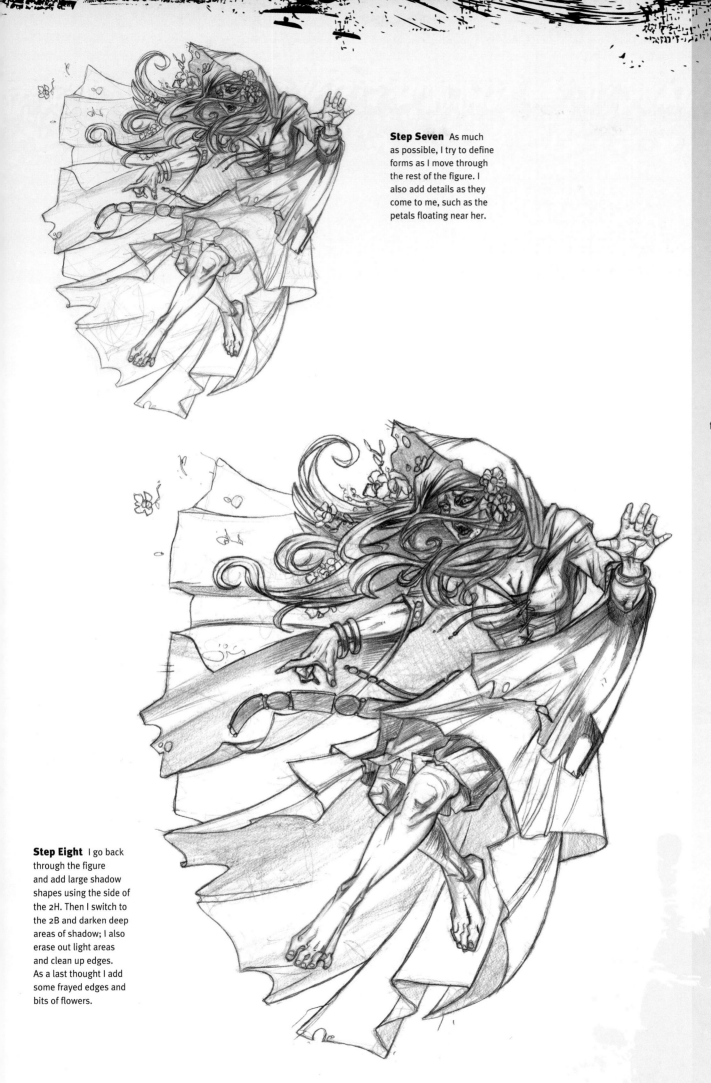

Step Seven As much as possible, I try to define forms as I move through the rest of the figure. I also add details as they come to me, such as the petals floating near her.

Step Eight I go back through the figure and add large shadow shapes using the side of the 2H. Then I switch to the 2B and darken deep areas of shadow; I also erase out light areas and clean up edges. As a last thought I add some frayed edges and bits of flowers.

Cthulhu

From the mind of H.P. Lovecraft came not only a singular creature that terrorized humanity but an entire pantheon of gods, creatures, and worshipers that have been embedded into popular culture. The stories of the Cthulhu (pronounced ka-thoo-loo) mythos have been a huge influence on the horror genre and continue to thrive far beyond the lifetime of Lovecraft himself. Accounts contend that the monstrous being lays in torpor deep in the Pacific Ocean in an antediluvian city that can drive one insane just by trying to comprehend its angles. Cthulhu's followers wait for him and the other Great Old Ones to return and set forth an age of madness, resulting in the end of man. In this project, the challenge is to create a creature that is described as almost unknowable.

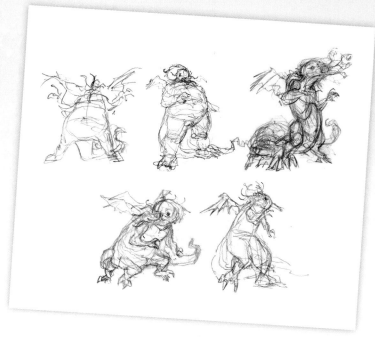

Concept Sketches The thumbnail sketches gave me a few ideas, but I wasn't getting the scale I wanted. I use a 2H pencil to lightly draw the basic pose, imagining a horizon line well below its knees.

Step One Descriptions of Cthulhu are primarily in the form of statues. One account tells us that seeing the beast gave one the impression of an "octopus, a dragon, and a human caricature" with "a pulpy, tentacled head surmount(ing) a grotesque and scaly body with rudimentary wings." We also know it is a large creature from a description that it looked as if "a mountain walked or stumbled."

Step Two Still using the 2H, I use the basic shapes and forms as a guide to place some details that will let me know if I am headed in the right direction. I also start placing lines to indicate perspective and shape, such as the ellipse at the top of the neck and the blocky shapes of the legs. Notice that the viewer's eye level is below the knees.

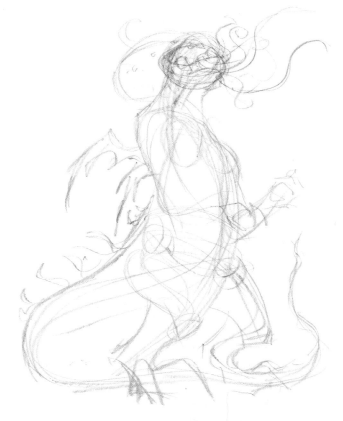

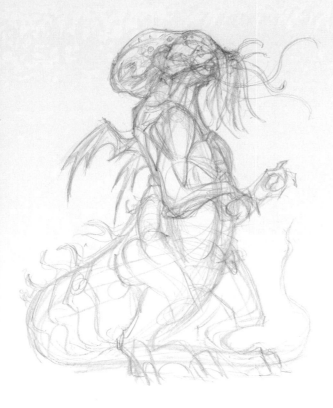

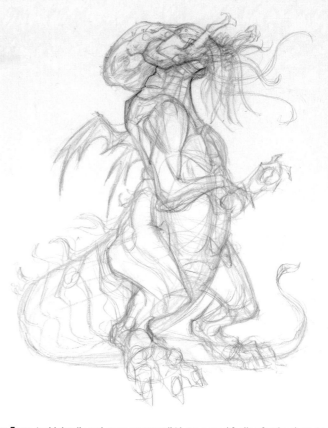

Step Three I continue adding details, using the side of the 2H for larger shapes and the point of the 2H for more specific details, such as those on the head. I add lines on the tail indicating shape, direction, and form so I can use them as a guide.

Step Four I add details and erase areas until I have a good feeling for the character. I also add more specific musculature and surface details. Notice the wrinkles around the neck and how they reinforce the low perspective.

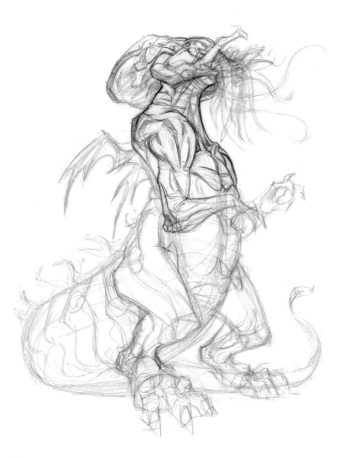

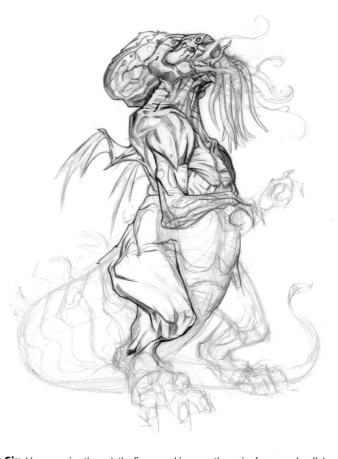

Step Five I switch to a 2B pencil and start to lay in final lines on the upper half of the body. I want to make sure the perspective is reading correctly and that it looks like the viewer is looking up at the gigantic creature. At this point, I'm mostly just outlining forms and finding edges.

Step Six I keep moving through the figure, making sure the major forms read well. I don't like the mandible-esque thing near the mouth so I erase it and change it to another tentacle. I start to place some shadows on the head, chest, and shoulders. All the texture lines of the wrinkles follow the forms underneath them, but they are basically ellipses in perspective, since we are looking at them from below.

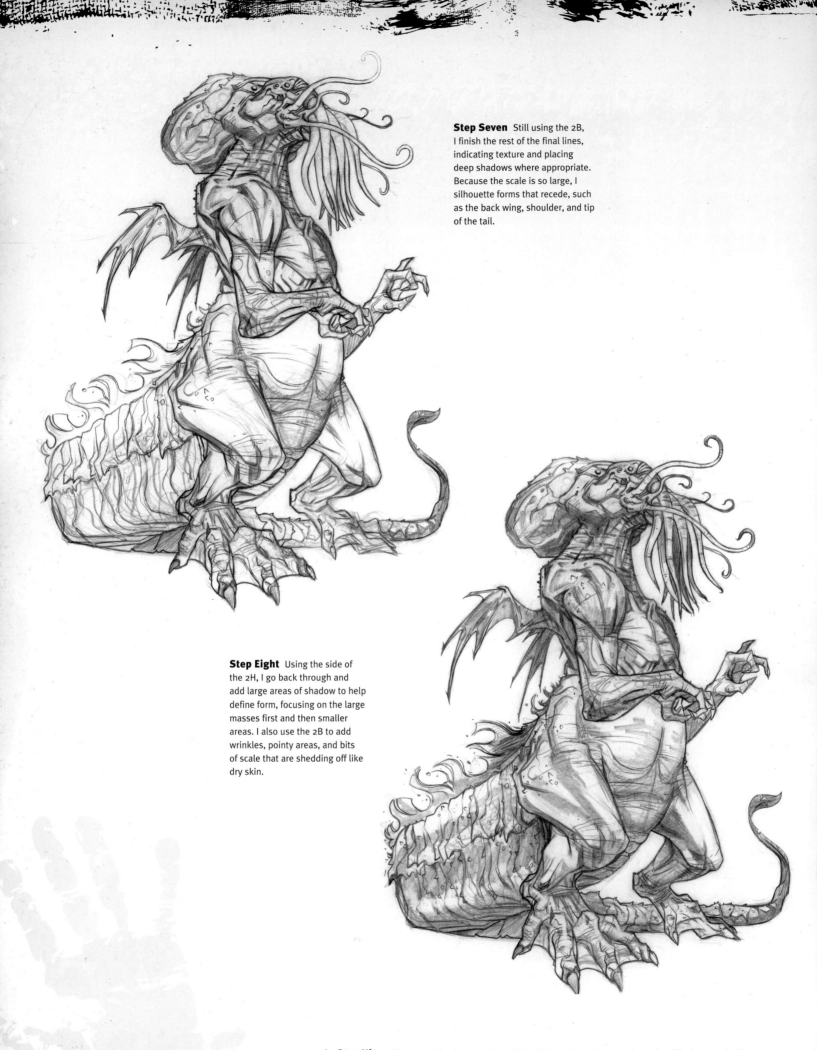

Step Seven Still using the 2B, I finish the rest of the final lines, indicating texture and placing deep shadows where appropriate. Because the scale is so large, I silhouette forms that recede, such as the back wing, shoulder, and tip of the tail.

Step Eight Using the side of the 2H, I go back through and add large areas of shadow to help define form, focusing on the large masses first and then smaller areas. I also use the 2B to add wrinkles, pointy areas, and bits of scale that are shedding off like dry skin.

▶ **Step Nine** After I scan the drawing, I tweak it a bit in order to increase the scale of the beast. I decide on a nighttime palette (blues and greens), using undersea colors like aquamarine blue. I shift to warmer colors in the feet and areas closest to the viewer to emphasize atmospheric perspective.

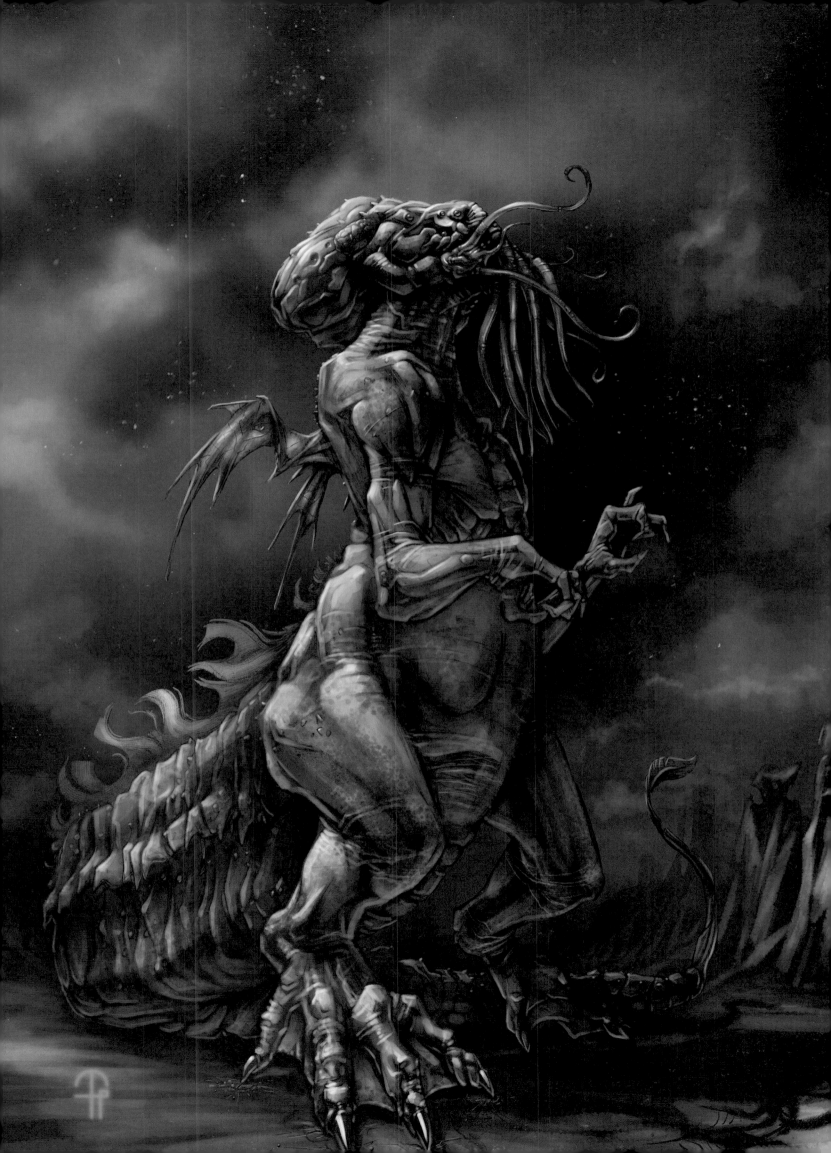

Masked Maniac

Modern cinema is filled with these characters (mostly male) to the point that they have almost become cliché. Generally it's a mass murderer in filthy clothes with some sort of hockey mask, Halloween mask, or even a sack with eye holes. It has become an archetype of horror, and couldn't have been left out of this book, but I want to create something a bit different.

Concept Sketches I sketch several possibilities and keep coming back to the idea of a possessed child. I find a cool ritual Mayan mask, so I'll use that. I've developed a story in my head, which will inform my drawing.

Step One I want the child to have a confrontational attitude—maybe a bit cocky. I use the side of a 2H pencil to lightly lay in the sketch. His head is tilted back, one arm at his side, while the other poorly hides his weapon of choice. I'm pretty sure he'll be holding an axe but haven't decided on the type.

Step Two As the story in my mind develops, I decide to have him holding a decapitated head by the hair. Because this character is a young boy, I use some reference materials to get the proportions right. I continue to lightly place lines with the tip of a 2H pencil, noting major anatomical points and figuring out the proportions and using basic shapes to build the forms.

Step Three The boy's pose was off balance so I adjust the legs. I decide that he is attending a private school, which will give me good details to add to the costume. I also add some background elements and details to the hanging head.

Step Four I develop the costume, including a blazer and tie. I use more pressure on the pencil to darken lines, and I begin detailing the horrific mask. I also decide on a shape for the axe.

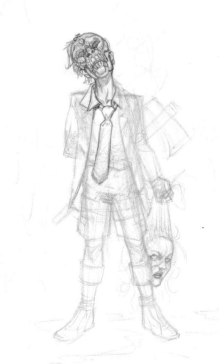

Step Five Starting with the mask, I make some final lines with a 2B pencil. The mask I chose is covered in small tiled stones and jewels. I use the texture of the tiles to indicate edge and form, and I lay in some major shadows (such as under the neck) to make sure the head looks correct before I move to the rest of the body.

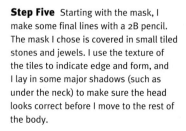

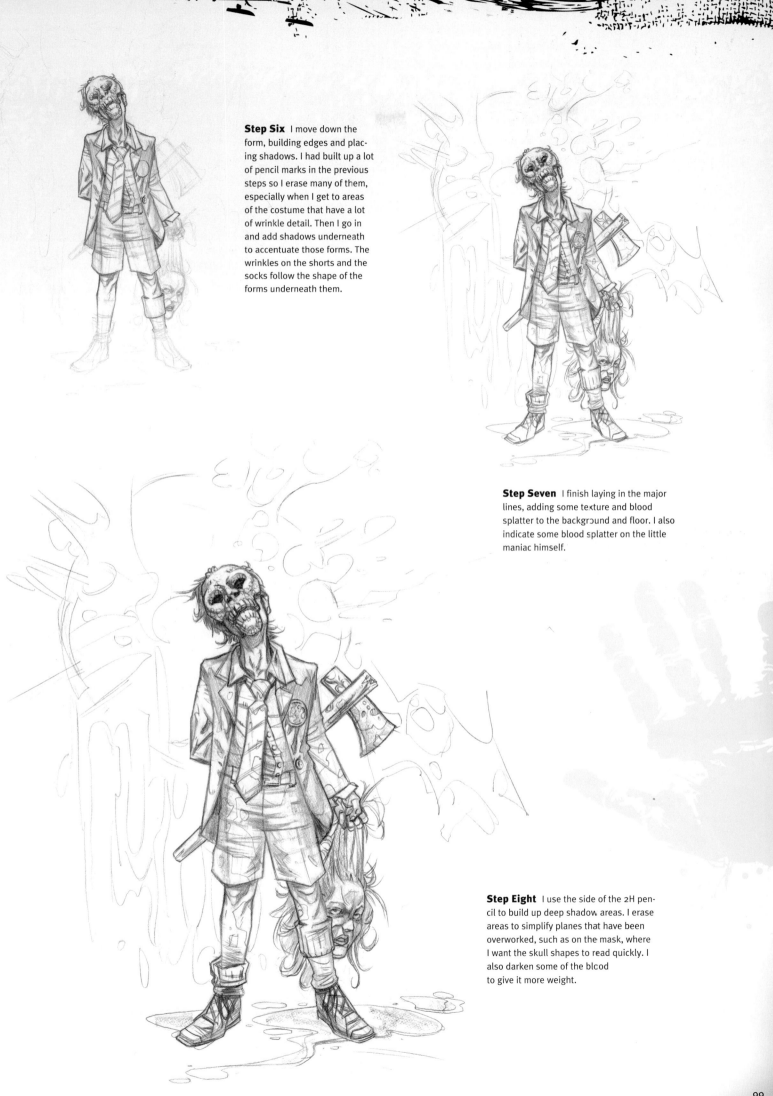

Step Six I move down the form, building edges and placing shadows. I had built up a lot of pencil marks in the previous steps so I erase many of them, especially when I get to areas of the costume that have a lot of wrinkle detail. Then I go in and add shadows underneath to accentuate those forms. The wrinkles on the shorts and the socks follow the shape of the forms underneath them.

Step Seven I finish laying in the major lines, adding some texture and blood splatter to the background and floor. I also indicate some blood splatter on the little maniac himself.

Step Eight I use the side of the 2H pencil to build up deep shadow areas. I erase areas to simplify planes that have been overworked, such as on the mask, where I want the skull shapes to read quickly. I also darken some of the blood to give it more weight.

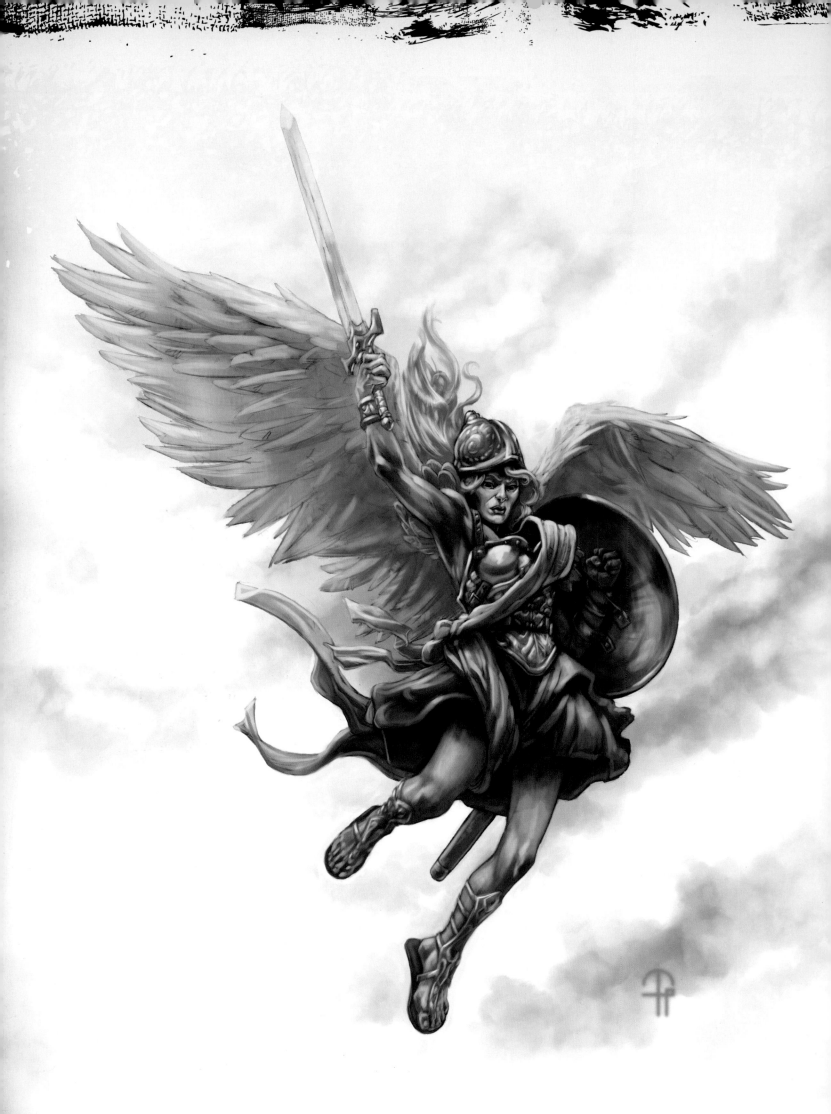

Adventure Characters

The tradition of the fantasy world (also known as Sword and Sorcery) is a mixture of myths, folklore, magic, and a romanticized view of the past. The typical fantasy story is set in a world inhabited by mythical beings, where gods take an active role in toying with the world, and magic is the equivalent social force to science: propelling both everyday convenience and large-scale warfare. The stories of JRR Tolkien, the folkloric tradition of Europe, and role-playing games are the sources of my archetype choices.

Young Hero

Evil despots underestimate the power of children to unravel their plans at their own peril. There are myriad films, books, and comics that attest to this very circumstance, and far be it for me, just one man, to contradict these hundreds (possibly thousands) of storytellers. They say that one's personality is pretty much fully formed by the age of 4 or 5, so it stands to reason that when backed into a corner, not every 10-year-old girl would pick up a sword to defend what she thinks is right; but a 10-year-old hero would. I want to create a child who is limited in size and strength but all hero in terms of personality and commitment to action.

Concept Sketches My first inclination was to go with a pose where the hero is standing with a weapon or arms akimbo, but I came across the charging pose and decided to go with it. It shows the ferocity of the character and the diminutive size in contrast with the weapon.

Step One I lightly sketch the charging pose with a 2H pencil, keeping in mind that I need to use a child's proportions so that the figure doesn't look like an adult. I also decide that the figure will be female.

Step Two I start adding the basic forms, drawing a centerline down the torso to reflect the twisting body. A child's head is much larger than an adult's (compared to body size), and the rest of the forms are less dramatic and smaller in size. I use reference materials as I draw, noting that the smaller musculature affects the forms of the body.

Step Three Getting more specific with the anatomy, I note major forms and indicate the planes of the skull so I can build up the facial expression.

Step Four Now that I have a good feeling for the underlying anatomy, I start to rough in the costume. I want her to look like a peasant girl, so I choose a simple dress, soft boots, and maybe an apron. I also sketch a bonnet flying off her head as an added touch. Then I further develop the face, trying to get a better feeling for her personality.

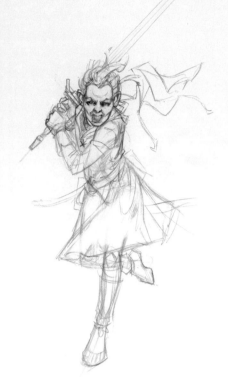

Step Five I use a ruler to create a center-line on the sword and then build the other lines of the sword all the way down the blade and into the guard, hilt, and pommel. I want the sword to be large compared to the girl but not so heavy that she couldn't pick it up. I also experiment with the flow of her hair and the top part of the blouse that interacts with her head.

Step Six Now I start laying in final lines with a 2B, filling in shadows and finding form edges. As I move down the figure to the boots, I lightly draw crisscrossing straps before using more pressure to define the edges. I also sketch a cast shadow on the ground.

Step Seven After I finish the major outlines, I go back in with the side of the 2H to create large areas of shadow and tone to help fill out the forms. Then I move through the rest of the figure and outline the rest of the shapes.

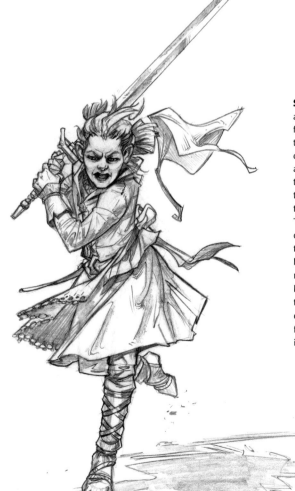

Step Eight After I get all the way through the figure, I erase some areas to enhance form and add deeper shadows to other areas with the 2B. Note that the more lines you place on the face, the older and uglier the character becomes: This applies to adults and children. I erase most of the structure of the face I had previously built up and redraw it to make her face look younger. Finally, I add tone to the cast shadow and draw some bits around her foot to show that she's kicking up dirt.

Evil Sorcerer

Magic users go by several different names: wizard, warlock, mage, and sorcerer are a few. They are either gifted with innate ability or have studied occult lore to gain the power to bend reality in supernatural ways. Since they wield powerful magic, sorcerers don't need to be physically strong, and usually accessorize with wands, staffs, capes, outlandish hats, and books rather than swords and armor. From an artist's standpoint, magic users are great fun and allow us to do all kinds of bizarre glowing effects and outrageous poses that have no other application other than maybe conducting an orchestra or possibly stretching. I want to go with an exaggerated pose and some dramatic wand effects, which will look great in color.

Concept Sketches I want to depict character with an exaggerated, confident pose that looks like he is casting a spell. The pose with outstretched arms seems to fit the bill.

Step One I enlarge the thumbnail sketch and lightly trace it with a 2H pencil, indicating the major shapes of the pose. I indicate the ellipses of the torso and the placement of the wand effect over his head.

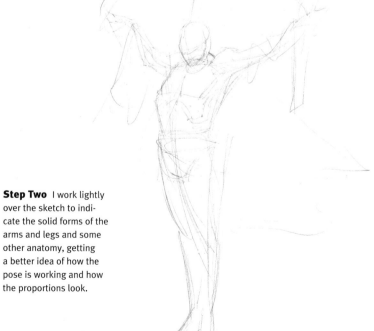

Step Two I work lightly over the sketch to indicate the solid forms of the arms and legs and some other anatomy, getting a better idea of how the pose is working and how the proportions look.

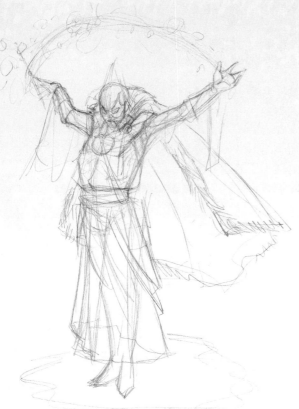

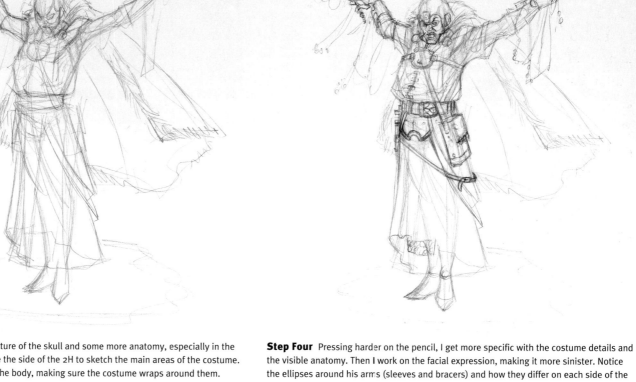

Step Three I create the structure of the skull and some more anatomy, especially in the shoulders and arms. Then I use the side of the 2H to sketch the main areas of the costume. I "draw through" the forms of the body, making sure the costume wraps around them.

Step Four Pressing harder on the pencil, I get more specific with the costume details and the visible anatomy. Then I work on the facial expression, making it more sinister. Notice the ellipses around his arms (sleeves and bracers) and how they differ on each side of the body. I also indicate a bunch of strung-together beads that may be part of the ritual or a fashion statement.

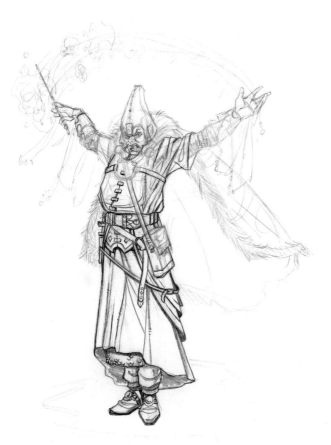

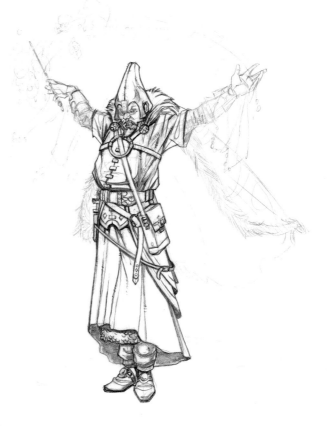

Step Five I grab my 2B and start to lay in final lines. Starting with the feet, I am mostly just outlining form, finding plane breaks, indicating texture, and filing in smaller areas of shadow. I switch to the side of the 2H to fill in the shadow under the robe. The shapes around the wand effect look like skulls so I add some more lines to define them.

Step Six Working up toward the head, I continue adding final lines to the details of the costume, including the bag that holds the spell book and the hat.

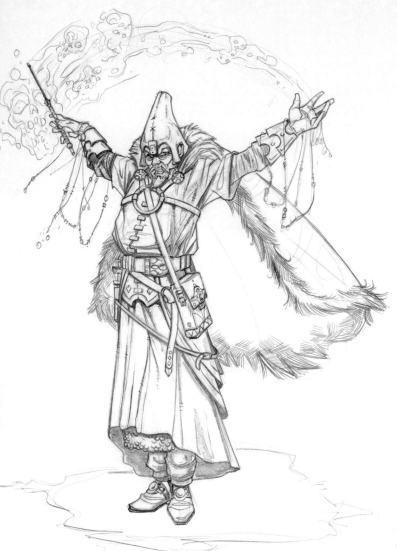

Step Seven I finish outlining the figure, and then use hatching to indicate the fur trim on the cape. As I darken the lines of the wand effect, I use a very sharp point on my pencil. I want to keep them nice and thin so they appear less substantial, as I will be coloring them.

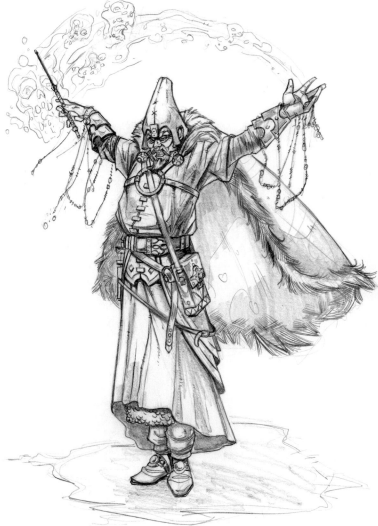

Step Eight I use the side of the 2H to lay in some midtones and large shadow areas.

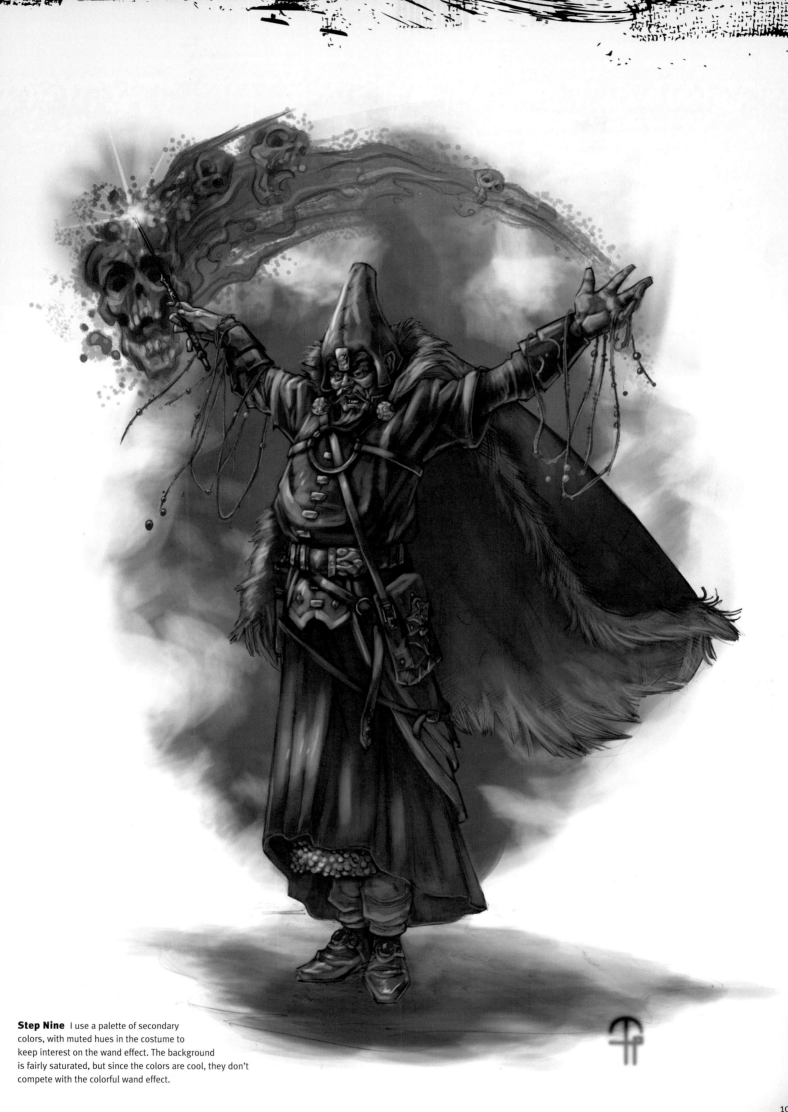

Step Nine I use a palette of secondary
colors, with muted hues in the costume to
keep interest on the wand effect. The background
is fairly saturated, but since the colors are cool, they don't
compete with the colorful wand effect.

Gnome Dragon Slayer

Known for being intelligent, wearing red conical hats, and helping with gardening at night, gnomes are often cast as inventors, tricksters, or whimsical creatures. In the interest of being different, I'd like to cast my gnome in the role of Dragon Slayer. I like the idea of a very small character taking on one of fantasy's largest and most powerful creatures. I want to combine the physical characteristics of the gnome with the slightly oversized gear of a hardened fighter.

Concept Sketches I want a pose that indicates the figure is ready for action, and I find I prefer the pose with the low stance and large spear.

Step One I lightly sketch the pose with a 2B pencil and indicate the shaft of the spear. The gnome's body is short and compact so the basic forms are pretty well taken care of already. Note how the centerlines of the torso and head indicate direction and form.

Step Two I start indicating his anatomy and lay in some facial features to get an idea of his expression and personality. I also sketch some of the costume and more equipment.

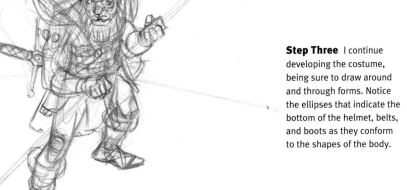

Step Three I continue developing the costume, being sure to draw around and through forms. Notice the ellipses that indicate the bottom of the helmet, belts, and boots as they conform to the shapes of the body.

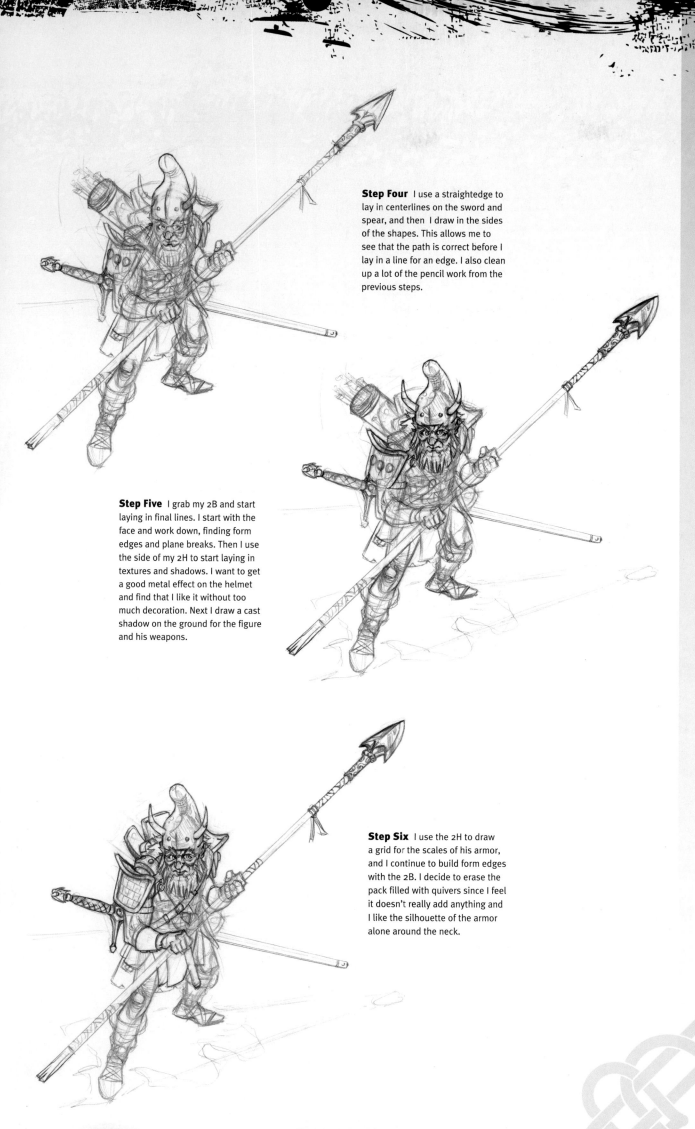

Step Four I use a straightedge to lay in centerlines on the sword and spear, and then I draw in the sides of the shapes. This allows me to see that the path is correct before I lay in a line for an edge. I also clean up a lot of the pencil work from the previous steps.

Step Five I grab my 2B and start laying in final lines. I start with the face and work down, finding form edges and plane breaks. Then I use the side of my 2H to start laying in textures and shadows. I want to get a good metal effect on the helmet and find that I like it without too much decoration. Next I draw a cast shadow on the ground for the figure and his weapons.

Step Six I use the 2H to draw a grid for the scales of his armor, and I continue to build form edges with the 2B. I decide to erase the pack filled with quivers since I feel it doesn't really add anything and I like the silhouette of the armor alone around the neck.

DID YOU KNOW?

Gnome sightings have been recorded as recently as 2008.

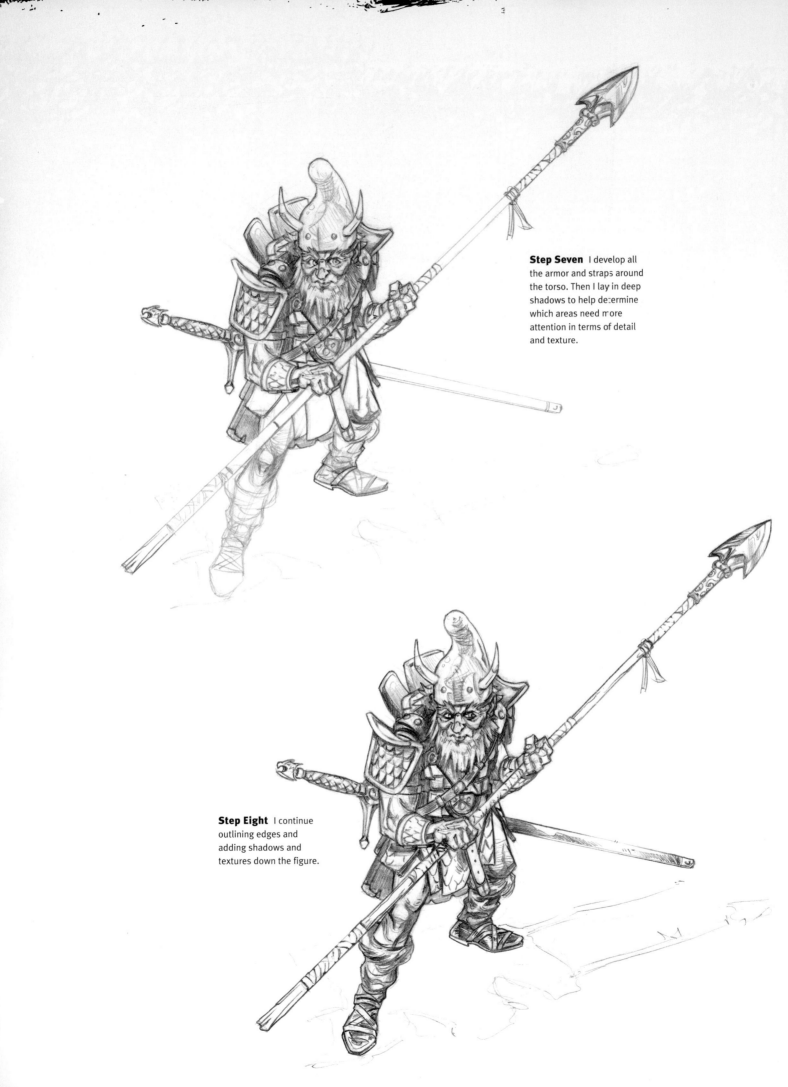

Step Seven I develop all the armor and straps around the torso. Then I lay in deep shadows to help determine which areas need more attention in terms of detail and texture.

Step Eight I continue outlining edges and adding shadows and textures down the figure.

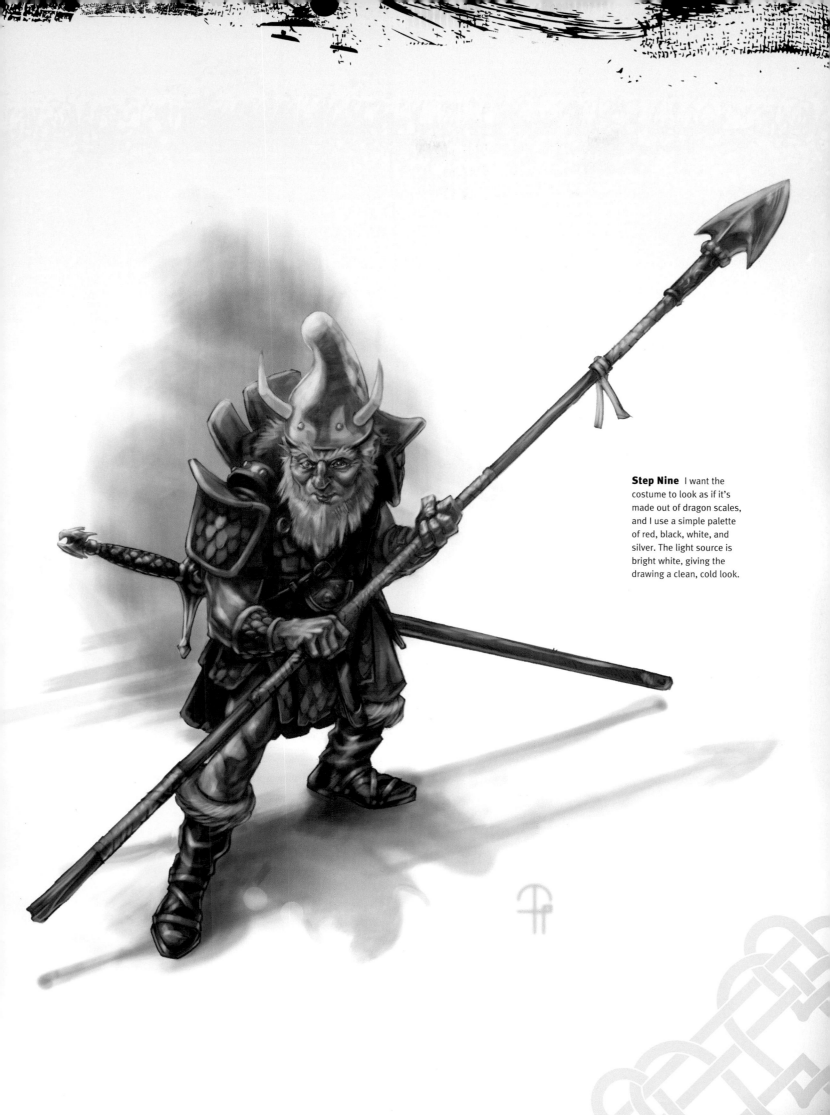

Step Nine I want the costume to look as if it's made out of dragon scales, and I use a simple palette of red, black, white, and silver. The light source is bright white, giving the drawing a clean, cold look.

Druid

In role-playing games and fantasy fiction, druids are far removed from their historical namesakes. From the little evidence we have, we know that historical druids were scholars and worshipers of nature and the movements of celestial objects. In fantasy, druids are more like nature sorcerers. They gain supernatural power from nature and can manipulate plant life and talk to animals. I imagine that bring removed from city life and living in nature would result in a monk- or hermit-like character, so I use this as my starting point in my thumbnails.

Concept Sketches I am looking for a pose that is mystical but relaxed and comfortable. I am not yet sure if I want a male or female character.

Step One I enlarge the thumbnail I like best and lightly trace the pose onto Bristol board with a 2H pencil. Keep in mind that you're not a slave to the thumbnail—just use it as a reference as you draw.

Step Two I lightly lay in the basic forms and anatomy. I've decided to go with a large male character. He will mostly be covered by robes so I lay in the costume with the basic forms.

Step Three Using the side of the 2H pencil, I develop the costume a bit further, trying to get a feeling for the way the robes wrap around the figure. I also experiment with some props like the shepherd's crook and different packs, bags, and jewelry. His head was too small in the last step so I enlarge it and lay in the forms of the skull so I can build up the facial expression in the next steps.

Step Four After I get a facial expression I like, I go back to the costume and really develop the forms and details. When drawing wrinkles and pleats in fabric, remember that they compress as forms move into the distance. I decide that instead of a shepherd's staff, he should have a "living" staff covered in plants.

Step Six I move through the rest of the figure, mostly outlining forms and placing textures and shadows. I also draw the plant in his right hand, making it curl up toward the sun. Before I lay in any final textures, I dab at the area with my kneaded eraser so that the final lines will stand out more strongly.

Step Five Now I start to lay in final lines with the 2B, outlining edges and finding plane breaks and textures. The sleeve closest to the viewer is defined by the cloth that hangs from his large round shoulder and gathers at the bend in his elbow

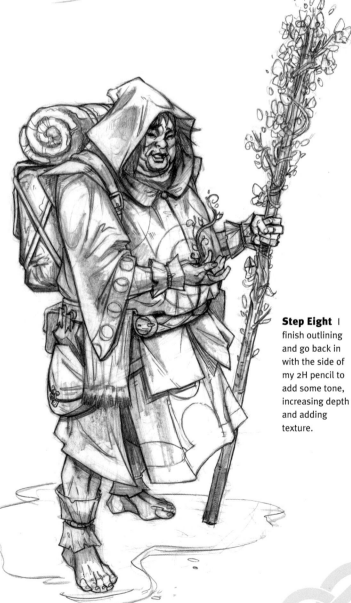

Step Eight I finish outlining and go back in with the side of my 2H pencil to add some tone, increasing depth and adding texture.

Step Seven As I place the final lines on the costume I am conscious of the forms underneath. Note how the hood conforms to the dome shape of the head and then drapes into looser forms as it falls away. The figure has a pudgy face but the forms still conform to the skull structure. Look at some reference materials to see how fat drapes and pinches much like fabric does.

Swordsman

Peter Blood, Conan, D'Artagnan, Zatoichi: The swordsman can take many forms, but always retains an air of mystery and deadly grace. Their dedication to swordsmanship allows these warriors to slide through their enemies like an elegant reaper. I want to depict a character from the subset of swordsmen known as Ronin, or the lone swordsman. This character type comes in many flavors but generally has some reason for moving often and alone. Sometimes it is the burden of genius that drives them to seek a worthy opponent, and sometimes they are motivated by their painful past. Whatever the case, the lone swordsman usually finds trouble, unless it finds him first. In most fiction, swordsmen are also known to hold to some kind of code, such as the Bushido code of the samurai, the pirate code, or the chivalric code of Arthurian fame.

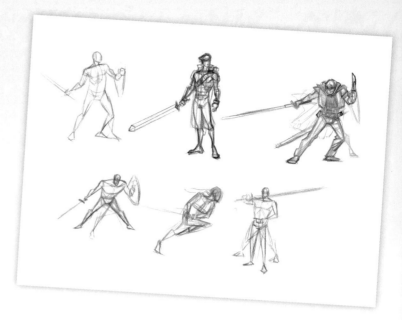

Concept Sketches When depicting any efficient killer, it's important to capture a sense of power and grace in the pose. Even a relaxed, non-fighting pose can get this across, but I prefer the coiled, ready-to-strike pose.

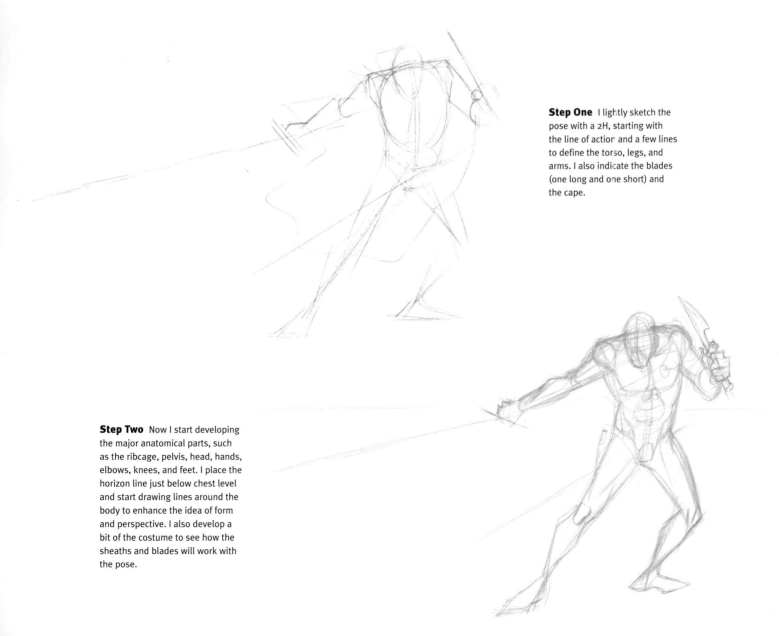

Step One I lightly sketch the pose with a 2H, starting with the line of action and a few lines to define the torso, legs, and arms. I also indicate the blades (one long and one short) and the cape.

Step Two Now I start developing the major anatomical parts, such as the ribcage, pelvis, head, hands, elbows, knees, and feet. I place the horizon line just below chest level and start drawing lines around the body to enhance the idea of form and perspective. I also develop a bit of the costume to see how the sheaths and blades will work with the pose.

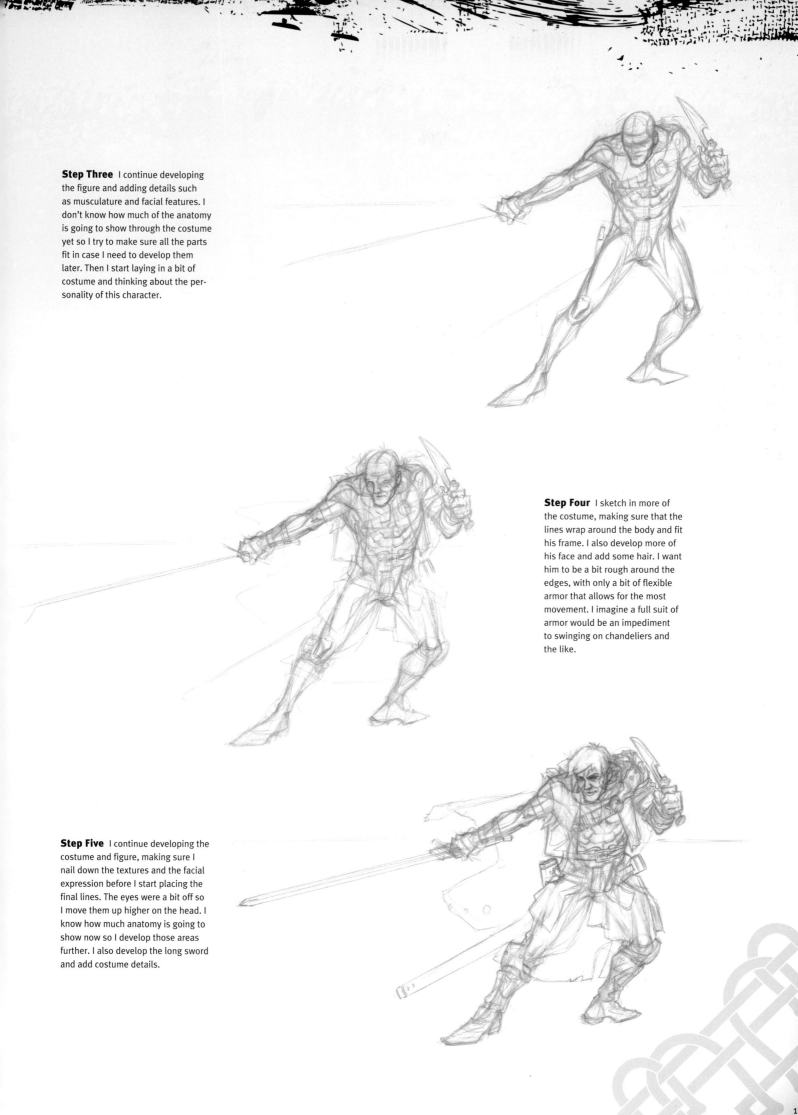

Step Three I continue developing the figure and adding details such as musculature and facial features. I don't know how much of the anatomy is going to show through the costume yet so I try to make sure all the parts fit in case I need to develop them later. Then I start laying in a bit of costume and thinking about the personality of this character.

Step Four I sketch in more of the costume, making sure that the lines wrap around the body and fit his frame. I also develop more of his face and add some hair. I want him to be a bit rough around the edges, with only a bit of flexible armor that allows for the most movement. I imagine a full suit of armor would be an impediment to swinging on chandeliers and the like.

Step Five I continue developing the costume and figure, making sure I nail down the textures and the facial expression before I start placing the final lines. The eyes were a bit off so I move them up higher on the head. I know how much anatomy is going to show now so I develop those areas further. I also develop the long sword and add costume details.

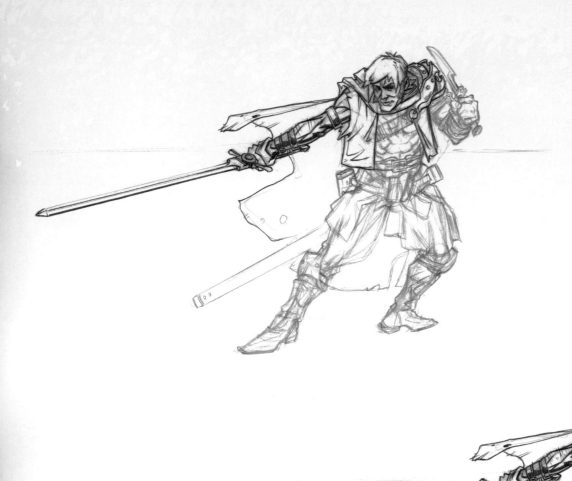

Step Six I decide that the light source is coming from above and a bit to the left, so I switch to a 2B pencil and begin with the lines and shadows. The important thing here is to make sure to keep the lines "alive" so I don't end up with lines that make the figure too stiff.

Step Seven I continue working my way down the body, darkening lines and adding shadows.

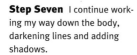

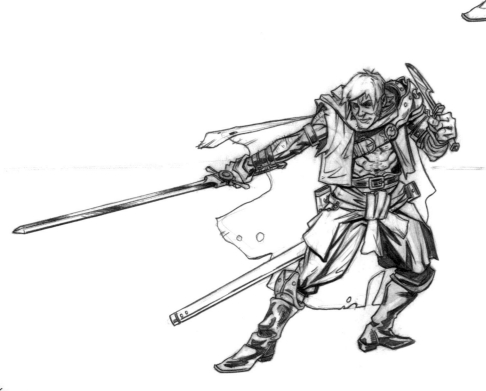

Step Eight I finish outlining shapes and darkening the final lines and add more shadows where needed.

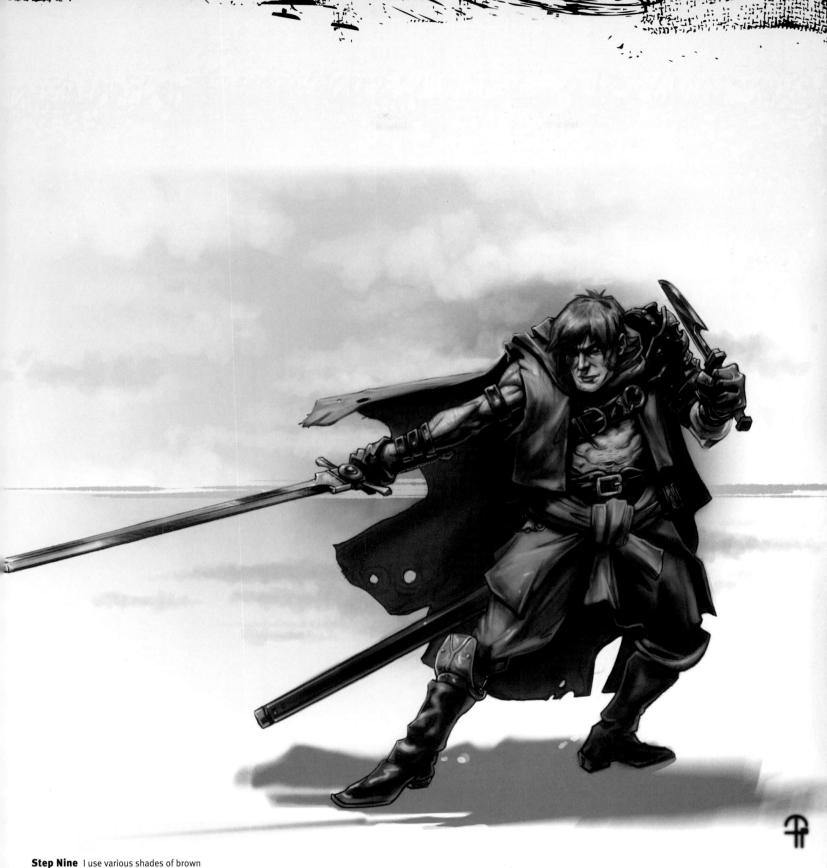

Step Nine I use various shades of brown and black for the clothing, shades of blue and beige for the background, and lighter pastels for the figure.

Drow

The cave-dwelling branch of the elven race are known as Drow. They are sometimes seen as the evil counterpart to the more kindly tree-dwelling variety. Some stories hold that the Drow were once of the same race as the other elves but were twisted by devotion to an evil god, black magic, or some other evil or impure force. Since they spend their lives underground, they are usually depicted wearing all black with white skin and hair, which probably doesn't help diminish the evil stereotype.

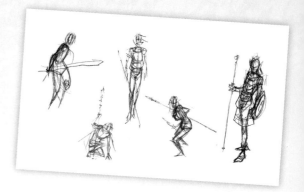

Concept Sketches To me, elves give the feeling of catlike movement: graceful and sometimes intimidating.

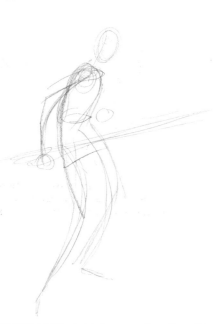

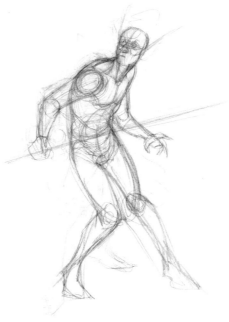

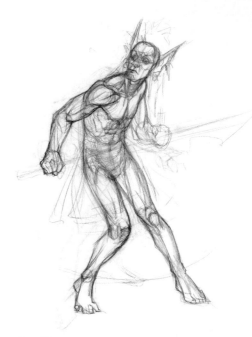

Step One I lightly sketch the pose with a 2H pencil. I am thinking of making the pose look as if he was moving and noticed something that caused him to stop short and turn.

Step Two The pose feels a bit too conventional for me so as I add the basic forms, I exaggerate the pose to make the figure look less human and more animal-like. Having him be up on his toes helps.

Step Three I want to have most of his anatomy showing so I take extra care in developing it. I also spend some time experimenting with the face, hair, and costume. For the costume I am thinking along the lines of cave dwelling, nocturnal creatures like crows, bats, and spiders. For example, his ears are taking a decidedly bat-like turn at this point

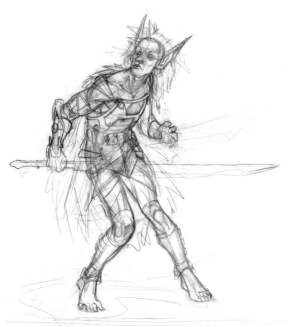

Step Four As I get more specific with the costume, I maintain the theme, using crow-like feathers on the cape and adding some spider designs to the armor and belt. I lay in a rough version of the sword, which I want to look rough and unfinished, as he is a native cave dweller.

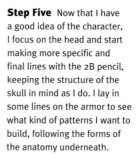

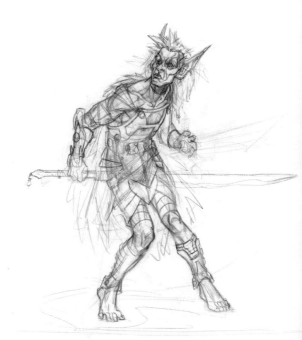

Step Five Now that I have a good idea of the character, I focus on the head and start making more specific and final lines with the 2B pencil, keeping the structure of the skull in mind as I do. I lay in some lines on the armor to see what kind of patterns I want to build, following the forms of the anatomy underneath.

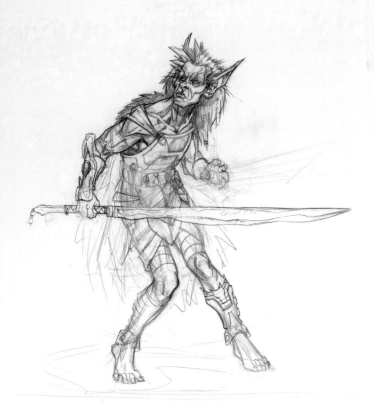

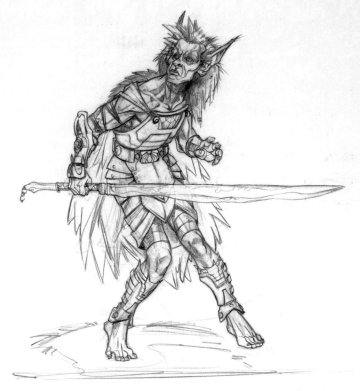

Step Six I move down the rest of the body, defining edges and building shadows and textures. I use the side of the 2H to create silhouetted forms and deep shadows, such as the armpit and the shadows cast by his head.

Step Seven I outline the forms and plane edges throughout the rest of the figure, keeping in mind the basic forms and laying in shadows where necessary. I erase my construction lines as I go, first by dabbing with the kneaded eraser and then (after the final lines are drawn) with a thick plastic eraser.

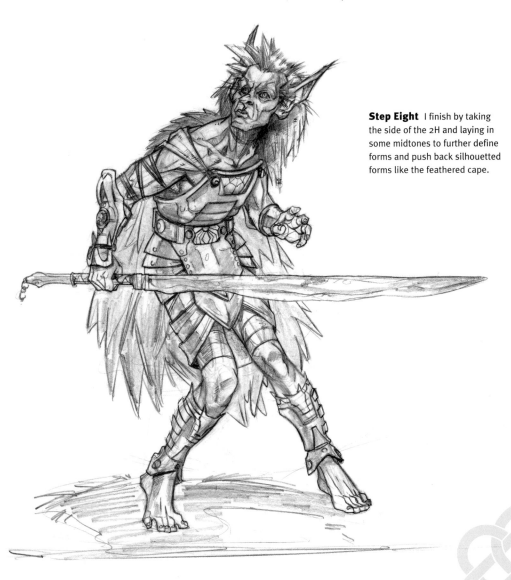

Step Eight I finish by taking the side of the 2H and laying in some midtones to further define forms and push back silhouetted forms like the feathered cape.

Barbarian Warrior

Stomping through the tundra in nothing but a loin cloth and sparse armor and bristling with weapons, the barbarian warrior is a romantic vision of the northern invaders that swept through Europe in the fifth century. In fantasy, barbarians are the ultimate primitive warrior, with rude-looking equipment but the ability to single-handedly take on entire civilized armies. So the character we are creating needs to have a wild, unfinished look and project the kind of power that would make his or her fighting prowess believable.

Concept Sketches I want an aggressive pose; at this stage I have not decided the gender of the character.

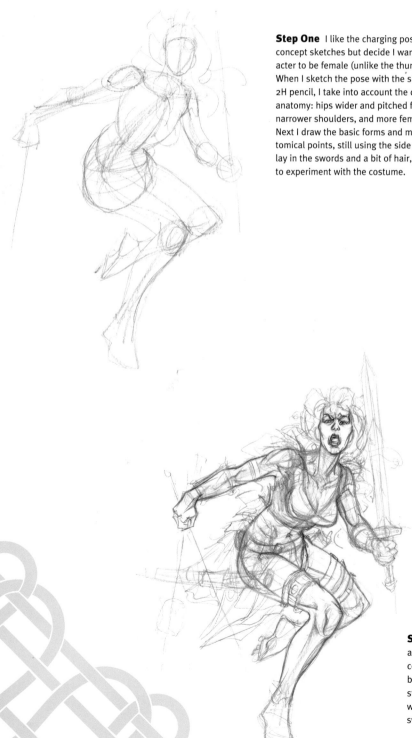

Step One I like the charging pose from my concept sketches but decide I want the character to be female (unlike the thumbnail). When I sketch the pose with the side of a 2H pencil, I take into account the different anatomy: hips wider and pitched forward, narrower shoulders, and more feminine legs. Next I draw the basic forms and major anatomical points, still using the side of the 2H. I lay in the swords and a bit of hair, and I start to experiment with the costume.

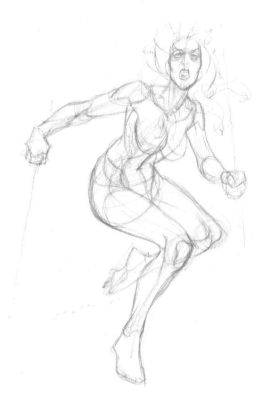

Step Two Barbarians generally show a lot of skin, so I develop the anatomy more than I usually would at this stage. I also start developing the structure of the skull and face.

Step Three I further define the muscles and use the side of the 2H to sketch some costume ideas. Notice the ellipses formed by the belt around her waist, as well as the straps around her thighs. I also experiment with facial expressions and develop the sword on the right.

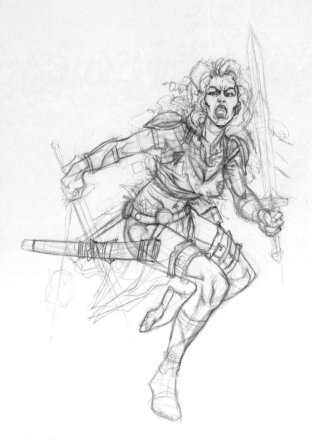

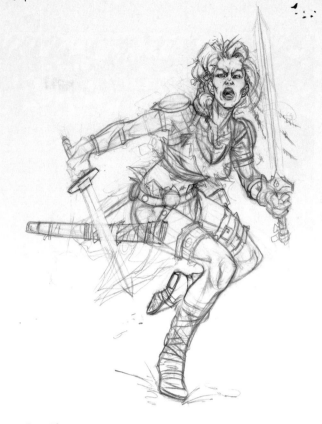

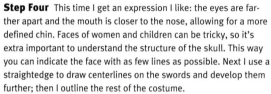
Step Four This time I get an expression I like: the eyes are farther apart and the mouth is closer to the nose, allowing for a more defined chin. Faces of women and children can be tricky, so it's extra important to understand the structure of the skull. This way you can indicate the face with as few lines as possible. Next I use a straightedge to draw centerlines on the swords and develop them further; then I outline the rest of the costume.

Step Five Now I lay in the final lines with the 2B, finding edges, planes, and textures. I also start to erase most of the construction lines, cleaning up edges with a hard plastic eraser.

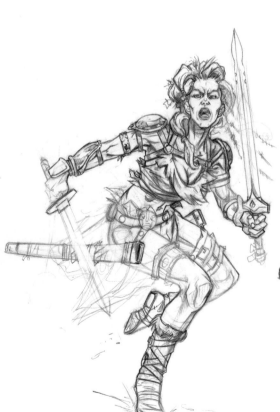

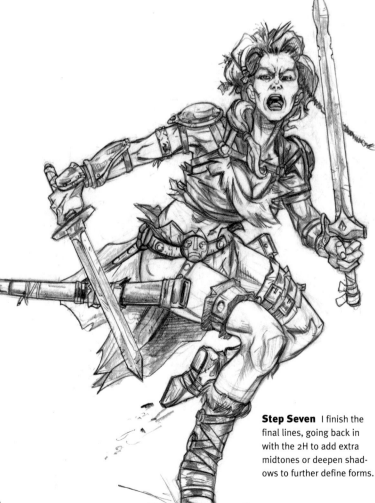

Step Six I move through the rest of the figure, adding shadows and refining the visible anatomy. On areas of metal, I use the side of the 2H to lay in streaks of high-contrast reflections, and then go in with the 2B to harden the edges, providing a metallic look. When adding wrinkles to the clothing, I make sure to follow the forms underneath them.

Step Seven I finish the final lines, going back in with the 2H to add extra midtones or deepen shadows to further define forms.

Jester

Jesters were employed to tell jokes and provide entertainment in royal courts and great houses of Europe until the 18th century. The earliest Jesters wore a donkey's ears and tail, which morphed into the familiar multicolored hat with three points tipped with jingle bells. Jesters have a reputation of speaking the truth freely and possessing the sharpest mind in the castle. In the fantasy world, they are portals into all aspects of court life, since their role as fool affords them almost unlimited access in a nearly invisible way. They are allowed interaction with everyone from the King to the stable boy and essentially hide in plain sight.

Concept Sketches I would like an active pose that shows both jocularity and agility.

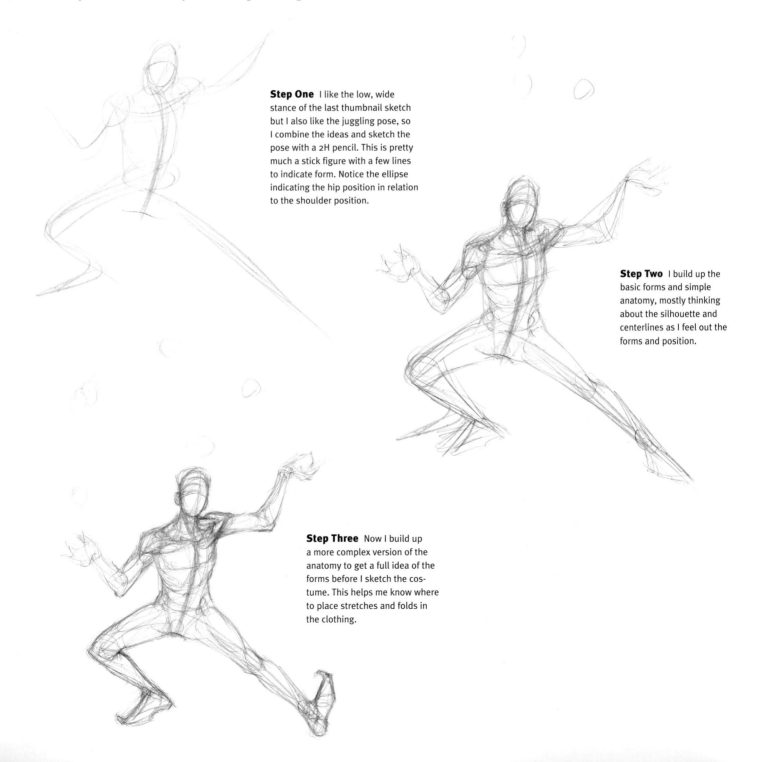

Step One I like the low, wide stance of the last thumbnail sketch but I also like the juggling pose, so I combine the ideas and sketch the pose with a 2H pencil. This is pretty much a stick figure with a few lines to indicate form. Notice the ellipse indicating the hip position in relation to the shoulder position.

Step Two I build up the basic forms and simple anatomy, mostly thinking about the silhouette and centerlines as I feel out the forms and position.

Step Three Now I build up a more complex version of the anatomy to get a full idea of the forms before I sketch the costume. This helps me know where to place stretches and folds in the clothing.

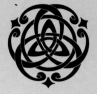

Step Four With the side of the 2H I lay in a rough version of the costume. I freely but lightly lay down lines, making sure I can easily erase them later as I refine the drawing. I build up puffy forms with layers and add many points with bells. Then I rough in the facial expression, going for a "Ta-Da!" moment.

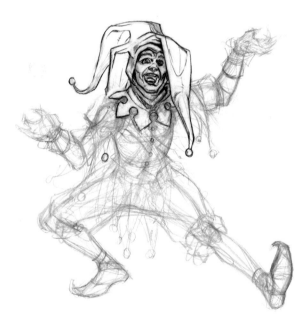

Step Five I'm confident with the rough so I pick up a 2B pencil and begin the final lines, starting with the head. As I draw I consider the underlying forms: the skull under the face and the tapered cylinders of the hood and its points.

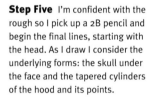

Step Six I continue to move down the body, outlining forms and plane edges and defining textures. I switch to the 2H to more clearly define his hands and the points around his waist, as well as the ribbons on his legs. I leave areas of shadow alone and basically draw in light planes with the eraser as I remove the construction lines.

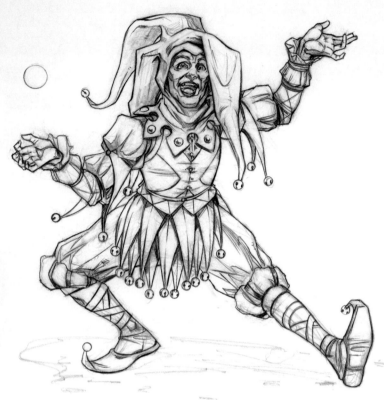

Step Seven The bells need some help so I blot them with the kneaded eraser and redraw them using a circle template. I do the same for the balls in the air and then finish outlining forms and surface details with the 2B. Then I place a sketchy cast shadow to indicate the ground.

Step Eight I finish by using the side of the 2H to place midtones and define forms with simple, blocky shadows.

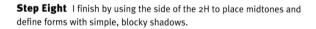

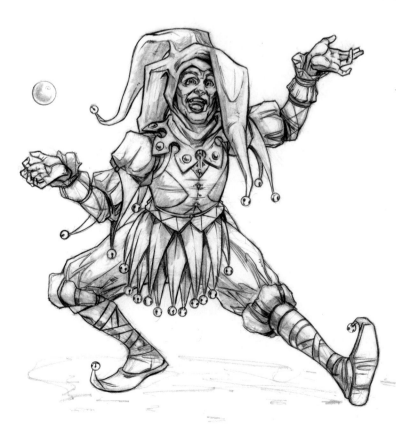

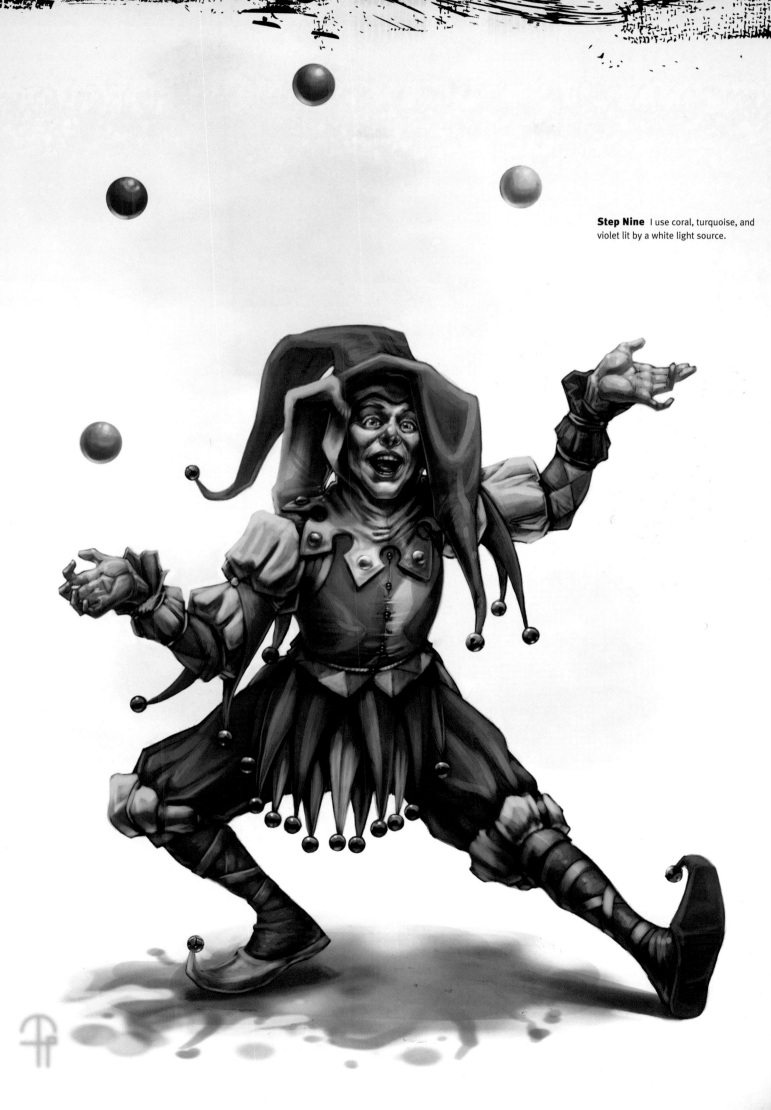

Step Nine I use coral, turquoise, and violet lit by a white light source.

Blacksmith

When you live and die by your sword, you're going to want to get a good one and keep it sharp. Master blacksmiths are credited with the creation of many powerful and legendary weapons, armor, and magically enhanced items. Characters like this, along with barmen, serving wenches, and the like, help to fill out and define different worlds. For the purpose of the adventurer, these characters can be a great source of local information and can help when the hero is in a pinch.

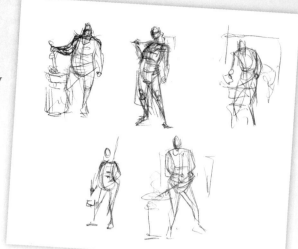

Concept Sketches I want to find a nice, relaxed pose that can show off the power of someone who swings a hammer all day but also serves the public.

Step One I lightly draw the pose and indicate the hammer, since it is a large form the affects the pose. Then I indicate the major forms such as the knees, hip bones, ribcage, and shoulders. Her waist is at eye level, as indicated by the ellipses of the hips and ribcage.

Step Two I get more specific with anatomy to check my proportions and the position of the figure. I also work on the face to get an idea of personality and expression.

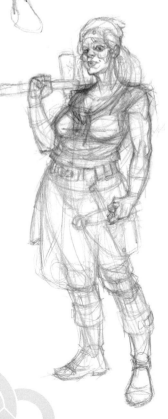

Step Three With the side of the 2H, I roughly sketch the costume and props. As I draw, I refine the visible anatomy, especially where it interacts with props such as the hammer and tongs. I don't get caught up in the details at the stage since I am thinking about forms and how they wrap around the body.

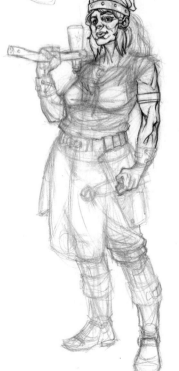

Step Four Next I add the bracers and erase some of the construction lines with the kneaded eraser. I add a few more surface details with the 2H. Then I switch to the 2B to continue finding forms and plane edges, defining forms with textures like those in the hair and clothing.

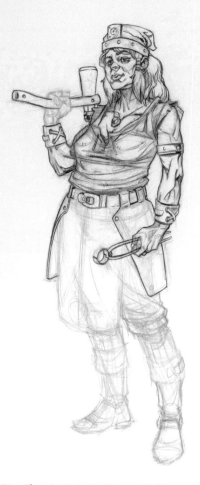

Step Five As I lay in final lines and build texture, I add more wrinkles and strands of hair in areas of shadow and leave areas of light open. Keep in mind that lines on light edges are thinner and lines on shadow edges are thicker.

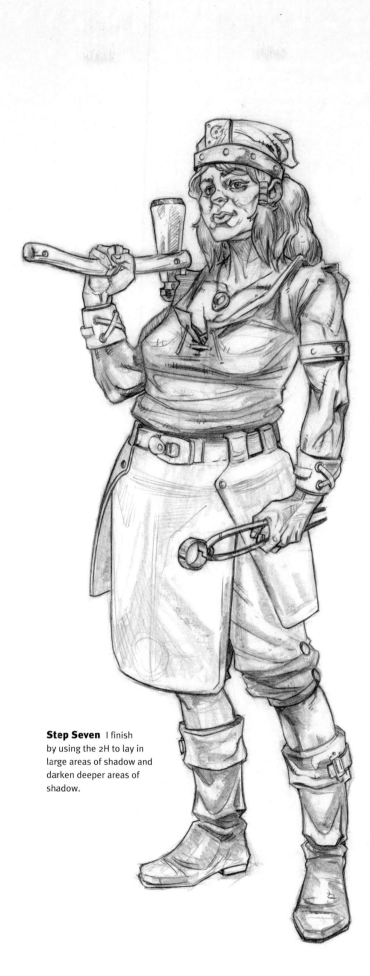

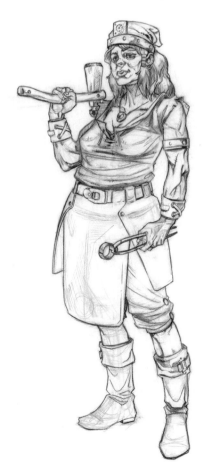

Step Seven I finish by using the 2H to lay in large areas of shadow and darken deeper areas of shadow.

Step Six I finish outlining and defining texture on the figure. Notice that the ellipses above the chest are seen from below and those beneath the chest are seen from above. This also applies to the belt, boots, and wrinkles on the clothing.

Maiden

Always in peril from a dragon, witch, or marriage to some vile despot, the tower-bound maiden awaits the arrival of her hero. A virtuous young woman will often be abducted or tricked into imprisonment, providing the catalyst for a dashing young man (most likely a prince) to ride off and become a hero. In our time, this idea may seem very anachronistic and has been lampooned to the point of cliché, but many of our favorite female leads are essentially built on this model: Rapunzel, Snow White, and Sleeping Beauty, to name a few.

Concept Sketches I'm thinking of a scene where the maiden sweeps out onto her balcony, singing of her true love. A little bird friend always helps too.

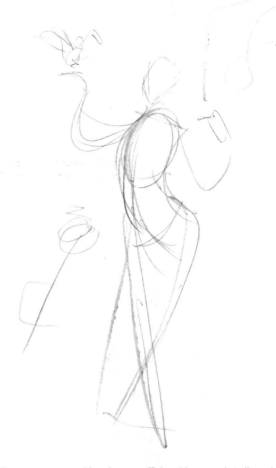

Step One For some reason, maidens have an affinity with nature that allows them to draw in wild birds (and mice and other cuddly forest creatures) as if they had been trained. I choose the pose with the maiden gracefully outstretching her arm, waiting for a bird to land on it. I enlarge the pose from the thumbnail and sketch it using a lightbox.

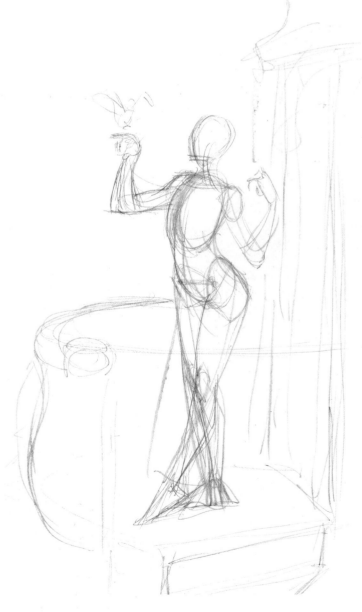

Step Two Using a 2H, I work up the basic forms, checking proportion and position. I also indicate some of the balcony she stands upon and a rough version of the bird.

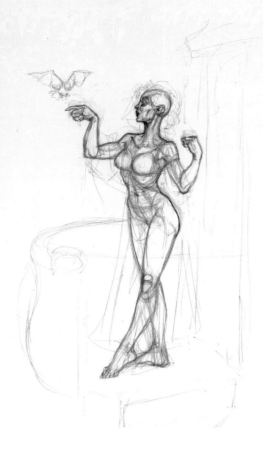

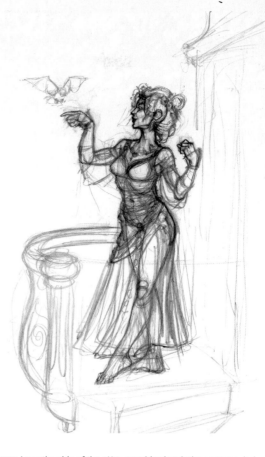

Step Three I lay in more specific anatomy, checking proportion and position as I go. The eye level is at about shoulder height, and the ellipses around the forms reflect this. I also sketch the basic forms of the bird.

Step Four I use the side of the 2H to roughly sketch the costume, hair, and background elements. I sketch several ellipses at key points to use as guides as I define the forms of the dress and indicate the movement of the skirt.

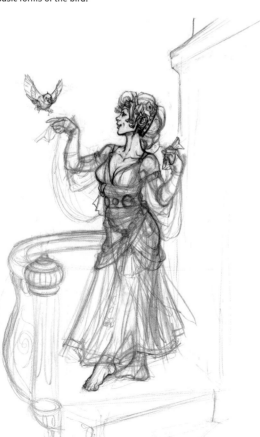

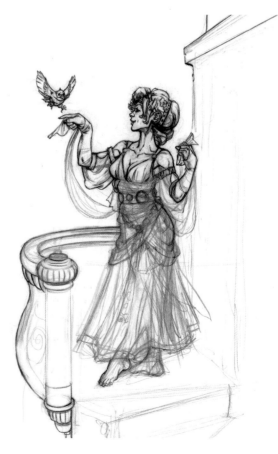

Step Five With the 2B, I start laying in final lines on her face, erasing much of the structure to prevent aging or making her look displeasing. I start building the texture of her hair, and then I use the 2H to lay in specific forms on the bird's body and wings, changing the position of the bird to portray active flight. I also add more detail to the background elements.

Step Six I finish the bird by darkening its forms, and then I move to the maiden's upper torso, where I build edges and texture. The sleeves follow the forms of the arms and drape from stress point to stress point. I erase more of the construction lines on light planes, leaving lines in area of shadow to help develop the forms. Then I refine the lines of some of the background elements.

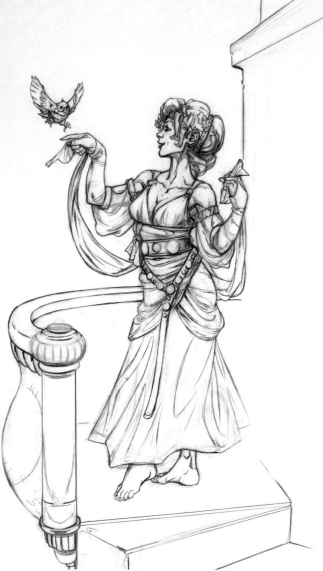

Step Seven I blot the figure with a kneaded eraser to clean up the construction lines, and then I lay in the rest of the outlines and shadow edges. I use thick lines on the shadowed side of forms and thinner lines on the lighter sides.

Step Eight To finish, I use the side of the 2H to block in a few more shadows. Then I erase any areas that have been overworked or look too heavy.

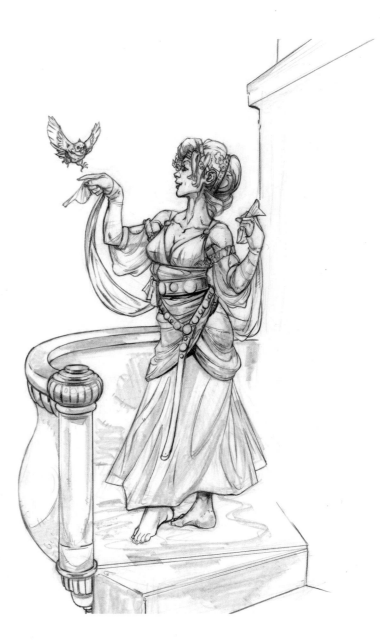

▶ **Step Nine** The palette is pretty subdued with pastel pinks and grays; the most saturated colors are around her head and on the bird.

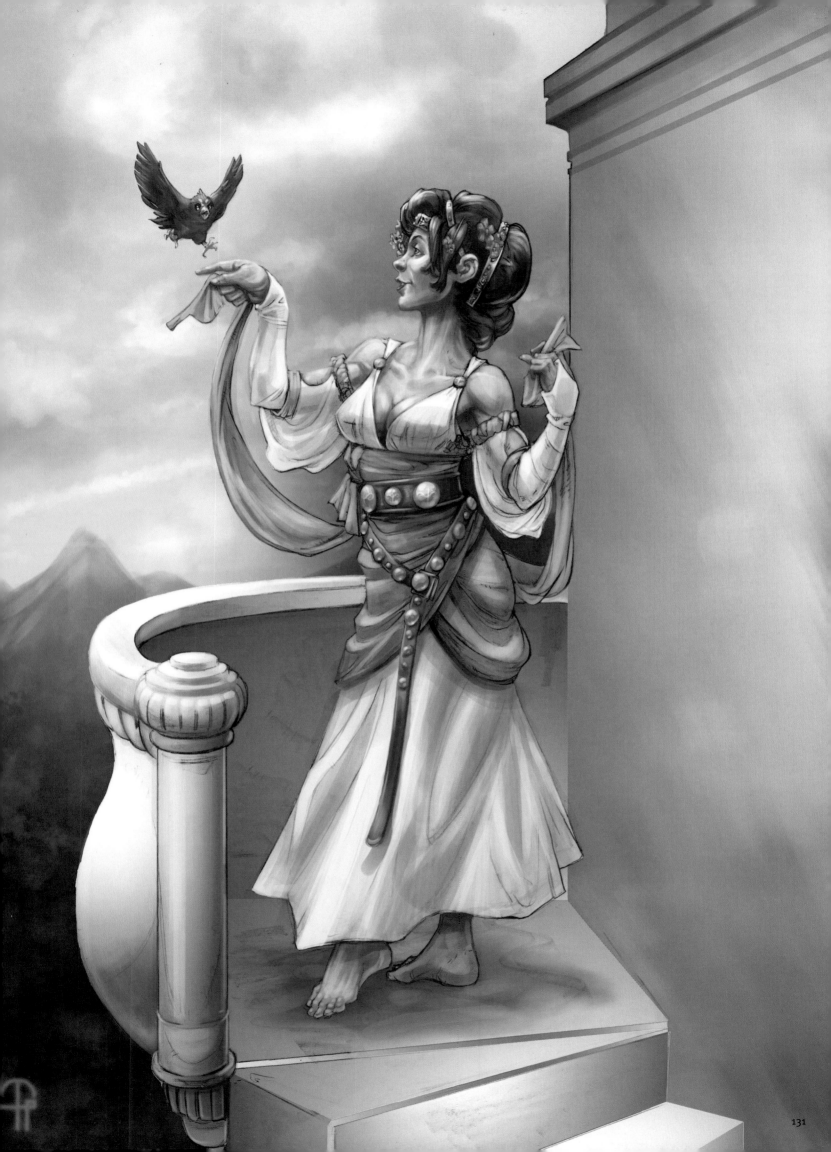

Archer

In a world where close combat is the norm, the ability to stand away from the fray and pick off enemies has an advantage. Since the bow is also used for hunting, it lends itself to a character forced to use it as a weapon rather than someone who intends to do harm by carrying a sword. The precision and ethos of legendary archers William Tell and Robin Hood elevate the weapon to a symbol of defiance of tyranny. One man with a bow and a precise shot can hold off and even take on a large force, using stealth and strategy to overcome the odds. These aspects have helped define the archer archetype as a clever hero of the common man and the bow the great equalizer in the battle of the classes.

Concept Sketches I tend to think of archers as lean fellows with little or no armor. I want a pose that reflects both the grace and tension of a bow.

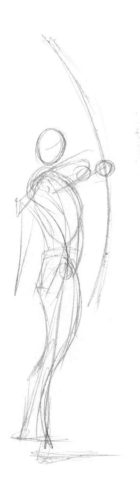
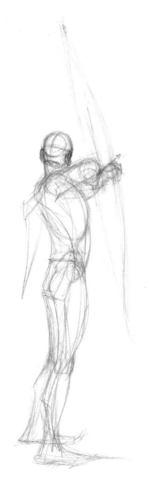
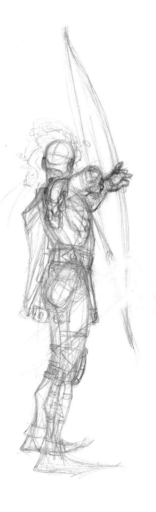
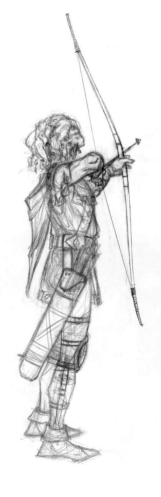

Step One I find myself drawn to the back view of the archer from a low point a view. I lightly sketch the basic pose with the side of a 2H pencil, indicating the curved bow and the outlines of forms like the oval ribcage and square pelvis.

Step Two I lay in a few basic forms to check position and proportion. I want to keep the figure lean, his pose somewhat mimicking the arch of the bow.

Step Three I use the side of the 2H to rough in some ideas for the costume, always thinking about the forms underneath and the point of view. I also further develop the visible anatomy. His arms and hands are a particular challenge so I follow the forms of the skeleton and muscle masses to feel out the shapes in space. I loosely sketch some hair, which I want to be wild, untamed locks. I find the center point between the two hands and lay in a perpendicular line with a straightedge so I can draw the arrow.

Step Four Still using the 2H, I continue to define forms, erasing some of the construction lines as I go. I erase the rough version of the bow and go back with a French curve to lay in the edges of the bow shape. I place the quiver on his hip rather than on his back to maintain the silhouette with the hanging hood.

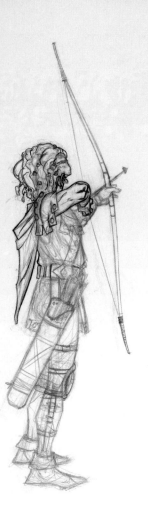

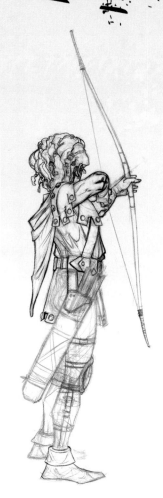

Step Five I use the 2B to start outlining forms and finding plane edges, starting with the hair. The textures of hair and clothing must follow the underlying shapes.

Step Six I continue to move down the figure, outlining forms with the 2B.

Step Seven After I reach the bottom of the figure, I go back through and lay in large areas of shadow with the side of the 2H.

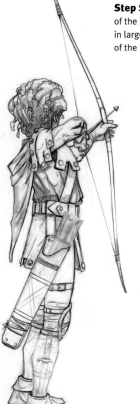

Step Eight I continue to add shadows and then switch to the 2B to harden edges, add texture, and deepen shadows. When drawing the bow string, it's a good idea to erase some sections of the line instead of leaving it solid. Finally, I use the side of the 2H to add a cast shadow on the ground.

King of the Dwarves

Gruff, squat, powerful humanoids that live primarily underground, the dwarves of legend are yet another iconic race included in most fantasy fiction. In personality and culture they are almost the exact opposite of the lean, carefree elves who use magic to maintain their lifestyle. The rugged dwarves are not gifted magically and many times cause magic to fail. Practical and hard working, they find joy in the toil of building vast networks of tunnels and crafting items of supreme strength and power. Other than their ability to extract and manipulate ore, dwarves are known for being fierce in battle (commonly wielding large double-headed axes) and their huge beards.

Concept Sketches I imagine the king of the dwarves as being outfitted in full plate armor and bearing an axe on his back.

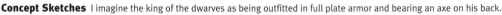

Step One With the side of a 2H, I lightly sketch the pose, making the figure look short and squat. Then I add the basic forms and major points of anatomy. Next I sketch the face and some of the costume, including the crown.

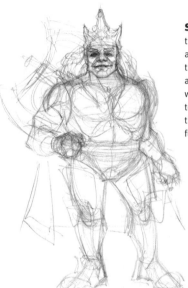

Step Two Using the side of the pencil again, I sketch lines for the hair, costume, axe, and massive beard. I work back into the face to widen the jaw and then develop the crown further.

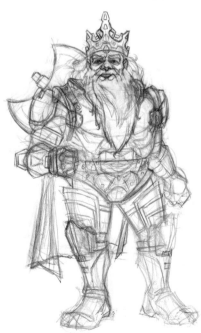

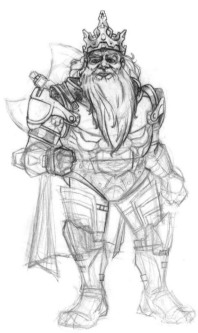

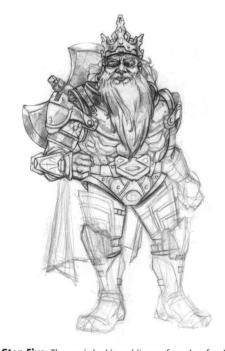

Step Three I place more pressure on the 2H and find edges and basic shapes for the armor, drawing through forms to make sure they wrap around the body and look convincing. I work on the face a bit more, exaggerating the loose skin under his eyes and drawing wrinkles to suggest his age. Dwarves have long lives but I imagine the aging process is similar to that of humans.

Step Four I'm feeling confident with the drawing so far so I blot the figure with a kneaded eraser to clean up construction lines. Then I switch to a 2B to start laying in the final lines, starting with the head. As I develop edges I also use the side of the 2H to place shadows. Since there are several layers of overlapping forms, this helps me see how they combine as they are developed.

Step Five The axe is looking a bit puny for a dwarf so I increase the size of the blades, using a circle template for the edges. I further develop the armor and then go back in with the 2H to add shadows, which helps me see how the forms are reading.

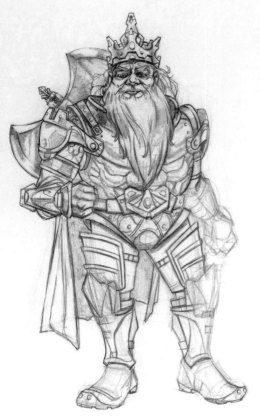

Step Six I continue the process down through the lower half of the figure. Then I go back into the shadows to build up some darker areas, and I erase light shapes to better simulate a reflective surface.

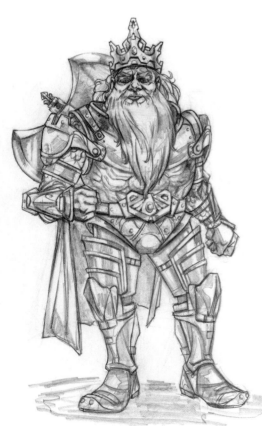

Step Seven I use the 2H to create more shadows and midtones, and then I go back in with the 2B to add details and extra texture. Then I use a hard plastic eraser and kneaded eraser to lighten up any areas that have been overworked.

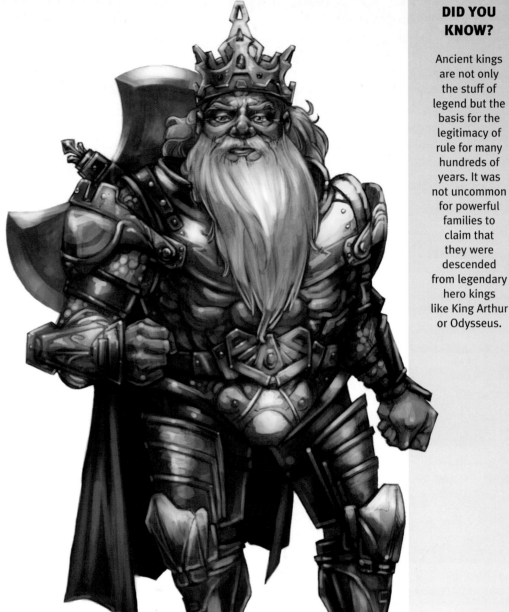

Step Eight I keep this one pretty simple, using a white light source, lots of gold armor, and a red cape with red jewels.

Black Knight

A black knight is a knight who has no allegiance to any kingdom or king. The lack of a standard or heraldic marking left these warriors free to pursue their own ambitions like the Ronin of Samurai lore. In an age of knights who swore their allegiance and built their lives around the code of fealty to a king, these free agents were ominous and unknown. This roaming status has lent itself to both a tarnished view of the mercenary aspect and a romanticized view of the adventurer aspect.

Concept Sketches I sketch several male poses but decide I would like the character to be female. I imagine a female knight would have even more reason to be an outsider.

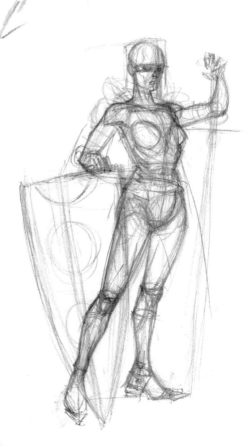

Step One I like the basic hero pose, so I interpret it as a female while I sketch. I quickly indicate a few forms to get a sense of the silhouette and position.

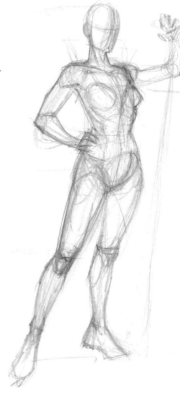

Step Two I place basic forms and refine the pose, checking proportion and placement. Notice the centerlines that indicate direction and surface planes. I want her to have a massive sword so I move the arm to accommodate it. Her left leg is bearing the weight of her body, so I raise the left hip.

Step Three Using the side of the 2H, I lightly sketch some of the costume. Much of this involves finding ellipses that follow the forms of the trunk and each limb. Once these work with the point of view, the resulting forms will be correct. I decide to add a large shield as well and change the position of her right arm to accommodate it.

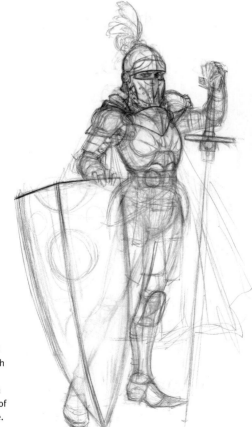

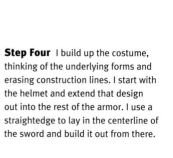

Step Four I build up the costume, thinking of the underlying forms and erasing construction lines. I start with the helmet and extend that design out into the rest of the armor. I use a straightedge to lay in the centerline of the sword and build it out from there.

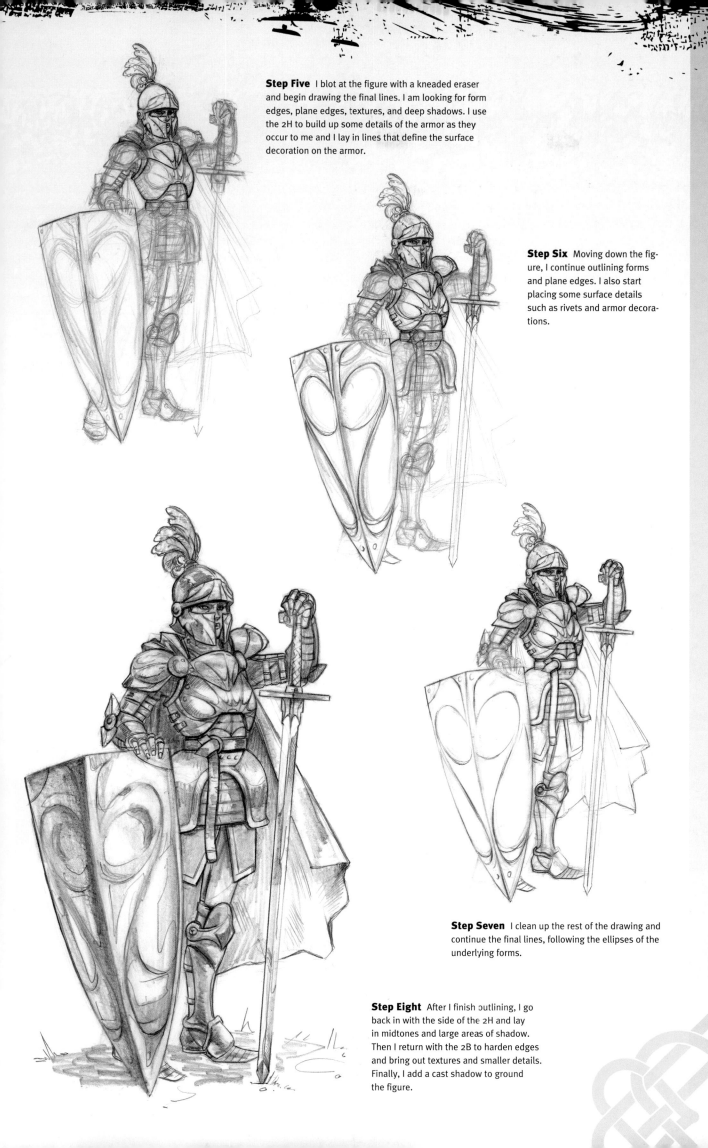

Step Five I blot at the figure with a kneaded eraser and begin drawing the final lines. I am looking for form edges, plane edges, textures, and deep shadows. I use the 2H to build up some details of the armor as they occur to me and I lay in lines that define the surface decoration on the armor.

Step Six Moving down the figure, I continue outlining forms and plane edges. I also start placing some surface details such as rivets and armor decorations.

Step Seven I clean up the rest of the drawing and continue the final lines, following the ellipses of the underlying forms.

Step Eight After I finish outlining, I go back in with the side of the 2H and lay in midtones and large areas of shadow. Then I return with the 2B to harden edges and bring out textures and smaller details. Finally, I add a cast shadow to ground the figure.

DID YOU KNOW?

Since these knights lacked the support staff to maintain equipment, it was common to cover their armor in black paint to keep off rust and tarnish. This is why there are known as Black Knights.

137

Undead Warrior

In the travels of any hero or heroine, it's not uncommon to come up against the undead, especially given the hero's propensity for crawling around old tombs, catacombs, and eldritch places of worship and human sacrifice. The undead tend to pop up in any location that hasbeen cursed or any time they have been sent by an evil wizard. Other favored places are old battlefields, since piles of dead soldiers make great candidates for raising by a Necromancer. Since the undead lack flesh, it's a good idea to equip oneself with a good bone-crushing hammer or club when facing these guys.

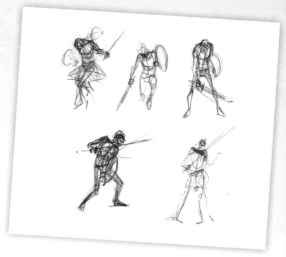

Concept Sketches I'm looking for a nice fighting pose that also has an element of stiffly lurching forward.

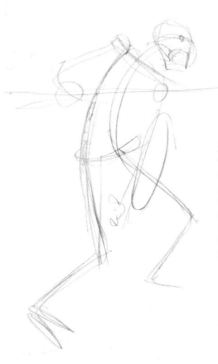

Step One I enlarge and trace the basic pose from the thumbnail, including the sword and shield, since they are weighty objects that affect the pose. The main lines to note here are the centerline down the middle of the figure and the hip and shoulder lines.

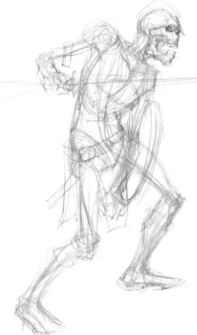

Step Two Since this is an undead character, I start the basic forms with bone shapes and note some large masses of atrophied muscles. I sketch in a few costume elements as well.

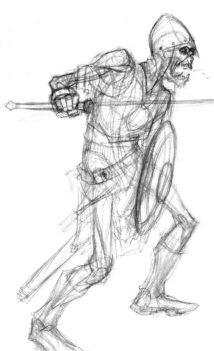

Step Three As I continue to work up the costume, I refine the forms of the anatomy that show through the tattered garments and armor. I concentrate on bones and tendons when drawing the anatomy, since the muscles are less defined in their atrophied state. I also add bits of debris coming from the warrior's mouth to indicate his undead state.

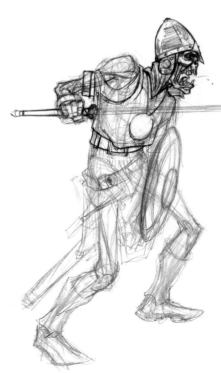

Step Four I feel confident with the forms and have a good idea of where I'm going, so I start to lay in final lines with the 2B. I work on the face to get deeply sunken eyes and a visage that is mostly defined by the shape of the skull. I work my way down from the head, outlining and adding areas of deep shadow. I use a straightedge to create a centerline for the sword and start to build up the shapes of the blade, guard, and hilt.

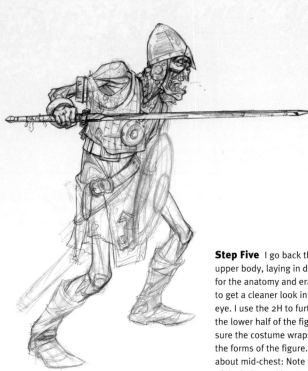

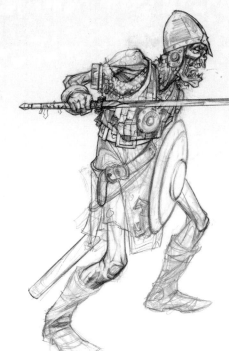

Step Five I go back through the upper body, laying in deeper lines for the anatomy and erasing areas to get a cleaner look in the face and eye. I use the 2H to further define the lower half of the figure, making sure the costume wraps around the forms of the figure. Eye level is about mid-chest: Note the ellipses of the belts and boots compared to the helmet.

Step Six I continue building up the texture of the chainmail and the decayed flesh. Then I dab at the shield with the kneaded eraser to clean it up before outlining the ellipses.

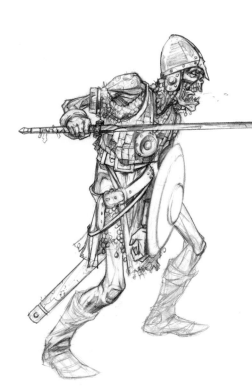

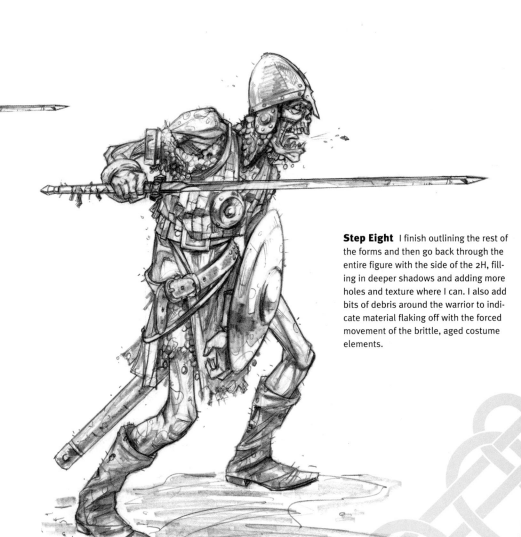

Step Seven I move into the lower half of the figure to develop texture, form edges, and shadows. Where I feel I need a bit of extra shadow, I use the side of the 2H to fill in areas like holes in the plates or the bottom planes of the knee and leg.

Step Eight I finish outlining the rest of the forms and then go back through the entire figure with the side of the 2H, filling in deeper shadows and adding more holes and texture where I can. I also add bits of debris around the warrior to indicate material flaking off with the forced movement of the brittle, aged costume elements.

Avenging Angel

The gods in many fantasy worlds take very active roles in the lives of those over which they lord. When not dancing on the heads of pins, angels are the enforcers of the will of the gods. Our angel is an avenger, out to smite an evildoer and bring retribution to his people. Angels are a fun subject and a classic one. I made sure to use reference materials from the Renaissance and Baroque periods of art when paintings of angels abounded. There are many routes I could take with this type of character, but after looking at the work of the masters, I'm in the mood to do something traditional. I want to create an attractive humanoid that exhibits both power and grace.

Concept Sketches I really like the pose where the angel is gliding down from heaven with one arm raised. I try a few others but like this one the most.

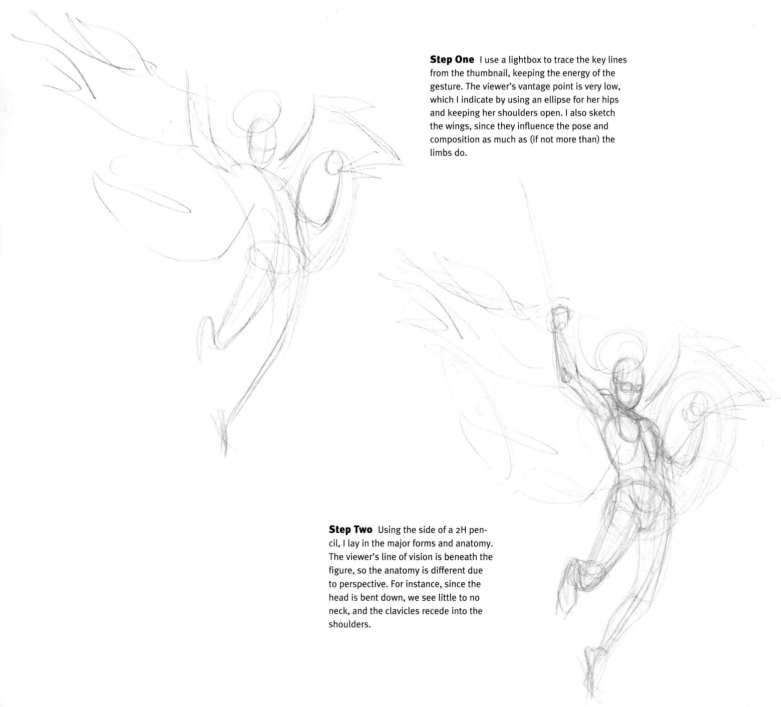

Step One I use a lightbox to trace the key lines from the thumbnail, keeping the energy of the gesture. The viewer's vantage point is very low, which I indicate by using an ellipse for her hips and keeping her shoulders open. I also sketch the wings, since they influence the pose and composition as much as (if not more than) the limbs do.

Step Two Using the side of a 2H pencil, I lay in the major forms and anatomy. The viewer's line of vision is beneath the figure, so the anatomy is different due to perspective. For instance, since the head is bent down, we see little to no neck, and the clavicles recede into the shoulders.

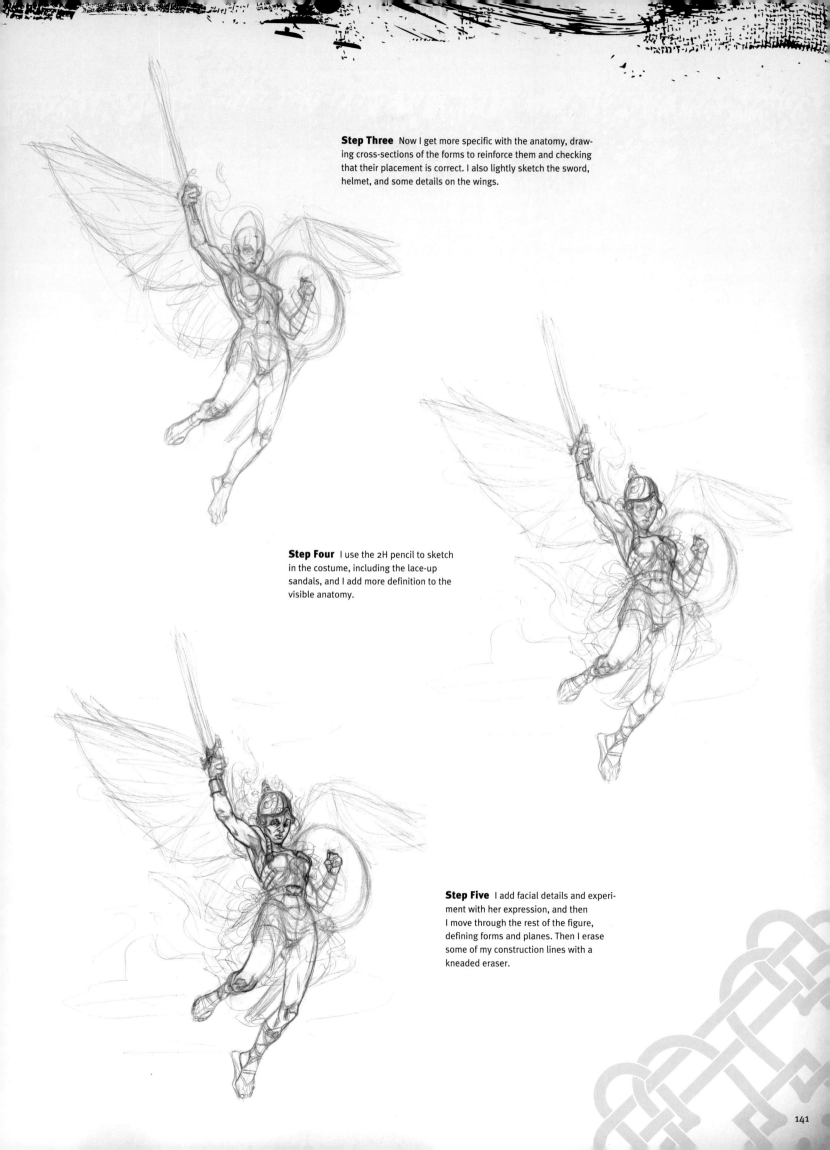

Step Three Now I get more specific with the anatomy, drawing cross-sections of the forms to reinforce them and checking that their placement is correct. I also lightly sketch the sword, helmet, and some details on the wings.

Step Four I use the 2H pencil to sketch in the costume, including the lace-up sandals, and I add more definition to the visible anatomy.

Step Five I add facial details and experiment with her expression, and then I move through the rest of the figure, defining forms and planes. Then I erase some of my construction lines with a kneaded eraser.

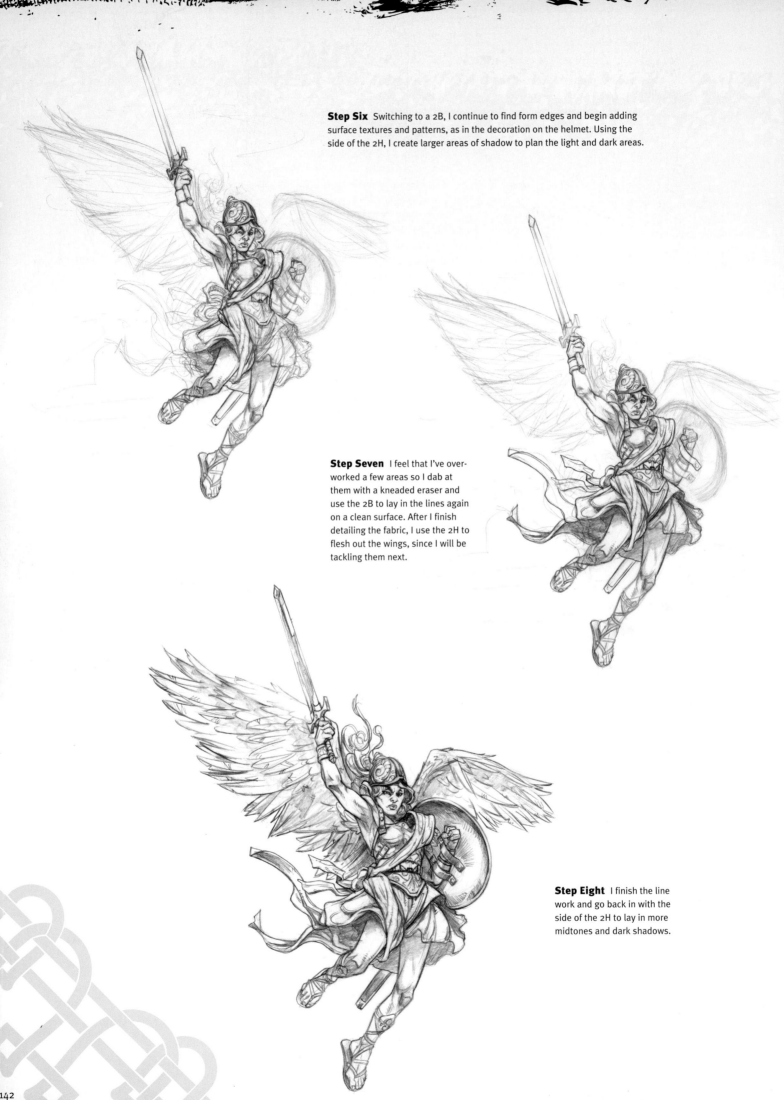

Step Six Switching to a 2B, I continue to find form edges and begin adding surface textures and patterns, as in the decoration on the helmet. Using the side of the 2H, I create larger areas of shadow to plan the light and dark areas.

Step Seven I feel that I've over-worked a few areas so I dab at them with a kneaded eraser and use the 2B to lay in the lines again on a clean surface. After I finish detailing the fabric, I use the 2H to flesh out the wings, since I will be tackling them next.

Step Eight I finish the line work and go back in with the side of the 2H to lay in more midtones and dark shadows.